Quilts
and health

Marsha MacDowell

Indiana University Press

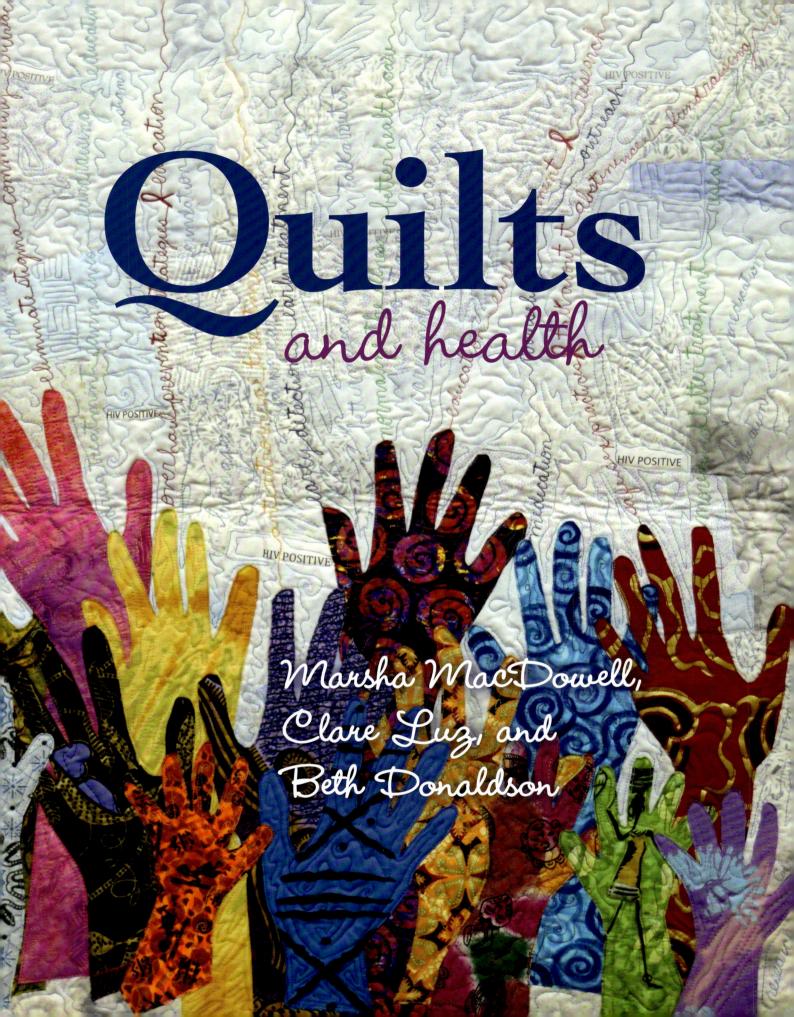

Quilts
and health

Marsha MacDowell,
Clare Luz, and
Beth Donaldson

This book is a publication of
Indiana University Press
Office of Scholarly Publishing
Herman B Wells Library 350
1320 East 10th Street
Bloomington, Indiana 47405 USA

iupress.indiana.edu

The paper used in this publication meets the minimum
requirements of the American National Standard
for Information Sciences—Permanence of Paper for
Printed Library Materials, ANSI Z39.48–1992.

Manufactured in China

*Cataloging information is available from
the Library of Congress.*

ISBN 978-0-253-03226-3 (cloth)
ISBN 978-0-253-03227-0 (ebook)

1 2 3 4 5 22 21 20 19 18 17

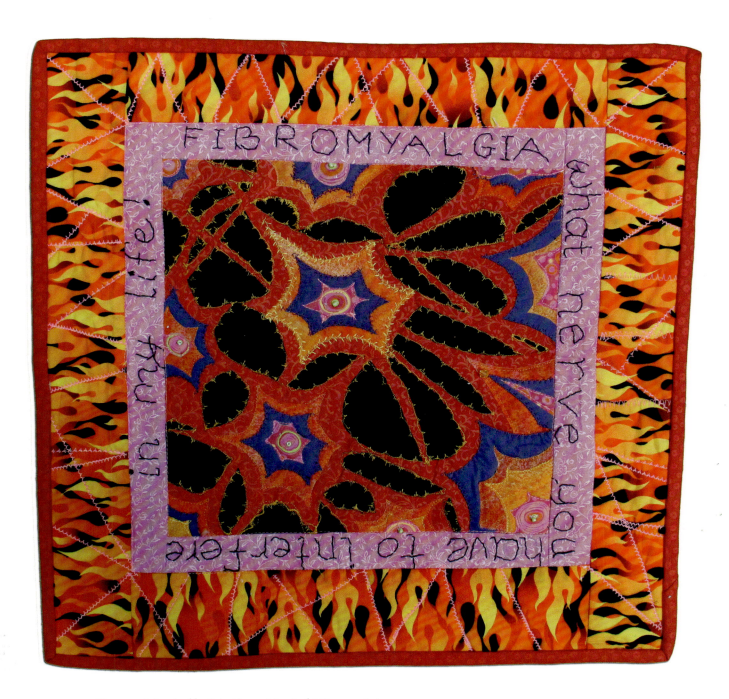

Figure 3.8. *Inspired by Pain*, Karen Mowinski, Tucson, Arizona, 2014.

Contents

PREFACE

In August 2009, my sister, Clare Luz, a faculty member in the Michigan State University College of Human Medicine, was asked by a colleague to organize a public panel on arts and healing in conjunction with ArtPrize in Grand Rapids, Michigan.[1] Since Clare had long been interested in the intersection of arts, health, and medicine, she agreed to do a presentation. Knowing that I have conducted extensive research on quilts in my capacity as a curator at the Michigan State University Museum and as an art history professor at MSU, she then turned to me to ask if I might be willing to join her as a second speaker. Off the top of my head, I knew I had data on the AIDS Memorial quilts and a few other health-related quilts, so I tentatively replied, "Yes, but let me check my files to see if I have enough to produce a full presentation." That night, as I looked through several physical and digital files I maintain, I was astounded at the breadth and depth of what I had already amassed on the topic and emailed her with a most definite yes. That night, I realized that the topic of quilts and health is an area of quilt studies that has been woefully under-researched.

A few days before our scheduled presentation, Clare and I sat in a hospital room with our mother and fellow scholar, Betty MacDowell, who was recovering from hip replacement surgery. Partly out of curiosity and partly as a way to pass the time, we asked nearly every medical professional who came into the room to try to give us an example of one disease or illness they thought could *not* be connected to quilts. All of them indulged us, and some even wrote their suggestions on surgical tape, which I then applied to the back of my computer. Before they made their next round of visits, we did Internet searches. As it turned out, we found quilts for every illness they thought would stump us, and we had fun sharing the stories with one another and with the medical staff as they returned to the room. As a quilt scholar, I was very surprised to see that we were finding not just one quilt made by one individual per illness or disease but often thousands of quilts made by thousands of artists. Even more surprising was that so many large projects were connected to medical institutions, patient advocacy groups, survivors of illness, and medical educators.

By the time we gave our presentation at the ArtPrize event, we knew that we needed to begin in-depth research on quilts and health. We partnered with MSU colleagues Heather Howard and Emily Proctor to conduct studies and presentations on Native American health and quilts. We joined the Society for Arts and Health, and with Beth Donaldson we created

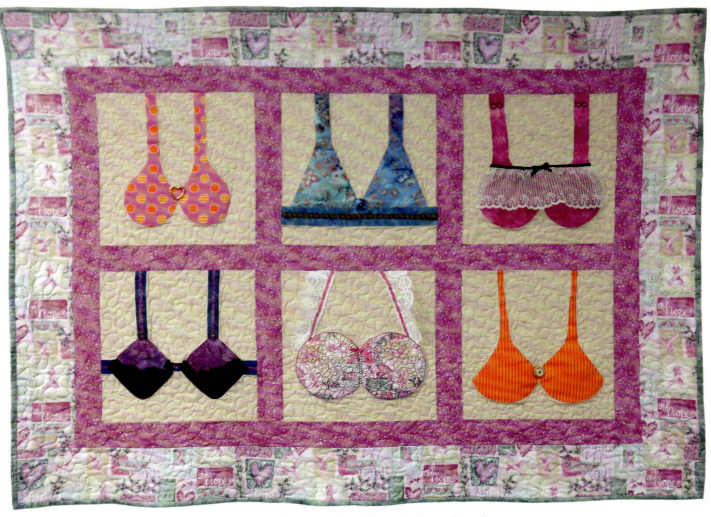

Figure 0.1. *Fighting Breast Cancer, One Breast at a Time*, Marie, Clarice, and Lucille (last names not identified), Lansing, Michigan, 2010. 38.5" × 51.5". Collection of the Michigan State University Women's Imaging Center. Photo by Marsha MacDowell, February 2016.

Google searches for the subject of quilts and health; initiated a Quilts and Health blog and Facebook page; sent out calls through Listservs and social media for stories about health-related quilts; scoured the interviews on Quilters Save Our Stories (QSOS); created a Mendeley site to collect the scientific papers, newspaper articles, and blogs we uncovered; and established a special section of the Quilt Index to allow for easier searching of health connections to the over eighty thousand images and stories in this massive digital resource.[2]

When Carol Slomski, MD, worked at the Breast Cancer Center of Lansing, she attended an "It's a Breast Thing" event to raise funds for and awareness of breast cancer and purchased this quilt, one of many pieces of art donated to the event. Slomski displayed it in her office, but when she moved to another state, she gave it to her colleague David Anderson, MD, who hung it in the center's main waiting room. He brought it with him when the Breast Cancer Center merged with the MSU Women's Imaging Center, East Lansing, Michigan, and it now hangs in a patient waiting area there. Center personnel say they get many great comments about the piece.[3]

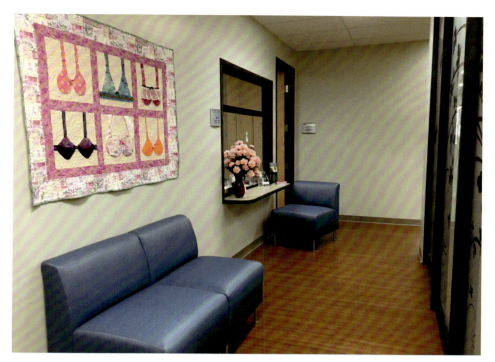

Figure 0.2. Waiting room, Michigan State University Women's Imaging Center, East Lansing, Michigan. Photo by Marsha MacDowell, February 2016.

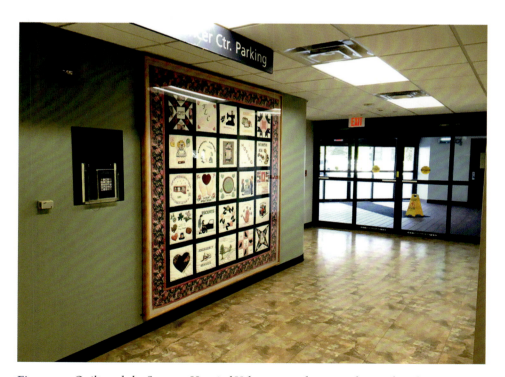

Figure 0.3. Quilt made by Sparrow Hospital Volunteers and presented as a gift to the Sparrow Health System on the occasion of one hundred years of service to the Lansing area for the 1896–1996 centennial year. From Michigan State University Museum, Michigan Quilt Project. Photo by Marsha MacDowell. This quilt is on permanent display in one of the hospital hallways. For more information, see the Quilt Index: "Sparrow Hospital Volunteers Quilt."

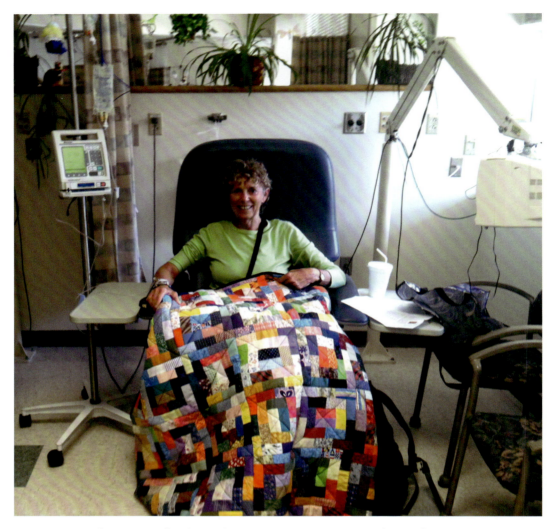

Figure 0.4. Marsha MacDowell at the Breslin Cancer Center, Lansing, Michigan, after being presented with a quilt made by Bobbie Slider, May 9, 2012. Photo in author's collection.

In January 2012 the topic of quilts and health took an unexpected personal turn. A regular mammogram detected some abnormalities, and I was scheduled for a biopsy. I walked into the waiting room of the Breast Cancer Center of Lansing, where a quilted wall hanging of a set of six bras was the only adornment of an otherwise bleak area. I tested positive for breast cancer and subsequently had a lumpectomy followed by six weeks of radiation and two doses of chemotherapy. In one of the hallways of Sparrow Hospital in Lansing, where I had my surgery, hung another quilt, each of its blocks depicting one facet of volunteer hospital work—from the wheelchair escorts, to the medical librarians, to the Tender Loving Care group in support of family members in the critical care visitor lounge.[4] At the clinic where I underwent daily radiation treatments, the registration counter often displayed baskets of quilted and knitted items as gifts for patients. But it was at my first chemotherapy treatment that the emotional and physical comfort of quilts to those who were coping with illness came most powerfully into my life. In the austere and rather chilly room, I was surrounded by other

Figure 0.5. *Brenda's Quilt.* Bobbi Slider, Lansing, Michigan, 2012. 48" x 56". Collection of Marsha MacDowell. Photo by Pearl Yee Wong.

At her first chemotherapy session following breast cancer surgery, Marsha MacDowell received from the clinic staff a quilt they described as a "new patient gift". Tucked in the bag with the quilt was a letter which read as follows:

Hello,

Several years ago I witnessed many patients receiving chemotherapy while I visited with my dear friend who was also receiving treatment for leukemia. Thanks to God, and a lot of prayers, she is now in her 6th year of remission. I know she often asked for blankets to keep her warm during the long hours of the procedure and was so grateful for them. In honor of her, I want "Brenda's Quilt" to help bring some comfort and warmth to you during your treatments and for many years to come. The bag may also come in handy to bring your books, purse, snacks, or whatever you need while you are being treated. As you can see, the quilt easily fits into this bag and has room for other necessities. Let the bag and quilt become your treatment care package and please use it anytime you feel the need for a little warmth and love.—Bobbie Slider "The Quilt Lady"

P.S. URGENTLY NEEDED! If you have, or know of anyone, who has any fabric or thread that could be donated, please bring in to the Center and the nurses will either store it or call me for pickup. I will be happy to take anything you can offer to go towards this endeavor. If you would prefer, I will also accept cash or checks. This will enable me to purchase the items that I currently need. Thank you so much.

After Marsha sent Bobbie a donation, Bobbie sent Marsha this note:

Dear Marsha,

There are no words to express my thanks to you for your contribution to my passion of making quilts for patients like you. I get so much joy from knowing that there are people out there that I've never met who find some comfort and warmth during those long chemo sessions.

If I can alleviate some pain and suffering, then it's all worthwhile. Your gift will be extended many, many times since I purchased 2 bolts of fleece and 30 yards of batting. These are the items that are most expensive and the ones I need constantly. Bless you, Marsha, Thank You. Looking forward to talking with you soon.—Bobbie

patients, some of whom had lost their hair and most of whom had companions with them. Alone, I was hooked to the intravenous chemo drip, and almost immediately the head nurse appeared before me with two large shopping bags and said, "You are a new patient; you can choose which of these you would like." Imagine my surprise, joy, and happiness in seeing that the choice she was offering me was between two quilts. Throughout my diagnosis and surgery I had not cried, but at that point the floodgates of tears let loose and I said to her, "Do you know what my research is?" She snapped a picture for me and then I read the letter accompanying the quilt. It was written by Bobbie Slider of Lansing, who had started making quilts for new patients of the Michigan State University Breslin Cancer Center after accompanying a friend to the center and experiencing firsthand the sterile and chilly environment. I quickly contacted her and found that, as of 2012, Bobbie had already made and donated more than four hundred quilts just for this purpose. She had also made many more quilts for other charitable causes, including several that are health-related.

I now see quilts everywhere I go as I continue my journey of health. The same bra-themed quilt, now on display at the Michigan State University Women's Imaging Center, greets me when I get my annual mammogram. Quilts also adorn the walls of the Breslin Cancer Center, and I have signed the Cancer Survivor Quilt that hangs in the office of my gynecologist. My oncologist gifted me with a copy of a book that was in the waiting room when I went for an annual checkup as part of a clinical medical trial of which I am a part. The book, *Lilly Oncology on Canvas: Expression of a Cancer Journey*, is a catalog of the work in a competition and exhibition of art created in various media by cancer survivors. I immediately recognized the cover image of the top prizewinner and was surprised to see it had been made by Judy Elsley, a quilt artist and scholar I knew, who had been diagnosed with breast cancer at nearly the same time as I. Needless to say, my own quilt-and-health-related experiences heightened my focus on the realm of study. My sister, Clare, and Beth Donaldson, a quilter, quilt scholar, and colleague at the Michigan State University Museum, joined me on this quest to explore the history, depth, and meaning of quilts and health. And, until she unexpectedly passed away in 2012 of pancreatic cancer, Betty MacDowell, whose own research was focused on stained glass and women's history, continued to help us find quilt references.

As of the end of 2015 we had spoken with many individuals who had made or used quilts in health-related contexts, viewed scores of quilts with connections to health, and had read numerous blogs and websites devoted to quilts and healing. We had amassed more than twenty-eight hundred published references to textiles and health, the vast majority of which were human interest stories about individuals who have been comforted and even improved their health by making, receiving, and using quilts. It seems that the making and giving of quilts has been striking emotional chords in communities around the world. The scientific literature, while limited, substantiates what those human interest stories in newspapers and the postings on many blogs and Facebook pages reveal: that the making, giving, and using of quilts are important, and sometimes even critical, to the health and well-being of individuals and communities around the world.

Notes

1. ArtPrize is an open international art competition and public engagement with art event that is held in citywide locations in Grand Rapids, Michigan. See http://www.artprize.org.

2. "Quilters Save Our Stories" (QSOS), http://quiltalliance.org/projects/qsos, and the Quilt Index, www.quiltindex.org. The QSOS, coordinated by the Quilt Alliance, collects interviews with quilt artists and digitally preserves and presents the interviews. The Quilt Index is a digital repository of stories and images of quilts and quilt artists from private and public collections around the world. Headquartered at Michigan State University Museum, this freely accessible repository serves as a resource for teaching and research, and data are added daily.

3. Field notes of Marsha MacDowell, May 20, 2016, and MacDowell phone interview with Carol Slomski, May 20, 2016.

4. Sparrow Hospital Volunteers Quilt, Quilt Index, http://www.quiltindex.org/fulldisplay.php ?kid=1E-3D-1DCE.

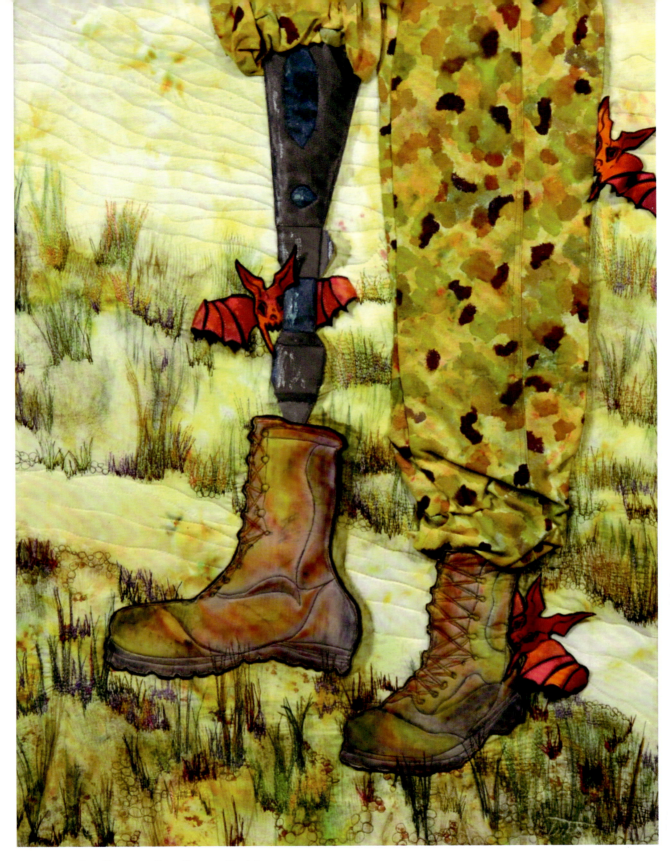

Figure 3.28. *Post Traumatic Stress Demons*, Patricia
Anderson Turner, Punta Gorda, Florida, 2014, detail.

ACKNOWLEDGMENTS

*M*any individuals and organizations contributed to the development of this publication, and we are grateful for their interest in and support of this endeavor. First we want to acknowledge individuals who shared images, stories, and information about quilts they made or owned and who led us to stories, reference, artists, funding, and assistance in various stages of research, writing, and production of this publication: Karen Alexander, Karen Albertus, Mona Alderson, Diana Alishouse, Kathleen Athorp, Sally Barker, Joshua Barnes, Dorothy Rocker Batkins, June Belitz, Judy Bell, Debra Bentley, Joann Bentz, Susan Berger, Virginia Berger, Michele Bileu, Lisa Binkley, Sandra Branjord, William J. Brickley, Judy Brown, Dawn Bryde, Lyn Bruner, Bonnie Bus, Betty Busby, Brianna Bushre, Carole Cappriotti, Laurie Ceesay, Shin-hee Chun, Paula Chung, Jackson Cloyd, Wilma Cogliantry, Marion Coleman, Shannon Conley, Nancy Brennan Daniel, Michele David, Jennifer Day, Anne Deaton, Jean M. Degl, Daisy DeHaven, Lynn DeRoche, Ellen Dilorio, Sheila Drevna, Ruth Dukelow, Mary Ann Dunn, Nicole Dunn, Lee Ebs, Jill Ellert, Lisa Ellis, Judy Elsley, Sharron K. Evan, Maria Eyckmans, Margaret Filiatrault, Janet E. Finley, Theadra L. Fleming, Cynthia Fowler, Mary Beth Frezon, Mary Kieras Frazier, Siobhan Furgurson, Carol Gebel, Jan Gagliano, Lisa Garlick, Barb Garrett, Mary Lou Gast, Lynne Geary, Troyd Geist, Eileen Gianodis, Karen A. Gibson, Joan Gilliland, Rayna Gillman, Mary Gold, Merton Goode, Lynn Lancaster Gorges, Joyce Graff, Jeanne Graham, Laura Marcus Green, Michael Guilfoil, Kay Guillot, Jessica Haak, Joan Bladl Haar, Katherine Hanson, Eric Hanson, Carole Harris, Karen Harsch, Craig Hartley, Georgia Hayden, Molly Greene Haywood, Janis Helton, Elizabeth Hendricks, Jeanne Henry, Garland Herndon, Gretchen Hill, Joanne Hindman, Judy Howard, Linda J. Huff, Beatrice Hughes, Debora J. Hulbert, Linda J. Hunter, Elma Hurt, Alice Johnson, Donna Johnson, Kathy Kansier, John Kay, Nadine Kelly, Donna Killoran, Judy Kinsey, Amy Kitchener, Suzanne Knox, Pat Kyser, Kathy Lane, Dorothy Ives, Teresa Jennings, Jane Johnson, Dorothy Jones, Bunnie Jordan, Terri Kohlbeck, Linda Kuhlman, Cathy Lamontagne, Sandra Larson, Mary Leadom, Joanne Lester, Pat Lester, Sandy Lindal, Joyce Linn, Cindy Liska, Carolyn Castaneda Little, Patty Livingston, Sylvie Lortie, Doris Lovadina-Lee, Betty MacDowell, Helen Marshall, Suzanne Marshall, Helen Martin, Lauryn Martin, Susan Gray Mason, Katie Pasquini Masopust, Christine Mauersberger, Chris Maynard, Vimala McClure, Lea McComas, Terry McKenney-Person, Diana McLaughlin, Ginny McVickar, Krista Meadows, Cindy Mielock,

Joyce Montanari, Karen Mowinski, Louise Mueller, Francis Murphy, Linda Murphy, Helen Murrell, Ollie Napesni, Kay Needles, Alden O'Brien, Phyllis O'Connor, Mary Olson, Carol Orme, Amy Orr, Gay Young Ousley, Judy Parlato, Paula Perelstein, Jean Perkins, Emma Petersheim, Laura Petrovich-Cheney, Yvonne Porcella, Gayle Pritchard, Patty Prodonovich, Ann Randolph, Sue Reich, Jean Replogle, Amy Rettig, Rhonda Reuter, Bonne Rhoby, Justine Richardson, Karen Rips, Anita Risbridger, Joan Rockenbrock, Pamela Roesler, Kathy Rogers, Debbie Rolek, Lori Rorstad, Elaine Ross, Bernie Rowell, Sandy Sanders, Marlene J. Shea, Bobbie Slider, Leona Scharfenberg, Ginny Schaum, Pat Scheid, Linda S. Schmidt, Linda Scholten, Carol Schon, Susan Schrott, Martha Schwab, Dawn Sees, Karen Smith, Anne Smyers, Gail P. Snow, Carolyn DeFord Solomon, Linda Sophiasworth, Cynthia St. Charles, Candace St. Lawrence, Pearl Spotted Tail, Mary Beth Stalp, Roxie Stark, Aafke Swart Steenhuis, Maxine Stovall, Jerri Stroud, Phyllis Tarrant, Ellen Thomas, Jeannette Thompson, Merrilee Tieche, Ricky Tims, Jeanne Trapani, Anne Triguba, Patricia Anderson Turner, Nettie Uher, Roger Ulrich, Kathleen Van Orsdel, Natalie Van Randwyk, Virginia Vis, Barb Vlack, Raymond Vlasin, Bill Volckening, Sue Walen, Patricia Washburn, Marita Wallace, Kathy Weaver, Terri Westberg, Annette Whims, Ruth A. White, Sandi Wierzbicki, Dee Williams, Samantha Hodge Williams, Claire Wills, Helen Willis, Lisa Wilson, Martha Wolfe, Victoria Findlay Wolfe, Margaret Wood, Sherri Lynn Wood, Linda Edkins Wyatt, and Becky Zajac.

We are profoundly appreciative of the willingness of the many organizations that shared their collections of images and information. These organizations (and in parentheses the individuals who assisted in sharing resources) include the following: Accuquilt "Have a Heart Make a Quilt," Agent Orange Quilt of Tears Project (Sheila and Henry Snyder); *American Craft Magazine* (Chris Mottalini, [Restorative Justice photo]), Angel Quilt Project; Alzheimer's Art Quilt Initiative (Ami Simms); American Heart Association, "Go Red For Women," Beth Israel Deaconess Medical Center (Donna Foley-Hodges); *Billings Gazette* (Darrell Ehrlick); Black Gold Quilt Patch Guild (Cecile Sigfuson); Block Party Studios Inc. (Jeanne Cloverday); Breslin Cancer Center, Lansing, Michigan (Marie, Clarice, and Lucille, Carol Slomski); Camo Quilt Project (Linda Weck); Capital Health (Lin Swensson); Caring Quilters; Cheyenne VA Medical Center (Carol Carr, Samuel House); Children's Inn at the National Institutes of Health (Lauren Kingsland); Christ Our Savior Lutheran Church Quilters; Comfort Quilters (Patricia E. Brown); Concord Piecemakers (Pam Cincotta); Conjeo Valley Quilters (Lynn M. Jurss); Disaster Quilting Project; Forever Warm; Fiber Artists @ Loose Ends (Lisa Ellis); Freedom Quilts (Betty Nielson); Full Circle Quilts (Kathleen Neiley); Heaven Scent quilt groups; *High Plains Daily Leader & Southwest Daily Times* Online (Earl Watt); Home of the Brave (Don Beld); Hopes and Dreams Quilters; Hug Quilters; IBD Project (Christina Sowell); Komen Race for the Cure (Karen L. Schultz); Lilly Foundation; Lizzies (Carla Fisher); Lutheran World Relief (John Rivera); McKay-Dee Hospital; Memory People (Leanna Chames); Messiah Quilters; Michigan State University Community Club Spartan Quilters (Martha Schwab, Joan Gilliland, Mike LeMense); NAMES Project Foundation Inc. (Julie Rhoad and Roddy William); Neighborhood Food Stores; Nifty Fifty Quilters (Joyce Neyers); Northwest Treatment Associates (Carol Fetzner); Ottawa Valley Quilters Guild (Grace MacNab); Pennsylvania Relief Sale (Kenneth M. Martin); Piece-Makers Quilt Group (Elaine Ousley); *Powell Tribune* (Ilene Olson);

Project Linus-Stockton on Tees (Majorie Cook); *Quad-City Times*; Quilt for Change; Quilted Expressions Quilt Shop; Rainbow of Hope (Tamera Ehlinger); Red Hill Baptist Quilters (Marie Bryant); Riverwalk Quilt Guild (Sandra Hess); Quilts for Community—Southeast Wisconsin (Barbara Vallone); Quilts of Valor (Catherine Roberts, Peggy Luck); Radiological Society of North America; Reed Brennan Media Associations (Susan White); Retired Senior Volunteer Program (RSVP) (Delora Blanchard); Ricky Tims Inc. (Cindy McChesney); Riverwalk Quilt Guild (Sandy Hess); San Antonio Eye Bank (Simera Nichols); Six Chix Cartoon (Benita Epstein); Studio Art Quilt Association; Tucson Quilters Guild Inc. (Jeannie Coleman); Two Chicks Designs, Warrior Quilt Project, Wichita, Kansas; University of Alabama at Birmingham, Women and Infants Center (Mary Colurso, Kimberly Kirklin, Sandra Holt Milstead, Deardra Pinkett, Lillis Taylor, Angellia Walker); University of Missouri Health Care (Sandy Scotten, Lori Hibbs, Christopher Fender); Wheeling Hospital's Comprehensive Breast Care Center (Deb Radosevich); Women of Color Quilter Network (Carolyn Mazloomi); Women's Health Initiative; and Zuma Wire (Florence Combes).

We are grateful that the Michigan State University Museum has been able to engage in quilt history projects and to develop a world-class collection of quilts with funding support from the Michigan State University Foundation through the following: MSU Office of Vice President for Research and Graduate Studies, Kitty Clark Cole Endowment, Harriet Clarke Endowment, Cuesta Benberry Quilt History Endowment, Anne Longman Endowment, Marsha MacDowell and C. Kurt Dewhurst Endowment for Traditional Arts, Carolyn L. Mazloomi/Women of Color Quilters Network Endowment, Quilt Index Endowment, and Michigan Quilt Project Endowment. This collection can be freely accessed through the Quilt Index (www.quiltindex.org), the international digital repository based at the Michigan State University Museum.

We are indebted to the strong support of the following colleagues at Michigan State University who contributed in large and small ways and were critical to seeing this project germinate, grow, and flourish: C. Kurt Dewhurst, Veronica French, Katherine Hanson, Heather Howard, Jilda Keck, Julie Levy-Weston, Micah Ling, Molly McBride, Emily Proctor, Sue Schmidtman, Mike Secord, Lynne Swanson, Mary Worrall, and Pearl Yee Wong.

We were fortunate that so many individuals from various backgrounds were able to lend their time and expertise to read drafts of the manuscript. They included a quilt historian, three medical doctors, a university medical school educator who is also a quilter, an oncology nurse who is also a quilter, a professor of family studies, a professor of American studies, a university museum-based folklorist, and an individual who was a former editor and has no connection to quilts but lives with a debilitating illness. Our thanks to C. Kurt Dewhurst, Becky Green Fellow, Molly Greene Haywood, Roberta Imhoff, Joanne Keith, Susan Reardon, David Stowe, Vincent WinklerPrins, and Mary Worrall. We are grateful for the close reading they gave the manuscript and took to heart their many suggestions. We are also grateful to the two external readers of the manuscript, Diana N'Diaye and Kate Wells, who also provided acute observations that helped us strengthen the book.

Lastly, we are especially appreciative of the enthusiastic, caring, and supportive team at Indiana University Press, especially Janice Frisch and Gary Dunham, as they oversaw the production of this book. It has been a pleasure to work with them.

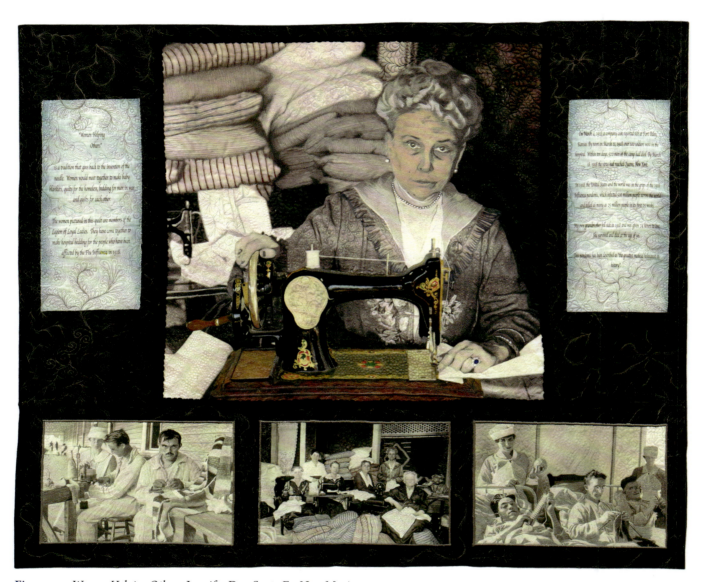

Figure 4.1. *Women Helping Others*, Jennifer Day, Santa Fe, New Mexico, 2014.

Quilts
and health

Introduction

Quilts substantially contribute to health and well-being.[1] The number of health-related quilts made is in the millions.[2] Name an illness, medical condition, or disease and you will likely find quiltmaking associated with it. From Alzheimer's disease, to irritable bowel syndrome, to Lou Gehrig's disease, to Crigler-Najjar syndrome, to nearly every form of cancer, associated quilts have been made by thousands of individuals in support of personal well-being, health education, patient advocacy, memorialization of victims, and fund-raising. In addition, a long history exists of individuals and groups making quilts in response to the physical and emotional needs of those who are facing disasters or difficult times. When illness or disaster strikes, quilts can play a key role in both individual and public healing.[3] Some health-related quilts are the singular expression of one person's experience with illness or coping with adversity. For some diseases or disasters, there are literally tens of thousands of quilts.

Aided by the quick dissemination of information via blog accounts, Facebook pages, websites, and other social media, long-standing health-related quilt traditions are becoming more widespread and new traditions are emerging. Increasingly, quilts are being made and used in health-care contexts. They are used to help create welcoming, comforting, and healing environments in hospitals and other caregiving settings; to provide dignity for those who are undergoing care; and to provide hands-on activities that help patients cope with their institutional care in a positive way. Recent research shows that making and using quilts has a measurable impact on strengthening cognitive abilities and mitigating emotional health issues. The words "quilt," "patchwork," and other terms associated with quiltmaking have also become part of our language related to health. Health coverage is referred to as being "pieced" or "patched together." One health information security project is even named HealthQuilt; the corporate logo for another health security firm is based on a quilt pattern, and a quilt of that logo hangs in their corporate office.[4]

The stories behind these quilts are often moving and speak strongly to the healing power of quilts and quiltmaking. Individuals tell about making and using quilts to cope with and recover from major illness, grief, and traumatic events. Many references are given to quilts being used as "textile hugs," enfolding the user in warmth and comfort. Whether or not they know the maker of the quilt, recipients know that another individual in the world cares about

them. Most of these stories are simply shared person-to-person, yet, more and more often, quilt and health stories are being recorded and shared through folklife and oral history projects; state and regional quilt documentation projects; and associated publications, films, blogs, and websites.[5] It is through these stories that the meaning and message of the quilts is more completely understood and that the deep connections between textiles and health become evident.

It is increasingly clear that the realm of quilts and quiltmaking is massive—in terms of numbers of makers and users—and is having a profound impact on the lives of individuals and on medical education and care. It is an important aspect of history that deserves to be better known. Indeed, quilts have documented history, including that of medical research. For example, one particular quilt by Helen Murrell is a statement of outrage and bewilderment for the unjust treatment of 600 African American men who, without their knowledge or consent, were subjected to a forty-year medical experiment conducted for the United States government. Through the experiment, 399 men were deliberately infected with syphilis and were allowed to go untreated, even after a cure was developed. The Tuskegee Syphilis Study has been called perhaps the most infamous biomedical research in U.S. history and led to the establishment of the Office for Human Research Protections. Demonstrated knowledge and understanding of the moral and ethical dimensions of the "Tuskegee experiment" are requirements for those undertaking research with human subjects.[6] The quilt was one of more than eighty-five commissioned from artists by Carolyn L. Mazloomi for *And Still We Rise: Race, Culture, and Visual Conversations*, an exhibition of quilts that chronicles important people and events in African American history.[7]

Quilts and their associated stories, systematically studied, have great potential to help us understand the human experience of illness and health, advance medical knowledge, and, ultimately, enhance the quality of health care, outcomes, and life. Yet, remarkably, the making and use of quilts for health and well-being purposes has heretofore not been substantially explored in humanistic and scientific literature. One of the earliest publications on quilt history in America was *Old Quilts* written by a quilt collector and psychiatrist, William R. Dunton Jr., MD, who is considered the father of occupational therapy.[8] Dunton credited his reading of Marie Webster's *Quilts: Their Story and How to Make Them* with awakening his interest in documenting and recording early quilts and their history.[9] Quilt historian Karen Alexander writes that Dunton also realized that "the process of selecting color and pattern, as well as the social interaction that quilts traditionally engendered, would be of great benefit to his 'nervous' patients. As a psychiatrist, he thought his female patients could benefit from the quiet calming influence of needlework as well as the sense of accomplishment it brought."[10]

Since then, quilt and health scholarship has been limited. A small number of publications on quilts and health have focused on specific projects, such as the NAMES Project quilt and the Alzheimer's Art Quilt Initiative, and a few scholars who are also quiltmakers have written reflectively on their own experiences with quilts and health.[11] There is a growing body of literature on the relationship of art in general, and some particular art forms such as music, to improved health and healing. However, researchers representing multiple disciplines are just now beginning to systematically document quilts related specifically to health and their stories; collect additional data, such as measures of coping; and apply findings to medical

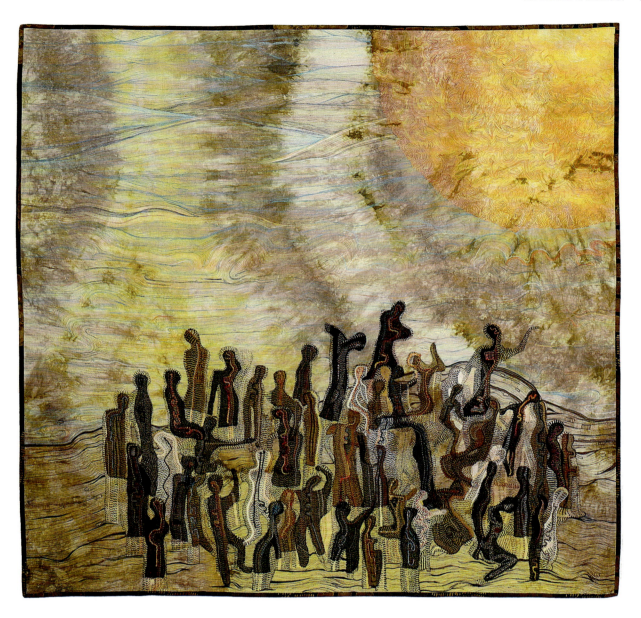

Figure 0.5. *We Are All Warmed by the Same Sun*, Helen Murrell, Cleveland Heights, Ohio, 2012.
54.5" × 54". Collection of Carolyn L. Mazloomi/Women of Color Quilters Network.
Photo courtesy of Charles E. and Mary Martin.
Murrell writes this about her quilt:

> In the book *Gandhi: His Relevance for Our Times* he is quoted [speaking of war], saying that "all
> mankind is supported by one universe—the same earth feeds us, the same sun warms us, and same
> stars shine upon us." I believe there is a common quality in all humans that should not give any
> person dominance over any other—especially when it comes to life and death. We should never
> forget that the tragedies of the past might occur again. I made this quilt hoping that it will remind us
> all that we are ultimately one family. If we are to give justice to the men who were the subjects of the
> Tuskegee syphilis study, we should not ever forget our own humanity, nor let others forget theirs.

(Helen Murrell, quoted by Carolyn L. Mazloomi for Quilts and Human Rights documentation record,
2013, collection of the MSU Museum.)

Figure 0.6. T-shirt. Collection of Michigan State University Museum, purchased from Two Chicks Design.

education, health care, and public health initiatives. And no one publication has described the history of quiltmaking and its connections to health, analyzed the wide range of ways in which quilts have been used to address health and well-being, or linked the personal stories of the makers with the material objects. With this volume we hope to provide that framework.

It is meant to be of interest to the makers and users of quilts, those who have endured health-related challenges, and those who are working in health care. We begin with an examination of the scientific literature on arts and health, particularly with regard to quilts; then we go from the very personal experience to the collective activities of making and using quilts for health and well-being; and finally we address how quilts are being made and used within the health-care community. The selection of which stories and images should be included here has been difficult, as there are so many that are powerful and worth sharing. Those that have been chosen are but a sample and stand for the millions of others that exist. Our aim is to motivate more research on how making or using quilts can improve health and

health care. We also hope to validate this tremendous art production; to give honor to those who have used their needle, fabric, and thread to provide comfort to others; and, finally, to offer comfort and hope to those who are currently coping with health and well-being challenges. Because perhaps, as the T-shirt proclaims, in some instances "actually, quilting is the best medicine."

Notes

1. Emily L. Burt and Jacqueline M. Atkinson, "The Relationship between Quilting and Well-being," *Journal of Public Health* 34 (2011): 54–59.

2. A version of the introduction by Marsha MacDowell and Clare Luz was published as "Quilts and Health," *Quilter's Newsletter Magazine* (December/January 2012): 44–47. At that time we stated the number as being in the hundreds of thousands. Based on our subsequent research we now know that there are millions.

3. Linda Giesler Carlson, *Quilting to Soothe the Soul: Create Memories for Today, Tomorrow & Forever* (Iola, WI: Krause Publications, 2003).

4. Fred Trotter, "NHIN-Direct Leans towards HealthQuilt Security Model," April 18, 2010, *Fred Trotter*, http://wwwfredtrotter.com/2010/04/18/nhin-direct-leans-towards-healthquilt-security-model. Also "The 'Madaket Quilt,'" November 24, 2015, http://www.madakethealth.com/the-madaket-quilt.

5. Examples include *Quilts and Health*, http://quiltsandhealth.wordpress.com; "300 Words about Quilting and Grief," http://www.quiltersnewsletter.com/articles/300_Words_about_Quilting__Quilting_and_Grief; and the Quilt Index, www.quiltindex.org.

6. Wikipedia, "Tuskegee Syphilis Experiment," https://en.wikipedia.org/wiki/Tuskegee_syphilis_experiment.

7. For the companion publication, see Carolyn L. Mazloomi, *And Still We Rise: Race, Culture, and Visual Communications* (Atglen, PA: Schiffer Publishing, 2015).

8. William Rush Dunton Jr., *Old Quilts* (Baltimore, MD: Privately printed, 1946).

9. Marie Webster, *Quilts: Their Story and How to Make Them* (New York: Tudor Publishing Company, 1915).

10. Karen Alexander, "William R. Dunton (1868–1966) Quilt Collector, Author, Psychiatrist," *The Quilters Hall of Fame Blog*, January 16, 2012, http://thequiltershalloffame.blogspot.com/2012/01/william-r-dunton-1979-honoree.html. See also Eileen Jordan, "William Rush Dunton, Jr.," in *The Quilters Hall of Fame*, ed. Merikay Waldvogel and Rosalind Webster Perry, 57–60 (Marion, IN: Quilters Hall of Fame, 2004); Dunton, *Old Quilts*; and Frederick E. Knowles, III, "Memories of Dr. Dunton," *Maryland Psychiatrist Newsletter* 22, no. 3 (1995), http://www.dunton.org/archive/biographies/William_Rush_Dunton_Jr.htm.

11. See, for example, Janet Catherine Berlo, *Quilting Lessons: Notes from the Scrap Bag of a Writer and a Quilter* (Lincoln: University of Nebraska Press, 2001); and Judy Elsley, artist statement, *Lilly Oncology on Canvas: Expressions of a Cancer Journey National Coalition for Cancer Survivorship* (Indianapolis: Lilly USA, 2012), 4–5. See also Judy Elsley, "Journal Quilts: The Micro Series," https://www.judyelsley.com/journal-quilts-the-micro-series.

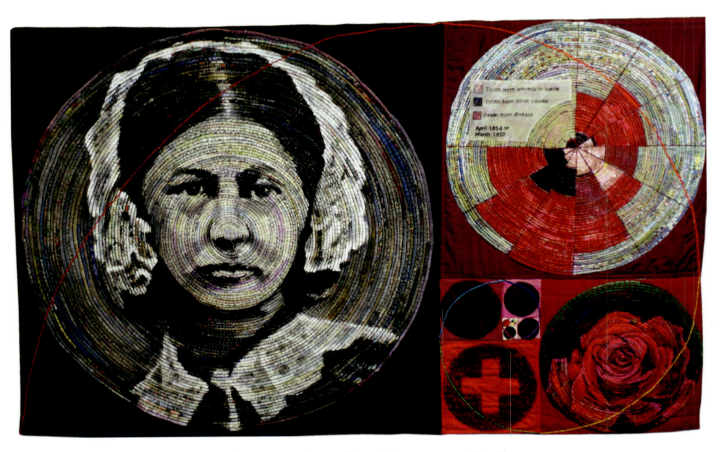

Figure 1.1. *Florence Nightingale*, Shin-Hee Chun, Hillsboro, Kansas, c. 2012. 48" × 78".
John M. Walsh III Collection. Photo by Del Gray.

This painted quilt won the award for "Most Innovative Use of the Medium" at the 2013 Quilt National held at the Dairy Barn Arts Center in Akron, Ohio. According to Chun, "Florence Nightingale used her data to show the correlation between the cleanliness of the hospitals and the mortality rate, creating a chart, often called [a] rose chart. In laying out her image with her rose chart, red rose, and red cross, I wished to honor her accomplishments. By synthesizing the Fibonacci Spiral, I wanted to illustrate circles and squares, math and art, beautiful mind and good deeds" (Shin-Hee Chun, correspondence and artist statement sent to Beth Donaldson, May 3, 2016).

Evidence of the Impact of Quilts and Quiltmaking on Health and Health-Care Outcomes

Literature on the association between quilts, quiltmaking, well-being, health, and health-care outcomes is still sparse. The majority of scholarly studies lack rigorous scientific research designs or deep humanistic investigation. There are few that have used randomized control groups, representative samples, or standardized instruments to measure indicators of health and clinical outcomes. Many of the qualitative studies are limited in their sample size or methods. However, there is no denying the accumulation of an astronomical amount of anecdotal evidence that clearly links quilts and health, from which we have gleaned just a fraction for this book. One could argue that when so many narratives are amassed, all indicating the same thing, the collective no longer fits the common definition of anecdotal, individual case examples, stories based on hearsay rather than on hard facts and statistical confirmation.

On the contrary, the data that have been compiled related specifically to quilts and health suggest findings that are anything but atypical. Further, they are conducive to being investigated using sound, replicable scientific methods as well as deeper humanistic exploration. Indeed, this field of inquiry is growing, just as it has in the area of testing the association of the arts in general with health outcomes. It is wide open for such critical analyses, and we posit that as such studies are undertaken, the empirical evidence will substantiate what we already believe to be true: that quilts, as they are used today and have been for centuries, equal good health. We will even go as far as suggesting that there are ways in which quilts can be distinguished from other art forms in terms of their therapeutic and clinical value. In this chapter we explore the current evidence for our claim and invite scholars to take on the challenge of closing gaps in knowledge so that the richness of this art form, and associated stories, can contribute to more holistic, person-centered health-care practices and, as a result, improved quality of life, health, and health-care outcomes.

Methods

We started our research for this book with several guiding tenets. The primary objective was to explore the prevalence, use, meaning, and impact of quilts related specifically to health, whether for therapeutic, educational, fund-raising, or other purposes. We were particularly interested in the stories behind the quilts. Multiple methods of data collection have been used since 2011, including posting requests on two major quilt-related blog sites and two

Facebook pages—*Quilts and Health* and *Quilts Vintage and Antique*—which, all combined, have nearly three thousand members. Blog and Facebook news feeds were also culled for relevant posts from other sites, which produced nearly three thousand news and journal articles. In addition, email requests were sent to eleven hundred quilt guilds across the United States asking them to share the invitation with their members. This generated 105 responses from individuals who hoped to have their quilts and stories recognized.

All of those who responded to these appeals were asked to complete a "Quilts and Health" documentation form. The form asked for extensive information on the quiltmaker, including demographics and their quiltmaking history, such as how they learned to quilt; from whom, when, and why they quilt; how many quilts they have made; and whether they belong to a guild. Data were also collected on the quilts themselves, including when they were made; where, why, and by whom; and how they are or were used.

Finally, an extensive search was undertaken of the massive Quilt Index archives, a digital repository of more than eighty thousand quilts, each with an associated, completed data collection form similar to that just described. In all of these searches, multiple key words were used, such as "quilts," "quilters," "quiltmaking," "health," "cancer" and names of other diseases, and "well-being." The searches resulted in an almost unmanageable amount of data, and we then faced the task of reading, organizing, and analyzing the wealth of riches we gathered.

The focus of this chapter is on the empirical evidence for an association between quilts and health, gleaned from close to one hundred academic journal articles. The primary inclusion criteria included a focus on measurable health indicators, such as stress, anxiety, grief, coping, and a sense of well-being, and factors that affect health, such as creative expression and opportunities for affirmation, feeling heard, constructively venting anger, and processing grief. Data collection and analyses will go on for years, but we are excited to share what we have learned thus far.

Arts and Health

As the scholarly literature on the specific association between health and quilts is still limited, we first turned to a growing body of literature that provided empirical evidence supporting the relationship of art in general to improved health and healing. It is reasonable to believe that in many cases the findings from these studies could be relevant to quilts as well. Studies that use multiple forms of art therapy have provided insight, such as Edward A. Ross, Tracy L. Hollen, and Bridget M. Fitzgerald's study on the impact of an Arts-in-Medicine (AIM) program in an outpatient hemodialysis unit on a broad measure of quality of life.[1] These researchers built on a highly successful twenty-year AIM program at their home institution, the University of Florida, that involved artists providing opportunities to engage in artwork, crocheting, crafts, poetry, and playing musical instruments. The Medical Outcomes Study 36-Item Short Form Health Survey (SF-36) and Beck Depression Scale were administered to forty-six patients at baseline and at six months, and clinical outcomes were tracked, including the percentage of perceived dialysis time, interdialytic weight gain, and predialysis lab results. At six months there was significant improvement in certain lab and hemodialysis parameters, a trend toward less depression, and a correlation between high participation in AIM and improved social function and bodily pain.[2]

Figure 1.2. *Research Now . . . There's Still Time*, Nancy Brenan Daniel, Prescott, Arizona, 2006. 30" × 44". Collection of Michigan State University Museum. Photo by Pearl Yee Wong. Daniel dedicated this quilt "to research—and those who do the research." Printed on silk organza and stitched onto the quilt are the phrases "Research is the key," "Our life is the creation of our minds . . . ," "Please Help, Help Me, Help Me, Help Me, Help Me, Help Me," "Remember Me, Remember Me," and "Research now . . . There's still time" The artist donated this quilt to the Alzheimer's Art Quilt Initiative for a traveling exhibition; AAQI subsequently auctioned it off to raise funds for Alzheimer's research (Quilt Index, http://www.quiltindex.org; see also Ami Simms, *Alzheimer's Forgetting Piece by Piece* [Flint, MI: Mallery Press, 2007], 104–105).

Heather L. Stuckey and Jeremy Nobel contributed greatly to this field by conducting an extensive literature review exploring the relationship between engagement in the creative arts and health outcomes.[3] Four major areas of scholarship related to arts and health care emerged: music engagement, visual arts therapy, movement-based creative expression, and expressive writing. Stuckey and Nobel's findings confirm that although art therapy has been used clinically for more than a century, the vast majority of the literature is theoretical in nature without attention to measurable outcome, and only recently have systematic studies been undertaken. Music has been perhaps the most researched medium, and evidence exists of its beneficial impact on decreasing anxiety, reducing pain, and increasing a sense of control, immunity, and wellness among patients suffering with chronic cancer pain. One study in 1989 by Cathie E. Guzzetta involved randomly assigning eighty patients in a coronary care unit to either relaxation therapy, music therapy, or a control group in order to determine the effects of such therapies on indicators of stress. The relaxation and music therapy groups had significantly improved apical heart rates and peripheral temperatures compared with the control group.[4]

Research in the visual arts also offers evidence of their impact on health outcomes, such as pain reduction and the need for less narcotic pain medication, reconstruction of a positive identity, reduced hospital stays, and fewer symptoms of physical and emotional distress. Stuckey and Nobel report, "Art helps people express experiences that are too difficult to put into words, such as a diagnosis of cancer . . . integrating cancer into their life story and giving it meaning." Findings from one qualitative study conducted with women with cancer indicated four major ways in which engaging in different types of visual art aided in the healing process. Art helped them focus on positive life experiences versus an ongoing preoccupation with their illness. It also enhanced their self-worth and identity and the ability to maintain a social identity not defined by their illness, and it allowed them to express their feelings such as fear and grief in a symbolic manner.[5] Another study, using a pretest-posttest, quasi-experimental design with multiple standardized instruments, tested the efficacy of a creative arts intervention with forty family caregivers of persons with cancer. Among those who took part in the program, stress and anxiety were significantly reduced.[6]

The review of studies related to movement-based creative expression and expressive writing revealed similar results. People who have been able to express their feelings about their illness or traumatic experiences, through dance, journaling, poetry, and related art forms, exhibit improvements in measures of physical health, immune system functioning, pain, depressed mood, and other clinical outcomes. Findings from randomized, controlled studies indicate that the ability to express anger through writing helps people suffering from chronic pain and may improve the health of patients with human immunodeficiency virus (HIV) infections as measured by lab results.[7] The use of poetry helps people find their voice in ways that are not accessible using ordinary language. In summary, Stuckey and Nobel's review provides clear indications of the positive health benefits of engagement in these four types of artistic expression. As they maintain, arts in healing does not contradict but rather complements the biomedical view by focusing not only on sickness and symptoms but also on the holistic nature of individual persons. The image of a quilt, titled *Where Words Fail . . . Music Speaks*, and its related story beautifully illustrate the nature of holistic health care.

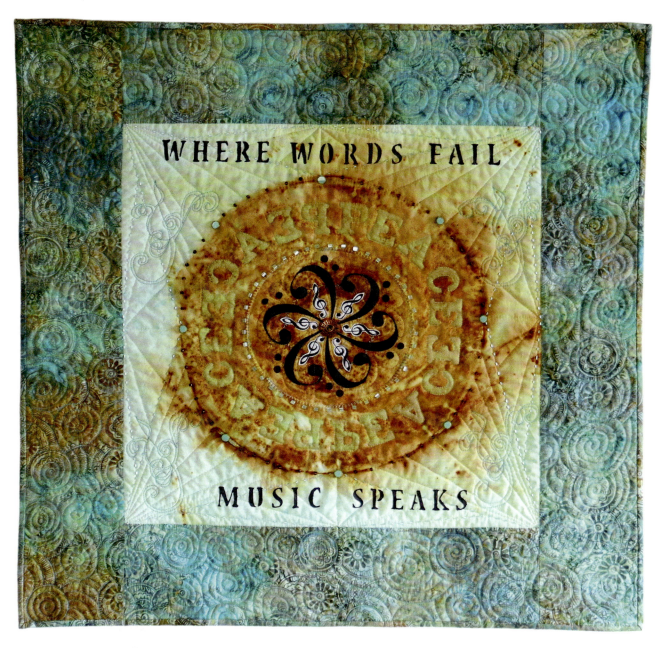

Figure 1.3. *Where Words Fail . . . Music Speaks*, Elaine Ross, Batavia, New York, 2014. 28″ × 28″. Collection of the artist. Photo courtesy of the artist.

Music has been my life, both as a vocation and an avocation. Throughout my times of depression and anxiety, when nothing seemed comforting, it has been music that I turned to—for healing, inspiration, and peace. A photo of the finished quilt was sent to a friend who cared for a mother with severe Alzheimer's disease. When she (a quilter and a musician) saw the photo—she spoke her first words in over two weeks. "What is that?" She proceeded to identify different music symbols and quilting patterns. The quilt continues to give me peace when I see it—and others when I share it. I believe in its "unspoken power."

(Quoted in Lauren Kingsland, ed., *Sacred Threads Exhibition 2015* [Rockville, MD: CQS Press, 2015], 195; additional materials submitted by artist to Michigan State University Museum.)

Quilts and Health

Researchers are just beginning to focus systematic documentation specifically on health-related quilts and their stories in order to examine their association with measurable health outcomes and to apply their findings to health-care education and practice. Like Dunton, medical professionals and health-care providers who have closely observed the intersections of quiltmaking and quilt use among their patients provide many anecdotal accounts of the positive impact, but systematic studies are rare. In 1992 Carolyn H. Krone, a mental health nurse, and Thomas M. Horner, a university-based psychologist, observed from their professional work with bereaved persons that quiltmaking had a profound relationship to grief and mourning. Drawing upon stories they collected from a number of their clients, they categorized distinct ways in which quiltmaking could serve healing purposes, including working through painful loss, commemorating specific losses, linking quilters who share a common cause or concern, dealing with definable ranges of depression arising from loss, and providing an activity aimed toward completing quilts that others have begun but are unable to complete.[8] They termed quiltmaking a form of indigenous healing and stated that quilt groups provide clinically significant pathways toward therapeutic healing. Limited as Krone and Horner's study was, it was a call for more attention to quiltmaking from researchers on health care and medical practices.

In 2009, nine decades after Dunton's pioneering publication on quilt history and the positive effect of quilts on his patients, J. O. Goh and Denise C. Park described one of the most systematic and rigorous studies to date to include quiltmaking specifically.[9] They proposed a randomized, controlled intervention trial known as the Synapse Program, designed to evaluate the behavioral and neural impact of engagement in activities that facilitate successful cognitive function. Their work was based on the scaffolding theory of aging and cognition, which postulates that compensatory changes take place in the brain to alleviate cognitive decline associated with aging and that this neuroplasticity can be experience-dependent. The study design included an extensive cognitive, neuroimaging, and psychosocial battery of tests administered to subjects at baseline and again twelve weeks later in order to determine changes in cognitive function, brain structure, or patterns of neural recruitment. The intervention consisted of subjects being randomly assigned to one of six groups in which some of them would participate in "productive-engagement conditions," or continual learning of new and increasingly complex engagement tasks, and some in "receptive-engagement conditions." The groups included a quilting engagement group, digital photography group, and quilting/photography group (productive-engagement conditions), along with social control and placebo control groups (receptive-engagement conditions) and a no treatment control group. With the exception of the no treatment control group, subjects participated in their assigned activity fifteen hours a week or more for fourteen weeks. Quilting and photography were chosen because they are deeply engaging tasks that could appeal to a broad spectrum of older adults, were complex enough to require learning new skills, and were fun. The social control group participants engaged in social activities that did not require actively learning new skills, and the placebo control group engaged in regular non-challenging daily activities at home. In 2014 Park and her colleagues reported that 259 participants were enrolled in and completed the study. Analyses resulted in findings indicating that productive engage-

ment resulted in a significant increase in episodic memory compared with receptive engagement. Participants in the photo and quilting/photography engagement group showed significant improvement in episodic memory, more so than those in the corresponding quilting/photography control group, although the latter group trended in a positive direction. The evidence indicates that memory function is improved by *engagement* in novel, cognitively demanding activities.[10]

Other studies buttress these findings. Virginia Allen Dickie conducted an ethnographic study with women quilters in North Carolina and found that eight clusters of learning took place while the women quilted and that such learning contributed to meaning and well-being.[11] She points out that with millions of quilters in the United States spending billions of dollars on quiltmaking, it is an occupation that is current, compelling, culturally relevant, and of economic interest. We contend that it should also be of serious interest to health-care providers as an easily accessible tool for holistic, person-centered physical and mental health practices. Two controlled studies are worth noting. First, Kurt D. Kausch and Kim Amer provided convincing preliminary data of the link between AIDS Memorial Quilt panel makers and self-transcendence that is associated with depression and an ability to cope with grief. In addition, through analyses of panel maker interviews, the

Figure 1.4. *Six Chix*, Cartoon, Benita Epstein. Used with permission of King Features Syndicate. March 1, 2013.

researchers identified five themes. AIDS quilt panel making provides validation, creates a living memory, generates a community of survivors, establishes a connection to a higher power, and contributes to acceptance of loss.[12] The second controlled study, by C. S. Knaus and E. W. Austin, demonstrated the power of the AIDS quilt to affect health in other ways. They surveyed college students who had or had not visited the AIDS Memorial Quilt and found that the visit not only changed the students' perceptions of people with AIDS but also contributed to important discussions that could lead to reduced risky behavior, an example of how quilts can be used as effective tools for public health education.[13]

The field of occupational therapy continues to be ripe for the study of quilts and for quiltmaking as a restorative activity that can renew depleted energy and lead to improved mental and physical health. Dana Howell and Doris Pierce claim that restorative occupations such as sleep and other restful activities have been largely ignored, particularly in Western cultures that place a high value on productivity as central to self-identity and that "identify work with pay and play with children."[14] In such a context, rest for adults is considered a waste of time that could be used more constructively. Howell and Pierce argue, as did Adolph Meyer, that rest is essential not only to good health but also to survival itself and should be included in any therapeutic goals. Further, it is important to go beyond false dichotomies of

"work/life balance," which simplistically divide our lives into work and leisure, and shift to "a more three-dimensional description of occupational experience as simultaneously plea-surable, productive and restorative."[15] There is a dynamic interplay between these three con-cepts within a wide range of occupations, including sleep and other restful endeavors, such as walking in the woods, reading a good book, and quiltmaking.

Quilts as Distinct from Other Forms of Visual Arts in Health and Well-being

Frances Reynolds explores why individuals choose one occupational activity over another, focusing specifically on the question of whether textile arts are distinctly different from other forms of creative expression in terms of contribution to indicators of health and well-being. She acknowledges that further research is needed to make such definitive claims. However, her careful literature review, phenomenological analyses of seven interviews, and multiple robust qualitative studies suggest that "textile art making does indeed have distinct subjec-tive properties that, taken together, are not typical of other creative occupations."[16] As Reyn-olds asserts, illness can become a "master status" in a person's life, cutting them off from their usual sources of self-identity and self-esteem. Textile art can become an avenue for challeng-ing this status and managing illness.[17] In a series of studies by Reynolds, the impact of textile art was examined in relation to persons coping with a range of debilitating conditions, such as cancer, multiple sclerosis, migraines, and arthritis. Study findings indicated that the bene-fits of engaging in textile art that is restful and restorative include reduced pain and improve-ments in physical and psychological functioning, manual dexterity, feelings of control and choice, identity and self-esteem, social connectedness, meaningful engagement with life, and hope. These benefits align with characteristics of well-being reported in the literature such as positive emotions, self-esteem, an acceptable degree of autonomy over one's lifestyle, feeling able to pursue valued goals, opportunities for flow, and meaningful social relationships or ex-periencing oneself as having a valued place in a social network.[18] In this context, Reynolds identified six distinct features of textile art that influence well-being.[19] First of all, it is both highly accessible and highly diverse. The fact that there is a wide range of textile art forms means that people with disabilities and acute or chronic health problems of all types can find a form suited to their interests and abilities and the resources to engage in such art. Assistive technologies, such as sewing machines and software, are readily available. They can be incor-porated into everyday life, worked on at home versus a studio, and subsequently contribute to the home environment. Interestingly, one appealing aspect of textile arts is that they can be time-consuming, requiring a long-term commitment. According to some participants, this helped "structure days that would otherwise be difficult to fill productively," and thus was a source of pride in completing such a major goal. Being involved in the creation of tex-tile arts was also a source of "future-orientation" and therefore the hope or belief that partic-ipants would "resist the progression of their illness" and live to finish their projects. As quilt artist Elaine Ross claims, quiltmaking allows the maker to put aside any physical or men-tal health concerns for a little bit and to totally shift one's focus toward doing something that not only gives them happiness at that moment but also produces a physical end result. Often-times in illness, finishing something seems so elusive because people are stuck in the imme-

diacy of their problem. In either situation quiltmaking can kindle that little spark of seeing something positive and hopeful in an otherwise negative situation.[20]

Howell and Pierce, along with Mihaly Csikszentmihalyi and many others, describe the benefits of "flow," or the ability to become so completely engrossed in a task that it becomes meditative and time passes quickly, a state that they believe to be common in quiltmaking and important to healing.[21] They identify numerous ways in which quiltmaking is distinct from other forms of art that people may engage in; among these distinctions is the unique historical meaning of quilts, which began as a practical way for women to provide warmth for their families. Yet, rather than make functional quilts as quickly as possible, women created beautiful works of art imbued with meaning. The careful attention to color, stitching, and design continued even after blankets became readily available. Patterns have been passed down through generations, and rituals, which are inherently restorative, developed around quiltmaking and were passed on as well, such as making and using quilts as gifts for rites of passage. Further, unlike painting or dance, quilts are often associated with sleep. They can be used in bedtime routines, to create a comforting sleep space, and to wrap up in for warmth and a sense of safety. When personalized, they affirm an individual's self-worth, a reminder of someone's love or concern. They are three-dimensional, offering textures that can be physically felt as well as beauty and colors that are visually pleasing. The "sensations, aesthetics, personal meaning, and biological need for rest and sleep all contribute to restoration."[22]

When quilt artist Debra Bentley was asked why she thinks quilts are being used as a means to address health issues, she replied:

> Artists often use their particular medium to present their ideas, concerns, and/or political views. There is no reason a fiber or quilt artist would not do the same. Many quilters have made quilts as comfort for those who undergo chemotherapy, or have other medical issues. Many quilters have made wall-hangings for hospitals and clinics. Quilt artists often want to do something to commemorate or memorialize a person or event. The extension of this desire into a way to address health issues is no surprise. Quilts are a wonderful medium for surface design and the depictions of ideas and themes are art. They offer a tactile means of showing joy, grief, love, anger, appreciation, gratitude, and spirituality. Unlike paintings, quilts are tactile and three-dimensional. Unlike sculpture, they are warm and flexible. I can't speak for others, but for me they are the perfect medium with which to express my ideas.[23]

And she believes that quilts like her *June's Dementia—A Life Unraveled* comfort others: "Many people who have experienced the effects of dementia on a loved one have liked my quilt. They understand it completely."[24]

Another quilt artist, Ruth A. White, of Ithaca, New York, affirms the choice of quilts, rather than other forms of art, to achieve healing and wellness: "There is also something soothing about handling fabric. We clothe ourselves in fabric and it protects us from the elements and from unkind eyes. It covers and protects us when we sleep. Quilts are a natural extension of the comfort and protection we receive from fabric. It seems right to use fabric to create healing quilts, whether they are to soothe us bodily as a lap quilt or to soothe our minds as we create art."[25]

Our own research leads us to believe that quilts and quiltmaking have additional qualities that distinguish it from other forms of art, even other forms of textile art. Quiltmaking is steeped in history. Even the materials chosen might be scraps from clothing of days gone by or of loved ones who have passed on. Newer traditions include quilts made from a teenager's T-shirts or a man's ties. Further, quilting is a form of textile art that can literally wrap an entire person in warmth and comfort. Countless quilts are made to provide what both maker and receiver term "hugs." They are both functional and portable, as in the stories of "camo-quilts" sent to active-duty soldiers. And, unlike more solitary art forms, they are often created in a community, whether it is a quilt guild or group or something more global, as in people from all over the world responding to an appeal to help victims of natural disasters or war. In these cases, quiltmaking becomes an act of social justice, an outlet for activism and contributing to a greater good. Combined, these traits distinguish quilts and quiltmaking as an art form with tremendous potential to contribute to health, well-being, and improved health-care outcomes for both the quiltmaker and the user; thus this form of art is worthy of special notice by health-care professionals and policy and funding decision-makers.

Despite growing evidence of the role of the arts in influencing health-care outcomes and talk of person-centered holistic care, it continues to be difficult to integrate art, humanities, and quilts into health care.[26] Our hope is that this book will shine a light on how quilts are already being used to influence health in multiple, measurable, and major ways. Through this illustrative compilation, it is clear that quilts and quiltmaking have been quietly leveraging the skills and desires of millions of people, health-care professionals and everyday people alike, to promote better health outcomes for everyone. The realm of quilting is a "treatment" that deserves greater recognition for its therapeutic value and an area rich for exploring how it could be more formally incorporated into medical education and practice.

Notes

1. Edward A. Ross, Tracy L. Hollen and Bridget M. Fitzgerald, "Observational Study of an Arts-in-Medicine Program in an Outpatient Hemodialysis Unit," *American Journal of Kidney Diseases* 47, no. 3 (2006): 462–68.

2. Ibid.

3. Heather L. Stuckey and Jeremy Nobel, "The Connection between Art, Healing, and Public Health: A Review of Current Literature," *American Journal of Public Health* 100, no. 2 (2010): 254–63.

4. Cathie E. Guzzetta, "Effects of Relaxation and Music Therapy on Patients in a Coronary Care Unit with Presumptive Acute Myocardial Infarction," *Heart Lung* 18, no. 6 (1989): 609–16.

5. Frances Reynolds and Kee Hean Lim, "Contribution of Visual Art-Making to the Subjective Well-being of Women Living with Cancer: A Qualitative Study," *Arts in Psychotherapy* 34, no. 1 (2007): 1–10.

6. Sandra M. Walsh, Susan Culpepper Martin, and Lee A. Schmidt, "Testing the Efficacy of a Creative-Arts Intervention with Family Caregivers of Patients with Cancer," *Journal of Nursing Scholarship* 36, no. 3 (2004): 214–19.

7. For the former, see Jennifer Graham, Marci Lobel, Peter Glass, and Irina Lokshina, "Effects of Written Anger Expression in Chronic Pain Patients: Making Meaning from Pain," *Journal of Behavioral Medicine* 31, no. 3 (2008): 201–12. For the latter, see Keith J. Petrie et al., "Effect of Written Emotional Expression

on Immune Function in Patients with Human Immunodeficiency Virus Infection: A Randomized Trial," *Psychosomatic Medicine* 66, no. 2 (2004): 272–75.

8. Carolyn H. Krone and Thomas M. Horner, "Her Grief in the Quilt," in *Uncoverings 1992*, ed. Laurel Horton, 109–126 (Lincoln, NE: American Quilt Study Group, 2010).

9. J. O. Goh and Denise C. Park, "Neuroplasticity and Cognitive Aging: The Scaffolding Theory of Aging and Cognition," *Restorative Neurology and Neuroscience* 27, no. 5 (2009): 391–403.

10. Denise C. Park et al., "The Impact of Sustained Engagement on Cognitive Function in Older Adults: The Synapse Project," *Psychological Science* 25, no. 1 (2014): 103–112.

11. Virginia Allen Dickie, "The Role of Learning in Quilt Making," *Journal of Occupational Science* 10, no. 3 (2003): 120–29.

12. Kurt D. Kausch and Kim Amer, "Self-Transcendence and Depression among AIDS Memorial Quilt Panel Makers," *Journal of Psychosocial Nursing and Mental Health Services* 45, no. 6 (2007): 44–53.

13. C. S. Knaus and E. W. Austin, "The AIDS Memorial Quilt as Preventative Education: A Developmental Analysis of the Quilt," *AIDS Education and Prevention* 11, no. 6 (1999): 525–40.

14. Dana Howell and Doris Pierce, "Exploring the Forgotten Restorative Dimension of Occupation: Quilting and Quilt Use," *Journal of Occupational Science* 7, no. 2 (2000): 68–72.

15. Adolf Meyer, "The Philosophy of Occupational Therapy," *Archives of Occupational Therapy* 1 (1922): 1–10.

16. Frances Reynolds, "Textile Art Promoting Well-being in Long-Term Illness: Some General and Specific Influences," *Journal of Occupational Science* 11, no. 2 (2004): 58–67.

17. Frances Reynolds, "Coping with Chronic Illness and Disability through Creative Needlecraft," *British Journal of Occupational Therapy* 60, no. 8 (1997): 352–56; and Frances Reynolds and Sarah Prior, "'A Lifestyle Coat-Hanger': A Phenomenological Study of the Meanings of Artwork for Women Coping with Chronic Illness and Disability," *Disability and Rehabilitation* 25, no. 14 (2003): 785–94.

18. Ed Diener, Shigehiro Oishi, and Richard E. Lucas, "Personality, Culture, and Subjective Well-Being: Emotional and Cognitive Evaluations of Life," *Annual Review of Psychology* 54, no. 1 (2003): 403–25.

19. Reynolds, "Textile Art Promoting Well-being," 58–67.

20. Elaine Ross, artist form submitted to Beth Donaldson, March 15, 2016.

21. Howell and Pierce, "Exploring the Forgotten Restorative Dimension"; and Mihaly Csikszentmihalyi, *Flow: The Psychology of Optimal Experience* (New York: Harper and Row, 1990).

22. Howell and Pierce, "Exploring the Forgotten Restorative Dimension."

23. Debra Bentley, correspondence and artist statement sent to Beth Donaldson, March 13, 2016.

24. Ibid.

25. Ruth White, artist statement, submitted to Beth Donaldson, Clare Luz, and Marsha MacDowell, March 15, 2016.

26. Guy Eades and Jacqui Ager, "Time Being: Difficulties in Integrating Arts in Health," *Journal of the Royal Society for the Promotion of Health* 128, no. 2 (2008): 62–67.

The Art of Health-Related Quiltmaking

The production techniques and designs used by quilt artists in their work associated with health and well-being are as varied as the individuals who make them. There are, however, certain materials, patterns, motifs, color palettes, and techniques that are closely connected to quilts and the experience of illness, healing, and well-being.

The art quilt movement, along with the Internet's ability to connect individuals from around the world who share common interests, has set the stage for new virtual communities of artists who are interested in both art quilts and health.[1] Facebook, email Listservs, Instagram, and Pinterest sites abound with examples of the connectedness and support these artists have for one another and their similar artistic—and healing—pursuits. Some individual studio artists have developed special interests in quilts and health issues, often stemming from their own personal experience with an illness, or that of a loved one, and have created bodies of work wholly devoted to health issues. Their websites, Facebook pages, blogs, and other social media they use to describe, showcase, and promote their work are constant testimonies to their passion for this subject. Some of these groups have developed exhibitions of the creations of members, displays that reside online in addition to being shown in typical settings for quilt exhibitions, such as museums, galleries, and local community spaces but increasingly in hospitals, a setting that until recently was not a typical place where quilts would be seen as art.

Materials and Patterns

Certainly, clothing of the deceased has traditionally been used in making quilts designed to comfort those who are grieving. The clothing and fabric stashes of deceased quilters are also often donated to quilt groups to make "charity quilts." Quilts are also made from the fabric of clothing worn by caregivers. More and more common are those referred to as "scrub quilts," as they are made out of scrubs and uniforms worn by hospital workers and other healthcare workers.[2] Quilts have even been made from the bandanas worn by those who have lost hair during chemotherapy treatment.[3] One inventive individual, Samantha Hodge Williams, used very personal material to educate others about her severe health problems in coping with chronic fatigue syndrome (CFS). She constructed a large bed-size quilt of the empty saline bags that had been used over a period of six weeks for her IV treatments. At times she could barely stay conscious and even lost consciousness, but she wanted to make some-

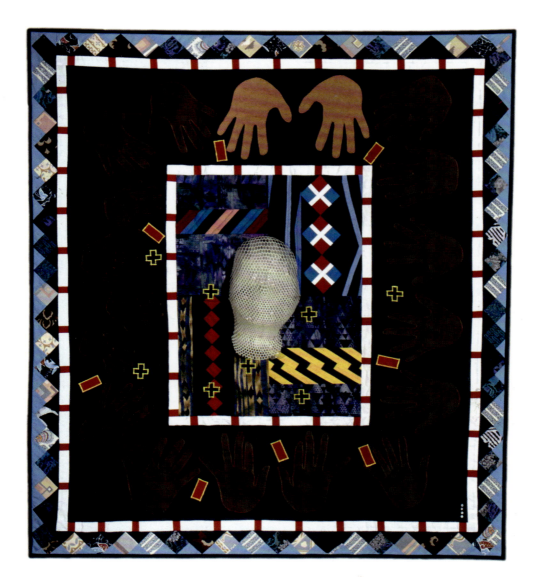

Figure 2.1. *Charlie Wood's Stoma Quilt*, Margaret Wood, Phoenix, Arizona, 1996. 44.75″ × 50.75″. Collection of the artist. Photo by Pearl Yee Wong.

Margaret Wood (Navajo/Seminole) made this quilt nearly two years after the death of her father as a tangible expression of his experience with throat cancer, a radiation mask, medical care, and family caregiving. She describes the quilt as follows:

> In the center is a white plastic mesh face, which is the actual radiation mask my father used for six weeks. The X's on the quilt represent the X's marked by radiologists on my father's mask to pinpoint where radiation treatment was to be directed. Radiation targets on the body are marked with permanent marker while masks are made for patients who need facial radiation targets. I put in Seminole patchwork because my father is Seminole and blue colors since his favorite color was blue. The red and white borders represent the cigarettes that caused the cancer, and the appliquéd [tracings of] hands symbolize some of the people, especially family, that helped him on his healing journey.

(Margaret Wood, email to Beth Donaldson, February 24, 2016; see also Quilt Index, http://www.quiltindex.org/fulldisplay.php?kid=6B-FF-0.)

thing that could represent to members of an influential CFS committee just how sick she was. Her illness prevented her from attending the meeting, but others held the quilt up for the committee to see, and it proved a powerful statement of the impact of the disease on patients.[4] Artist Amy Orr used recycled plastic medical cards to make a quilt in the Log Cabin pattern as an homage to the Affordable Care Act, a health support structure that was important in her own struggle with illness. Other artists, such as Laura Petrovich-Cheney, incorporate into their work materials that are scavenged from disasters. She, like others, finds solace and optimism in putting the broken, used, and scarred pieces back together into a whole quilt of orderly and harmonious patterns.

Businesses that produce the fabrics and patterns favored by quiltmakers are also supporting the growth of interest in quilts and health by printing fabric lines, patterns, and quilt kits that are connected to specific diseases. For instance, one can easily find a variety of fabrics printed with the pink ribbon symbol associated with breast cancer awareness and quilt kits that offer enough all-red fabric to produce a quilt connected to women's heart disease.

One hand-printed fabric, titled *What Cancer Cannot Do*, carries twelve inspirational quotes, including "Cancer Cannot Shatter Hope," "Cancer Cannot Steal Humor," and "Cancer Cannot Erase Memories" drawn from the poem by the same name. Quilt artist and quilt business owner Jeanne Coverdale designed the fabric during a period when she was being treated for breast cancer.[5] It is available in small blocks, and a free pattern is available with it to set the blocks into an overall design.[6] Online tutorials are available for making this quilt.[7] There is now a proliferation of how-to books for healing quilts in general but also for specific diseases; professional publishing houses produce some of the books, but many authors self-publish them as well.[8]

Figure 2.2. Facing: *Coverage*, Amy Orr, Philadelphia, Pennsylvania, 2014. 42" × 62". Collection of the artist. Photo by John Woodin.

During 2004, Orr suffered from Graves disease, which causes shaking hands and blurred, double vision. Although she was unable to quilt, she was still able to design new pieces that were then quilted by assistants. After radiation treatment and corrective eye surgery, her vision cleared. Of her illness, Orr said, "I always felt like the same creative person inside, though it was harder to get it out. It gave me a lot of new material that will feed into what I do in the future" (quoted in Robin Rice, "Exploring Excess: Amy Orr," *Surface Design* (Winter 2005): 35.

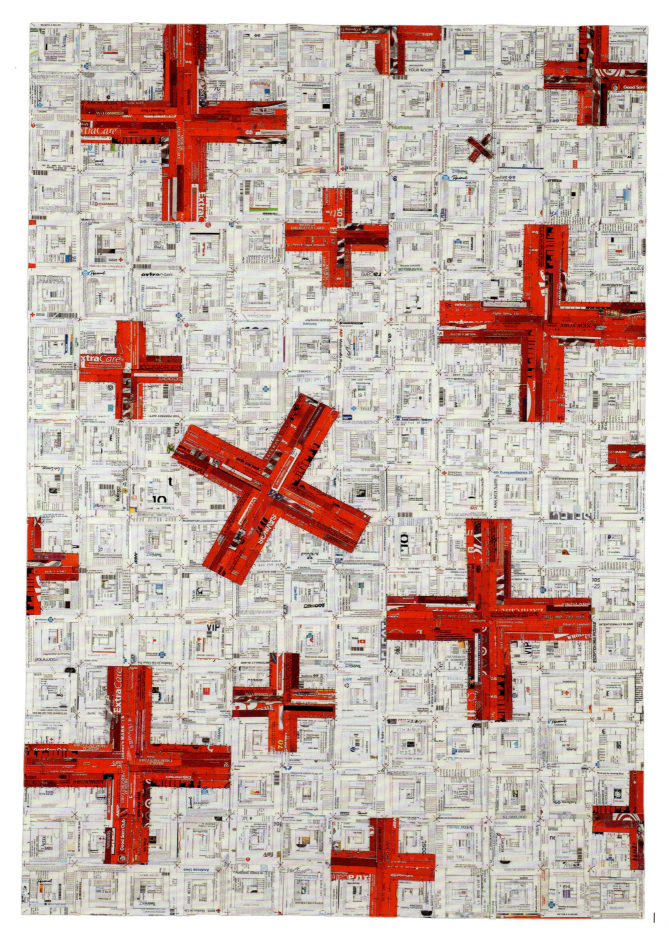

Figure 2.3. *Relative Confusion*, Laura Petrovich-Cheney, Asbury Park, New Jersey, Spring 2014. 36" × 36" × 1". Private collection. Photo by David B. Smith.

The devastation that Hurricane Sandy brought to coastal communities in fall 2012 was evident in the wooden debris that littered the affected communities. In its aftermath, the once organized communities and lives of the residents were recognizable only as piles of rubble distributed haphazardly during the chaos of the storm. It was after the storm that I began collecting the castaway wooden debris of domestic spaces that were remnants evocative of life before the storm. My hope was to restore some order, meaning and sense of place to the ravaged landscape by creating something with the wood.

I looked to the past for ideas and discovered that inspiration in the American ideal of a pioneer woman's can-do resilient spirit and instinct for survival. I learned that these women crafted quilts for warmth and comfort with scraps of cloth. As both formal, abstract art objects and expressions of feminism, traditional American patchwork quilt are designs I find familiar and comforting.

Inspired by the geometry of American quilts whose simplicity belies their conceptual underpinnings, I begin to piece together this salvaged wood into something meaningful and orderly, seeking solace from Hurricane Sandy. By deliberately organizing the salvaged wood within each piece of artwork to balance the relationship between the material used with texture, color, pattern and scale, I am exploring ideas that are rooted in the repetition of life—birth, growth, death, and regeneration.

(Laura Petrovich-Cheney, email to Beth Donaldson, January 3, 2016.)

Figure 2.4. *Lady Liberty Goes to Hawaii*, Marita Wallace, San Diego, California, 2011. 54" × 67". Cotton print fabrics; machine pieced, machine quilted. Collection of Bill Volckening. Photo courtesy of Bill Volckening.

Bill Volckening, a quilt artist and collector, purchased this quilt through Etsy. He indicated that Karen Stone designed the pattern and that the quilt is made with hospital scrub fabric (Bill Volckening, email communication to Beth Donaldson, January 7, 2016).

Forms and Formats

Many of the quilts made for charitable projects continue the traditional forms of bed-size quilts, but new variations on the traditions have become prevalent for health and well-being. Smaller quilts, often referred to as "lap quilts," are made for persons confined to a bed or chair. When made for wheelchairs, the quilts are constructed with one end wider than the other so that the fabric won't catch in the wheels.[9] Bags designed to hang over wheelchair arms or on walkers are made by volunteers so that patients can easily carry items without using their hands. "Quillows," quilts with a pocket into which the quilt can be folded and put inside, thus forming a pillow, have become popular to make for patients who have to spend extended time in bed.[10] "Prayer quilts" are typically those in which the maker has said a prayer as he or she ties the two or three quilt layers together with thread or yarn. The quilt is then gifted to someone in need who is enveloped in the power of those prayers.

Color and Design

With the rise of the art quilt movement; the ability to easily secure new fabrics; and the proliferation of fabrics, how- to books, and quilt kits for health-related quilts, there has been a concurrent rise in the use of certain colors, color palettes, and design motifs. Campaigns to align certain colors with particular illnesses (e.g., pink for breast cancer, red for women's heart health, purple for Alzheimer's, orange for leukemia) have also influenced the color choices that quilt artists make, especially when they create health-related works. Textile artists also make greater use of colors associated with human emotions (red for anger, black for grief, blue for depression). It is not unusual for these artists to incorporate hearts and hands in their work, alluding to the love in which the quilt was made and given or the many individuals who shared in making the quilt or caring for the recipient.

Certain design formulas can often be seen in health-related quilts. Jagged lines, ripped and pinned-together seams, punctures, and burns in fabric vividly convey a sense of the trauma that the maker or the recipient has endured. Many artists have created quilt patterns that have grids that disintegrate into chaos, move from complexity to simplicity, or employ color schemes that move from darkness to light or light to darkness. Some artists incorporate empty or safe spaces within otherwise chaotic textile canvases. These design ploys clearly evoke the maker's passage of health to illness, illness to well-being, and the attempt of the maker to find solace, security, and peace. Passage of time and state of illness are often conveyed with allusions to the time of day, the phases of the moon, and the life cycles of trees and plants.

Figure 2.5–2.7. Facing: Three examples of preprinted health-related fabric to be used in making quilts. Collection of Michigan State University Museum. Photo by Pearl Yee Wong.

Therapy In Session

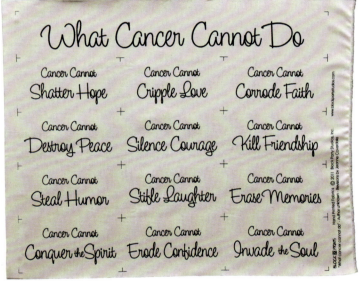

What Cancer Cannot Do

Cancer Cannot
Shatter Hope

Cancer Cannot
Cripple Love

Cancer Cannot
Corrode Faith

Cancer Cannot
Destroy Peace

Cancer Cannot
Silence Courage

Cancer Cannot
Kill Friendship

Cancer Cannot
Steal Humor

Cancer Cannot
Stifle Laughter

Cancer Cannot
Erase Memories

Cancer Cannot
Conquer the Spirit

Cancer Cannot
Erode Confidence

Cancer Cannot
Invade the Soul

Prayer Shawl Panel

- Charm Square Friendly -

For **God** didn't give us a spirit of fear, but of **power, love, & self-control.**
2 Timothy 1:7

Rejoice in hope, **be patient** in tribulation, **be constant** in prayer.
Romans 12:12

And he said to her, "Daughter, be of good cheer; your faith has made you well. **Go in peace."**
Luke 8:48

May the **God of Hope** fill you with all joy and peace in believing, that you may abound in hope, in the power of the **Holy Spirit.**
Romans 15:13

Beloved, I pray that you may **Prosper** in all things and **Be Healthy,** even as your soul prospers.
3 John 1:2

The **Peace of God,** which surpasses all understanding, will guard your hearts and your thoughts in **Christ Jesus.**
Philippians 4:7

All the multitude sought to touch Him, for **Power** came out from Him and healed them all.
Luke 6:19

One of them, when he saw that he was healed, turned back, **Glorifying God** with a **Loud Voice.**
Luke 17:15

Ask and it will be given you. **Seek** and you will find. **Knock** and it will be opened for you.
Matthew 7:7

Those who wait for the Lord will renew their strength. They will **Raise Up** with wings like eagles. **Run,** and not be weary. **Walk,** and not faint.
Isaiah 40:31

Then you shall call, and **Yahweh** will answer; you shall cry, and he will say, **"Here I am."**
Isaiah 58:9

But if we **Hope** for what we do not see, we wait for it with **Patience.**
Romans 8:25

Gretchen Hill of Longmont, California, uses quilt designs to express difficult feelings and to bring calm to hard times. She created a quilt called *Holding It Together* when one daughter moved away, another had unexplained seizures, and her husband was diagnosed with kidney cancer. In her words, "It was like the whole world was falling in on me. . . . I felt very fortunate that I was able to quilt during that stressful time. It was a way for me to get away from reality. It was therapy for me." The quilt depicts a mountain of chaotic colors surrounded by a deep blue sky. When Hill finished it, she used scissors to cut a jagged gash at the top, splitting the blue like a bolt of lightning. "I had never done anything like that before but I wanted it to have meaning." She then used safety pins to refasten the split fabric together. One viewer of this, Garland Herndon, of Canadian Lakes, Michigan, said, "When I first saw this quilt, I had tears in my eyes. I know the process of life going gradually from bright into dark, and finally earnestly trying to hold that life together by the threads."[11]

Designs of health-related quilts can also graphically convey hopefulness, optimism, and joy; their makers intentionally incorporate brilliant or peaceful colors and imagery that literally, metaphorically, or abstractly speak of well-being.

The majority of health-related quilts, however, have no visual reference that would point to their being health-related. For many artists, the construction of quilts is, in and of itself, the therapy, keeping their minds off of their worries or their pain, or keeping them focused

Figure 2.8. Facing: *Phoenix*, Vimala McClure, Willow Springs, Missouri, 1993. 89" × 61". Collection of the artist. Photo by Vimala McClure.
After a concussion suffered in a fall in her studio, McClure began suffering from a variety of debilitating health conditions, including chronic severe pain. She underwent many treatments in a variety of Western and non-Western medical facilities, and her condition was eventually diagnosed at the Mayo Clinic as fibromyalgia complicated by depression. Although she had to give up running a small publishing company, she continued to make quilts as a means to express her experience living with the illness:

> *Phoenix* is a journey, from being well, the first experience of the chronic pain, and finding the courage to continue, coming through it and being completely changed by it. The left side of the quilt represents my life before Fibromyalgia hit. It is my happy, quiet, pretty life. The black figure represents the Fibromyalgia hitting me. The spiky shape is the pain, and fireball shows the feeling of fire searing through me. The middle of the quilt, over-dyed in grays, represents the period when I was depressed and couldn't function. My life felt like a morass of smoke and ashes. The right side of the quilt represents my rising from the ashes. I used the traditional Birds in Flight block [pattern] with Flying Geese [block pattern] representing the energy of flying again. On the right side of the quilt, the large black "lightning bolt" is transformed into the Birds in Flight and Flying Geese blocks; in addition, on the right side of the quilt I used bright colored fabric with black within them. This represented how I integrated Fibromyalgia into my life, and that in many ways it made my life richer.

(Vimala McClure, artist statement sent to Beth Donaldson, February 3, 2016.)

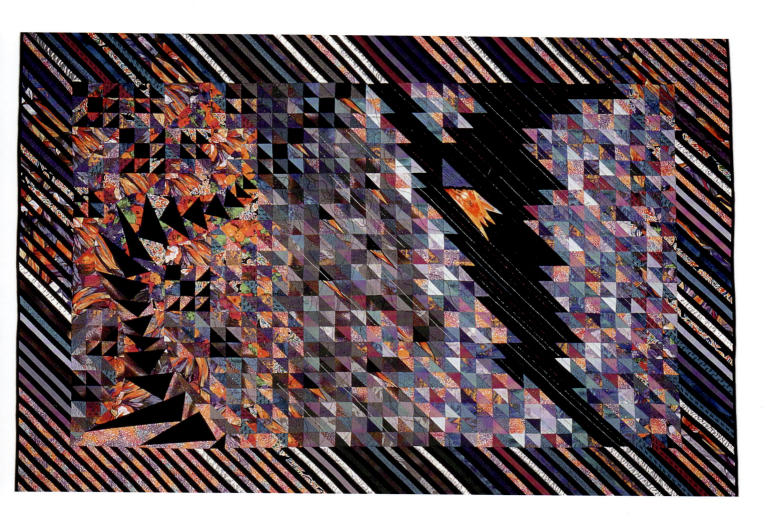

Figure 2.9. *The Followers*, Marlene J. Shea, 2009. 45" × 44".
Collection of the artist. Photo by Marlene J. Shea.
"My inspiration came from my personal struggle with a medical issue. I'm finding that letting go of control and looking for spiritual guidance is helping me deal better with my problems." (Marlene J. Shea, artist statement, in *Gallery—Sacred Threads 2009*, http://www.sacredthreadsquilts.com/html/gallery_2009.htm).

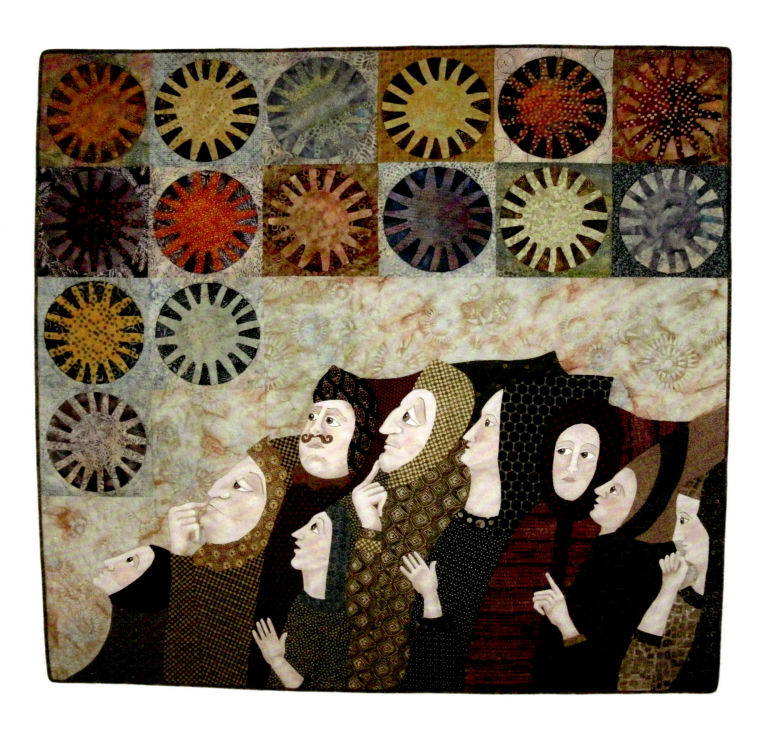

Figure 2.10. *LeMoyne Star*, Rebecca Brickley, Ionia, Michigan, 1866. 68" × 78".
Collection of Michigan State University Museum. Photo by Pearl Yee Wong.

on activities that support their sense of well-being or their compassion for and commitment to helping others. Sometimes simple patterns are preferred, as they enable the maker to complete them more quickly, thus getting them more quickly into the hands of those who need them for comfort and warmth. The design of the quilt is incidental to the activity; a viewer can't really discern the quilt's connection to health except by knowing the maker's or user's story. An excellent example is a very ordinary-looking LeMoyne Star in the collection of the Michigan State University Museum; only in the family story does one learn its poignant relationship to an individual who faced cancer.

Figure 2.11. Jacob and Rebecca Brickley.
Photo courtesy of William J. Brickley and the Michigan State University Museum.

William J. Brickley told this story of his great-grandmother, Rebecca Brickley,
when he donated her quilt to the MSU Museum:

> This was made by my great-grandmother Rebecca Brickley, wife of Jacob Brickley,
> who died of cancer of the breast October 18, 1866, at the age of 46 years, 6 months, and
> 15 days. In 1865 my great-grandmother discovered that she had cancer of the breast. She
> told the family, "You all want to go to Michigan, so we will go this year so I won't be left
> behind." In the fall of 1865 they had harvested the crops and sold the farm in Niagara
> County, New York. Then they started for Michigan with their possessions in wagons
> and with cows tied behind the wagons. They left Lockport, New York, in the late fall
> and travelled all winter to reach Ionia, Michigan, in the spring of 1866. Great-grandmother
> made the quilt for my grandfather while she was dying. Grandfather was very choice of this
> quilt and refused to have it used. His daughter and then I have respected his wishes, and
> the quilt has not been used. That is why it is 120 years old and in original condition.

During what was most certainly a daunting period of her life, she made a quilt in an ordinary
common pattern, a quilt that became a prized possession of her son (William Brickley, statement
on the *LeMoyne Star Quilt*, Quilt Index, http://www.quiltindex.org/fulldisplay.php?kid=1E-3D-221).

Likewise, the meaning of the Broken Star quilts created by Pearl Spotted Tail, a Sioux art-
ist from Parmalee, South Dakota, cannot be discerned without her story. Though the Broken
Star pattern is common, in Spotted Tail's hands it is highly symbolic of her grief and of her
cultural spirituality. She makes them only when someone she loves dies or when she wants to
comfort others who are sad.[12]

Figure 2.12. *Broken Star*, Pearl Spotted Tail, Parmalee, South Dakota, 1994. 82" × 86".
Collection of Michigan State University Museum. Photo by Pearl Yee Wong.
"When my mom died I made a *Broken Star* and put it on top of her casket because
I had a broken heart." Spotted Tail also burns a small bit of sage and says a prayer for
peace and health before she begins to piece her quilts. She thinks then of her ancestors
who died and they give her inspiration" (Pearl Spotted Tail, *Broken Star*, c. 1994,
Quilt Index, http://www.quiltindex.org/fulldisplay.php?kid=1E-3D-1176).

Figure 2.13. *Dear Diary*, Kathy Kansier, Ozark, Missouri, 2006. 33" × 41".
Collection of the artist. Photo by Pearl Yee Wong.

On the first block Kansier writes, "Today the doctor said Mama has Alzheimer's. He said there is no cure for this and she will only get worse." The last block reads, "Mama died today in the nursing home. I feel so guilty that I didn't keep her at home. I wish they had a cure for Alzheimer's disease" (quoted in Ami Simms, *Alzheimer's Forgetting Piece by Piece* [Flint, MI: Mallery Press, 2007], 58).

Visual Diaries

Before the last quarter of the twentieth century, quilts rarely served as visual diaries or narratives of personal experiences, but toward the turn of the twenty-first century, a growing number of artists were making textile journals, often one block at a time. One particular form of quiltmaking, the Quilt Journal Project, has been an especially vital tool to work through these memories and feelings. The format, promoted by Karey Patterson Bresenhan, consists of creating six small quilts, the size of typing or copy paper (8.5" × 11"), that express the maker's thoughts, experiences, and creative progression through a period of time. Hundreds of artists who submitted their set of quilts for exhibitions curated by Bresenhan at the 2000 International Quilt Festival chose topics that related to difficulties in their lives. Many individuals now use the Quilt Journal technique to work through troubling experiences or concerns, which often include health challenges.[13] Artists have extended the notion of small quilt journals or diaries to full-size quilts, with text sometimes written directly on blocks that are pieced into a quilt pattern or on a single foundation fabric. A variation of this process is what Mary Kieras Frazier implemented when her "best friend suggested that I buy a fat quarter [pre-cut pieces of cotton fabric that are 18"× 22" or ¼ yard] for every treatment of radiation and make a quilt of my journey. Friday is my last treatment! I did 36 squares . . . 2 biopsies 1 lumpectomy and 33 radiation sessions. . . . This quilt will always remind me of how strong I am."[14] Gay Young Ousley of San Angelo, Texas, chronicled the devastating impact of Alzheimer's disease in a quilt she titled *She's Come Undone*. In large cloth block letters that she appliquéd onto a background were these rows of words: "Travel Golf Bridge Dine—Paint Read Garden—Drive Write Sing—Mix & Mingle Laugh—Sign Print Find—Tie Button Zip—Brush Comb Smile—Walk Hug Talk—Swallow—Breathe."[15]

Figure 2.14. *Facing: Whatever It Takes: An Ovarian Cancer Diary*, Phyllis Tarrant, Mint Hill, North Carolina, 2003. 50" × 58". Collection of Michigan State University Museum. Photo by Phyllis Tarrant.

In 2001 I had surgery to remove a very painful ovarian cyst. It turned out that I had ovarian cancer. As I was leaving the hospital a nurse suggested keeping a diary as a way of dealing with the cancer. I had seen a couple of magazine articles about diary quilts and decided that would be the correct choice for me.

When I had something to say, I would pull a fabric piece that related to the way that I felt at the moment out of the scrap bag and write on it. Sometimes I would add fusible appliqué. After 18 months of chemo, I was told that the cancer was gone and unlikely to return. That day I began to put all of the pieces together. I was surprised by how much symbolism I had put into the applique. I consider myself someone who does not understand symbolism. Even the quilting stitches are symbolic. The constant change from straight lines to zigzag represents the frequent mood changes that I experienced during this time. Although I made it just for myself, once it was complete I realized that it could be used to help people understand some of the many emotions that cancer patients experience. I also hope that it helps women be more aware of ovarian cancer. It can be survived and there are sometimes early stage symptoms.

This quilt was one of three quilts I created in response to my cancer. One was a comfort quilt, a free form yellow four patch, called *Sometimes You Just Need a Yellow Quilt*. The other, *An Unknown Person Is Many Different Worlds*, was my wildest quilt to date. It was in response to being asked to take part in a twelve-month clinical trial. I felt that I had no choice about agreeing to the clinical trial and that I had no control over my life. The quilt started out as a rebellion against my lack of control of what was happening to me. It ended up being much more. The chemo had weakened me physically leaving me much time to just think. The motif was based on a photo that I had taken of an unidentified wild flower. It became about how the people we know in different situations have a different impression of who we are. Few, if any people, totally know us.

(Phyllis Tarrant, Quilts and Health form sent to Beth Donaldson, May 18, 2006. The full text shown on Tarrant's quilt can be seen in appendix A; see also Phyllis Tarrant, artist statement, in *Gallery—Sacred Threads 2011*, http://www.sacredthreadsquilts.com/html/gallery2011.html.)

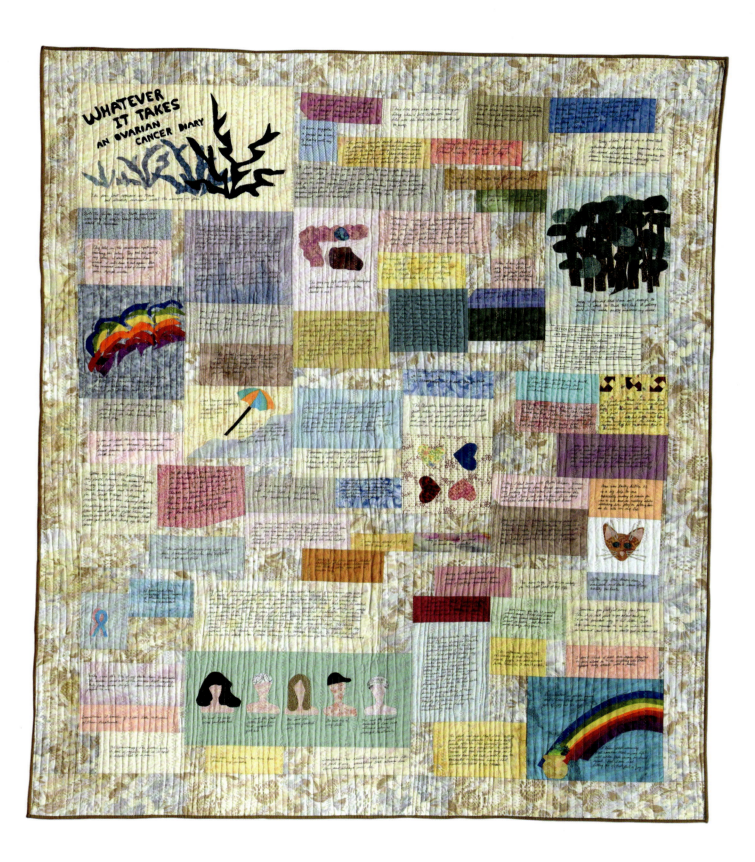

Visualizing Diseases and Illness

Some artists, in trying to understand what is happening with their own bodies, create visualizations of their disease or illness, often isolating the parts of the body impacted even down to the cellular level. Some base their renditions on microscopic or x-ray views of their disease or body part.

Aafke Swart Steenhuis from Ithaca, New York, diagnosed with a giant cell tumor in her right wrist in 2004, depicted her tumor in fifteen different quilts not only with graphic imagery but also in sheer size, representing the tumor as well as the magnitude of what she was experiencing:

> It started as an outlet to help me cope with the stress of having multiple (7) surgeries on my wrist. Giant Cell tumor is very aggressive and my quilts got larger and larger, up to bed-sized. When people see this quilt and the other Giant Cell quilts, they can imagine what I went through and see how I coped with the tumor. At one time the screws inside my wrist came loose. I needed to get replacement parts (another surgery) and took the screws and plate home. I drafted the plate, made a quilt out of it, sewed in the plate and various screws and washers from the hardware store. I called the quilt *Titanium Screw-Up* and took it to my next appointment to Dr. Damron [who was very supportive of her quiltmaking]. He just rolled his eyes and I could just imagine he thought: "There she goes again...."[16]

The tumor was not the first or last time Steenhuis would face a traumatic life event and use quilting to cope. A year earlier, in 2003, she was witness to a tragic accident:

> [She] heard a loud bang in her front yard and went to investigate. A car had crashed into a large tree, killing two young people she'd known from her West Hill neighborhood. The crash and its aftermath were traumatic experiences for her, but they unleashed a torrent of art in the form of quilts.
>
> "I know I went around the car and talked to the driver, but I have no visual memory of that," she says. According to paramedics at the scene, she says, it was the worst they'd seen. Her method of making sense of the tragedy was to create an abstract representation of the wreckage—called 5:46, the time of the 911 call she placed—as an art quilt.
>
> A member of the Tompkins County Quilters Guild, she had been learning to quilt, mostly using traditional piecing patterns and methods, but the accident unleashed a more abstract art form, and "It just came pouring out of me," she explains.[17]

Then, in 2011, Steenhuis was diagnosed with invasive lobular breast cancer. After a lumpectomy and radiation, she was put on Arimidex, an aromatase inhibitor, for five years. Once again she made quilts to cope, a series of "breast cancer quilts" that clearly represent the cancer cells in her body. Several of the quilts were featured on the website of the Cancer Resource Center of the Finger Lakes, and she hoped to eventually exhibit them for all clients and caregivers to see.

Figure 2.15. *Giant Cell III*, Aafke Swart Steenhuis, Ithaca, New York, 2004. 20" × 19.5". Collection of the artist. Photo by Cascadilla Photography.

There are two right arm and two left arm sets of bones in this quilt. The right distal radius had a tumor in it that had to be removed surgically and replaced with cement. I found cell-like fabric in my stash and used that to represent the bones. I fused and sewed the bones onto the black background fabric. The orange quilted circles represent the tumor radiating out. The quilted blue stripes with the two blue lines through it in the two circles, the red border and sashing represent the stitches I had with blue plastic suture thread.

(Aafke Swart Steenhuis, artist statement and materials sent to Beth Donaldson, March 18, 2016.)

Figure 2.16. *Lobular Carcinoma II*, Aafke Swart Steenhuis, Ithaca, New York, 2015. 20.5" × 38". Collection of the artist. Photo by Cascadilla Photography.

The pink circles on the dark blue background represent the view under a microscope of the lobular cancer cells. To make them, I took a large piece of pink fabric, fused the purple and blue "cells" on them, put wool batting and a back on it and quilted lines in various colors on it representing the flow of the cancer cells and the image you get of it under the microscope. After that was done, I cut the fabric in circles and sewed those onto the dark blue hand dyed fabric. Then I pieced all the pieces together. The quilting on the dark blue is small circles. On the aqua blue I quilted connecting circular forms, representing the lobular breast cancer cells.

(Aafke Swart Steenhuis, artist statement and materials sent to Beth Donaldson, March 18, 2016.)

Figure 2.17. *C3: Infiltration*, Ruth A. White, Ithaca, New York, 2012. 12" × 12". Private collection. Photo by Andrew Gillis of Cascadilla Photography © Ruth A. White.

In *C3: Infiltration*, black/gray cancer cells squeeze between the normal cells, infiltrating another organ. Joanne Hindman wrote the following in an article about White:

> A molecular biologist by trade—she works at the Boyce-Thompson Institute of Cornell—White uses the visual tools of science in her quilts, which depict nebulae, cells, lunar phases, petroglyphs, waves, Sudoku, and cancer. When she learned that she had advanced appendix cancer in 2009, "the scientific part of my brain kicked in, and I became curious," she says. She turned to quilting again to make sense of her illness, creating a series of art quilts that she calls "the cancer series," including *C3: Infiltration*, that she donated to the Studio Art Quilt Associates. Another cancer quilt, *C8: Fatigue*, "explores how chemo affects the patient's energy levels and mood after a succession of chemo infusions," she explains.
>
> "Making art and sewing," says White, "let me work out some of my fears and worries about the cancer, to make something beautiful out of something ugly." Several of White's quilts have been shown in art galleries and quilt shows, often winning awards.

(Joanne Hindman, "Witness to Fatal Ithaca Crash Turns to Quilting after Trauma," *Ithaca Voice*, September 21, 2015, https://ithacavoice.com/2015/09/witness-to-fatal-ithaca-crash-turns-to-quilting-after-trauma; see also Anita Swart Steenhuis, artist statement submitted to Michigan State University Museum; and http://www.rawquilts.com.)

Other quilt artists, such as Shannon Conley, depict disease in their art as a means to educate others. Conley is a scientific researcher studying many forms of retinal degeneration that cause blindness, including macular dystrophy and diabetic retinopathy. In her *Two Blind Mice and a Wild-Type*, she aims to help "bring to light the crucial role that biomedical research and model systems play in fostering our understanding of critical human diseases."[18]

An unidentified artist, whose work titled *Thread of Life* was included in the Lilly Oncology Canvas Project, spoke of her quilt as a visual metaphor for what she was enduring:

> Cancer found me three times. Surgeons invaded my body fabric to gather, snip and discard the lumps and bumps they found inside. The resulting scars were left by the tracings of not-so-neat doctors' stitches. However, throughout pain, treatment and recovery, I picked up my thread of life and slowly untangled the knots that fate had put in it. I took this thread and embroidered its various strands into art, music and poetry to celebrate my fight, my strength and my survival. In the days that I have been given, I turn my inartistic scars of cancer into elegant and jubilant symbols of a life that I continue to live with determination and courage.[19]

Fiber artist and author Diana Alishouse speaks eloquently of how imagery in her quilts reflects her own experience of depression and bipolar illness and how expressing her feelings through quiltmaking helps her deal with these conditions. She says, "As I wonder and think about something, the works and ideas tumble around in my head, going faster and faster, and getting all confused. The best way I have found to tame that whirlwind in my head is to anchor the thoughts by giving them a visual reality and stitching them down. Somehow the wondering in my brain connects with the knowledge that has been built up in my eyes and hands, and the thoughts get sorted into an image or collection of images that make sense. My art speaks for me without words."[20] Her quilts have been shown at the National Museum of Health and Medicine in Washington, D.C.

Figure 2.18. Facing: *Shattered Red*, Diana Alishouse, Akron, Ohio, 1985–1988. 84" × 96". Collection of the artist. Photo by Gregory Case Photography.
In addition to making quilts, Alishouse wrote *Depression Visible: The Ragged Edge*, which documents the work she did to express how she coped with her depression and bipolar illness:

> *Shattered Red* is a quilt I worked on while I was deeply depressed. It is not well crafted. Good quilting techniques didn't matter. I didn't realize it at the time, but making it was a desperate attempt to try to hold myself together. As I sewed the fractured pieces of red together (the background), I had no plan for the final quilt. I remember thinking that I felt like that jumbled mess of red. . . . I sewed those little pieces of cloth together not knowing what they were for, clutching at something, anything, just trying to hang on even though I couldn't think of a good reason why I should.

(Diana Alishouse, *Depression Visible: The Ragged Edge* [Duluth, GA: Doggie in the Window Publications, 2010], 29–31; see also http://depressionvisible.com.)

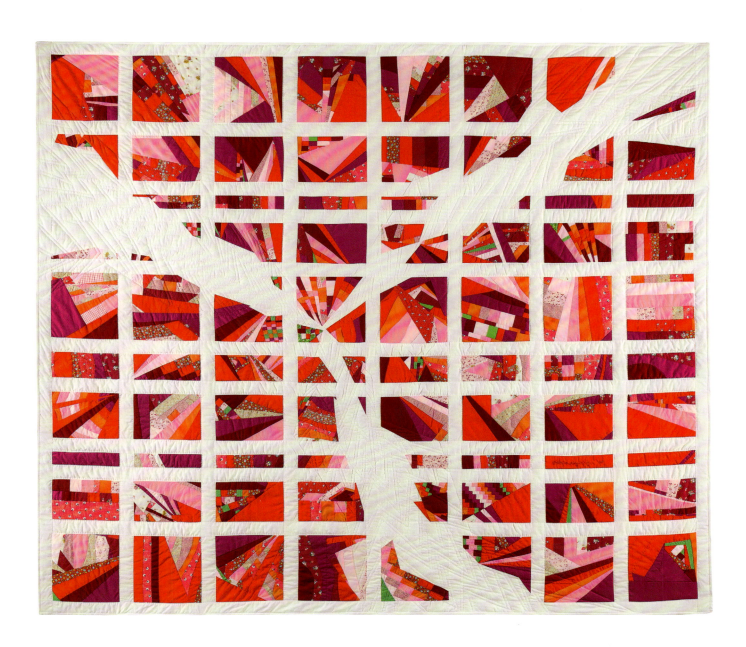

Notes

1. In brief, this was a time when an increasing number of individuals, trained as fine artists, were turning to the format and construction techniques of quilting to make textiles intended as wall art. For more about the art quilt movement, see "Quilt Art," Wikipedia, https://en.wikipedia.org/wiki/Quilt_art; and Robert Shaw, *The Art Quilt* (New York: Beaux Arts Editions, 1997).

2. Bill Volckening, June 26, 2014, Quilts and Health Facebook page, https://www.facebook.com /groups/quiltsandhealth/permalink/724132140959564.

3. See, for instance, "Jody's Bandana Quilt," illustrated in Janet Wickell, "Pictures of Comfort and Charity Quilts," The Spruce, January 25, 2017, https://www.thespruce.com/pictures-of-comfort-and -charity-quilts-4051126.

4. "CFSAC Meeting IV Quilt unraveled," discussion in 'Fibromyalgia Main Forum' started by Michele K., June 14, 2012, http://forums.prohealth.com/forums/index.php?threads/cfsac-meeting-iv-quilt -unraveled.212957. A video of the meeting, including the presentation of the quilt and a report via telephone by the bedridden maker of the quilt, Samantha Hodge Williams, can be seen on YouTube, https:// www.youtube.com/watch?v=ubjGm5dILpY.

5. "40 Quilts Honour 40 Years," *What Cancer Cannot Do*, https://40quilts.wordpress.com/about.

6. To see the fabric, go to "What Cancer Cannot Do Quilt Panel Fabric," Block Party Studios, Corp., http://www.blockpartystudios.com/shop/Hand-Printed-Fabric/p/What-Cancer-Cannot-Do-Quilt -Fabric-Panel-x2719960.htm. To see the pattern, go to "What Cancer Cannot Do Quilt Pattern," http:// siterepository.s3.amazonaws.com/3278/cancer_quilt_pattern_fina12.pdf.

7. "What Cancer CANNOT Do—Quilt Tutorial," February 3, 2015, *Home a la Mode*, http:// homealamode.blogspot.com/2015/02/what-cancer-cannot-do-quilt-tutorial.html.

8. See, for example, among many others, Laura Zander, *Sew Red: Sewing and Quilting for Women's Heart Health* (New York: sixth&springbooks, 2013); Kathy Cueva and Susan Ziegler, *The Giving Quilt: Fast Quilts for Comfort and Healing* (El Cajon, CA: Cozy Quilt Designs, 2007); Linda Giesler Carlson, *Quilting to Soothe the Soul: Create Memories for Today, Tomorrow & Forever* (Iola, WI: Krause Publications, 2003); Lesley Riley, *Quilted Memories: Journaling, Scrapbooking & Creating Keepsakes with Fabric* (New York: Sterling/Chapelle, 2006); Kelly M. Smith, *Open Your Heart with Quilting: Mastering Life through Patches of Love* (Las Vegas: DreamTime Publishing, 2008); and Mimi Dietrich, *Pink Ribbon Quilts: A Book Because of Breast Cancer* (Bothell, WA: Martingale & Company, 2011).

9. Wayne Ford, "Patch Quilters Gift Council on Aging with 57 Wheelchair Quilts," *Athens Banner-Herald* (Online Athens), December 17, 2014, http://onlineathens.com/local-news-blueprint/2014-12-15/gratitude-cotton-patch-quilters-gift-council-aging-57-wheelchair.

10. Blake Herzog, "Fidget Quilts Help Soothe Nerves of Alzheimer's Patients," *Yuma Sun*, January 1, 2015, http://www.yumasun.com/features/fidget-quilts-help-soothe-nerves-of-alzheimer-s-patients /article_659b66c6–921d-11e4-a564-93a72ab9c95b.html.

11. Alissa Norton, ed., *One Quilt, One Moment: Quilts That Change Lives* (Golden, CO: Primedia Consumer Magazine & Internet Group, 2000), 78–79.

12. Pearl Spotted Tail, *Broken Star*, 1994, Michigan State University Museum Collection, East Lansing, Michigan; see Quilt Index, http://www.quiltindex.org/fulldisplay.php?kid=1E-3D-1176.

13. Marsha MacDowell, Mary Worrall, Lynne Swanson, and Beth Donaldson, *Quilts and Human Rights* (Lincoln: University of Nebraska Press, 2016), 54.

14. Mary Kieras Frazier, December 9, 2014, Quiltville's Open Studio Facebook page, https://www.facebook.com/groups/291023511046957/search/?query=Mary%20Kieras%20Frazier.

15. Gay Young Ouslay, quoted in Ami Simms, *Alzheimer's Forgetting Piece by Piece* (Flint, MI: Mallery Press, 2007), 80–81.

16. Aafke Swart Steenhuis, artist statement and materials sent to Beth Donaldson, March 18, 2016.

17. Joanne Hindman, "Witness to Fatal Ithaca Crash Turns to Quilting after Trauma," *Ithaca Voice*, September 21, 2015, https://ithacavoice.com/2015/09/witness-to-fatal-ithaca-crash-turns-to-quilting-after-trauma.

18. Shannon Conley, Shannon Conley Art Quilts, 2015, http://www.shannonconleyartquilts.com/gallery/#/two-blind-mice-and-a-wild-type. Information also provided by artist, acquisition files, Michigan State University Museum.

19. Lilly Oncology, National Coalition for Cancer Survivorship, *Lilly Oncology on Canvas: Expressions of a Cancer Journey* (Indianapolis: Lilly, 2012), 232; image online at http://looc.lillyoncology.com/item/2012/1254.

20. Diana Alishouse, "From Diana," *Depression Visible: The Ragged Edge* (Duluth, GA: Doggie in the Window Publications, 2010), http://www.depressionvisible.com/about-diana-alihouse.html.

Individual Experiences of Health and Well-being through Quiltmaking

"When life throws you scraps, make quilts," "Our lives are like quilts—bits and pieces, joy and sorrow, stitched with love," and "Those who sleep under a quilt, sleep under a blanket of love."[1] These proverbs reflect the motivations of so many who turn to making and using quilts for personal well-being and healing. The scientific literature is now verifying what many quiltmakers already know: making quilts is therapeutic. The work these quiltmakers produce is tangible, tactile evidence of progress toward recovery or of acceptance of living with altered conditions, of perseverance, of life-affirming activity, and of continuing to be productive in the face of adversity. Quilt artist Michele Bilyeu powerfully expressed her feelings about quilting like this:

> I use the healing gifts that I have been blessed with, and I take those energies and infuse the fabric with heart, and thought, and caring, and prayer and I send them off into the world. That is the essence of a healing quilt, a prayer quilt, a quilt.
>
> Be kind to one another in word and deed and make a difference in someone else's life today, and every day. And then think about making and giving away quilts for charitable giving and charitable causes. I just know you'll feel a whole lot better!
>
> You'll look at yourself differently, your life differently, your aches and pains and challenges differently, and you will alchemize the transformative process that is really and truly mind over matter . . . the unity of mind, body, and spirit . . . by the act of giving, and the gratitude for what you do have . . . and not just focusing on your own sadness or your own losses or depression. Focus on what you do have, what you are grateful for and give to others as you also create a form of giving to yourself.[2]

On the individual level, the making or the receipt of quilts can profoundly affect health and well-being. Our research into both historical and contemporary accounts reveals that artists have used quiltmaking as a way of trying to understand and cope with their health situations or to distract themselves from external challenges. They have engaged in quiltmaking to express compassion and empathy for others who are dealing with health or traumatic life challenges, to provide tangible comfort. Often, the line between the giver and the receiver in terms of who benefits is blurred. While the recipient of a quilt is comforted

physically and emotionally, the quiltmaker gains a sense of their own well-being through the activity of making and giving.

Vital components of well-being include having a sense of purpose and self-worth and feeling connected to a community of others in which one is valued. Indeed, the previous examples we have given in this book provide evidence of how quilting not only contributes to improving the health and well-being of those who are facing illness or crisis; it also has substantial therapeutic value in terms of sustaining one's own health in the absence of illness. This is particularly relevant to the considerable attention currently being paid to self-efficacy and promoting healthy lifestyle choices and behaviors, based on the idea that people bear some responsibility for their own health. It also resonates with an increased recognition that health should be defined in holistic terms, that it is comprised of multiple, interrelated elements such as physical, psychological, social, spiritual, and mental well-being. In these contexts, quilting can be thought of as a preventive activity, a behavior that promotes holistic health and strengthens one's individual defenses against illness.

Grief, Mourning, and Quilts

The loss of someone dear is a time when many quiltmakers find that their work comforts them. Nettie Uher, quoted by Patricia Cooper and Norma Bradley Burferd in *The Quilters*, said, "After my boy Razzie died when he was fourteen, I began to quilt in earnest, all day sometimes. There was still the two younger ones to take care of but losing my oldest just took something. I lost my spirit for housework for a long time, but quiltin' was a comfort. Seems my mind just couldn't quit planning patterns and colors, and the piecing, the sewing with the needle comforted me."[3] Coping with the deaths of her husband and a daughter, Merrilee J. Tieche, who was living in Nixa, Missouri, found that making quilts allowed her a means to begin the healing process: "So many things they had both said stayed with me, fueling my anger at the injustice of it all. Making this quilt put a face to my grief and allowed a dialog with my subconscious."[4] While the stories have common refrains, each is unique, often filled with deeply personal emotion, and sometimes communicating feelings and experiences that otherwise would not be shared in expressive forms.

For Lisa Garlick of Salt Lake City, Utah, the tragic loss of her daughter at first made it impossible for her to sew, but then reengaging in her art not only brought her immediate comfort but also became a way to help heal others. "'At first,'" Lisa says, "'my heart hurt so much I didn't think I could possibly survive the pain.'"

> I couldn't even look at my sewing machine or my quilts or any of the creative things I'd always loved.
>
> There didn't seem to be any point. What was the use of my silly projects in this life when you can't take anything with you? But one day my husband said to me, "Maybe your quilts will help you heal? Maybe you can help others heal?"[5]

The first quilt Lisa made was out of her daughter's designer jeans, and she gave it to her daughter's best friend. "The creation of it was so healing that Lisa began working on another—and then another. Soon she was creating quilts for other families who had lost children" and has "found healing by remembering her and honoring her life."[6] Quiltmaker Virginia Berger

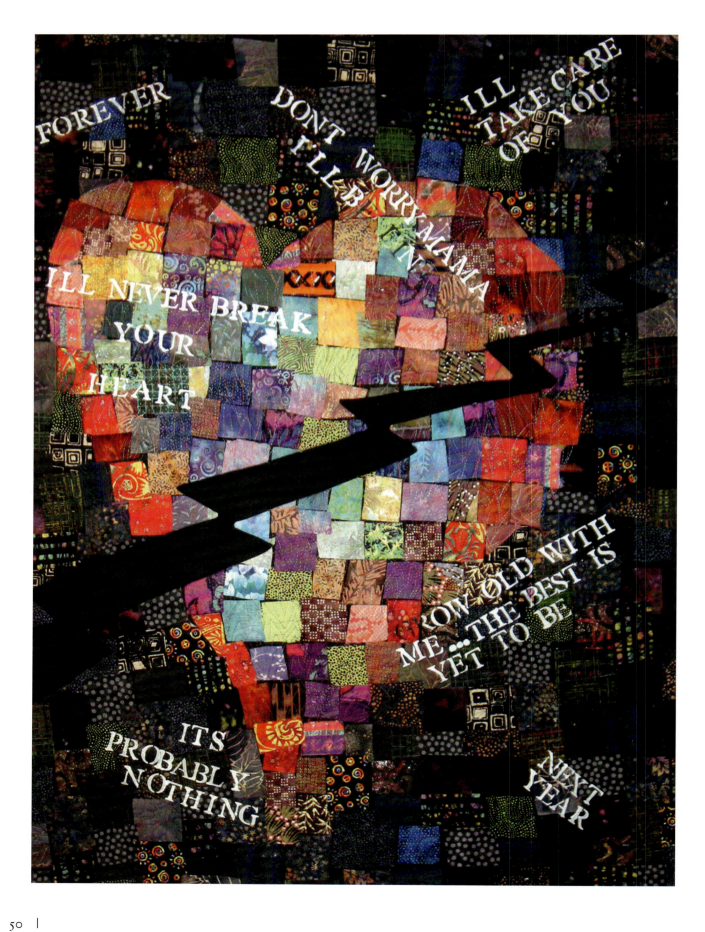

observes: "Keeping hands and mind busy in a time of sorrow is universal. After my divorce (another type of loss/mourning), I said something to my mother about an almost uncontrollable but unfocused urge to start a new quilt project. She shared with me that she had felt the same urge after my brother's death several years earlier and she felt that it was connected to wanting to create not so much as memorialize. Kind of spitting in death's eye? Or proof life goes on?"[7]

Quilt historian Carol Gebel has investigated the use of quilts in death rituals and believes that "those who make mourning quilts do so because they want to and even need to; it is for them a normal response to an abnormal situation in their life."[8] Gebel tells of hearing from one woman:

> During her husband's final struggle with cancer, she had started to make a small mourning quilt. When she mentioned this to others, they looked at her as though she was crazy. I told her that this quilt was obviously part of her mourning process and not to let the opinion of others stop her. She sent me a picture when she completed the quilt. It had four blocks and they were named Anger, Fear (these first two were made during his illness), Pain, and the last Acceptance. These are steps that many people go through in their personal struggle to deal with their tremendous loss. For her, making the quilt helped her to make "sense out of the chaos that death has brought."[9]

Another widow wrote to Gebel, saying that "she worked on a quilt as her husband was in the hospital and she could see the psychiatric ward from his window. She believed that quilting kept her from ending up in that wing of the hospital."[10] Gebel herself made a quilt that was important in the passage of the life of her father-in-law: "When I learned that my father-in-law's cancer had returned and was untreatable, I felt strongly that I needed to make him a quilt to help him keep warm. I sent it to him about a month before his death and my mother-in-law said it was always on his bed. After his death, she wrapped herself in the quilt and felt my arms and love and his arms and love surrounding her."[11] Gebel feels strongly that mourning quilts are among the very special quilts.

Figure 3.1. Facing: *Broken Promises*, Merrilee J. Tieche, Fremont Hills, Missouri, 2004. 34" × 46". Collection of the artist. Photo courtesy of the artist.

> Just before he died unexpectedly, my husband gave me a lovely gift, a sun dial inscribed with the phrase, "Grow Old with Me, The Best Is Yet to Be." That was never to be. A few years after that, my beloved daughter, my only child, was diagnosed with ovarian cancer at age 34. She fought to stay with her three young daughters for 5 very difficult years. So many things my loved ones had said kept running through my mind, fueling my anger at the sheer injustice of their deaths. Making *Broken Promises* gave a face to my anger and allowed me to move forward in my grief. Grief is a long road that most of us will have to travel at some time and like any other journey, the first step is the most difficult. *Broken Promises* allowed me to take that first step in a safe and familiar environment—my studio. It was such an important therapeutic tool. . . . Touching the fabrics, becoming immersed in the colors and textures, and pasting the anger that was hidden in my heart on the face of a quilt were the beginnings of my healing process.

(Artist statement submitted to Michigan State University Museum, May 24, 2016.)

Many artists find that the process of quilting also allows them to infuse these tough times with humor. More than one artist enduring breast cancer has made quilts in the bra pattern. In addition to humor, quiltmaking also allows for life review—for people to look back, remember positive times, and tell stories that validate one's unique identity, experiences, and value to the world. Jeanne Henry of Austin, Texas, tells of losing her partner, Terence, to cancer: "While going through treatment with him, I secretly made him a quilt that looks like a giant bookshelf filled with his favorite 77 books he's read in his life. It helped calm my nerves to quilt when I was terrified. After I gave it to him, we had hours of good conversations talking about the books on the quilt. Now, when I sleep under that quilt, I have hours of great memories of those conversations, and I've read many of those books as well."[12]

Quilts also serve as tangible, physical connections between the living and loved ones who have died. A tradition practiced by some individuals of recycling the clothing of the deceased into quilts has become increasingly widespread. Sometimes artists have distributed these fabrics over many quilts and, like so many other bits of fabrics sourced from the too small, too dated, and otherwise no longer used clothing, they serve as touchstones to many memories. However, when the entire quilt is made of the clothing of just one individual, the quilts—sometimes referred to as "transition quilts," "passage quilts," "memory quilts," or "mourning quilts"—become powerful reminders of the deceased.

Pat Kyser tells of her experience making a memory quilt for her granddaughter and the impact that she believed using the quilt would have on her granddaughter:

> Our first grandchild was born six months after my husband's death from cancer a quarter of a century ago. Shortly after his death, I fell and broke several bones in my right hand. I cut his shirtsleeves and made a quilt from that part which would have held that precious granddaughter, struggling to keep my hand moving and usable. The stitches were far from perfection, but the solace I gained was immeasurable. And the granddaughter, now a veterinarian, grew up with that quilt and a memory of the grandfather she never knew.[13]

A similar story of anticipated connections between generations was told by Mary Gold:

> Last week it was my little girl's tenth birthday and, after a hectic day, I tucked her up in bed underneath a very special patchwork quilt I had made for the occasion.
>
> It was created entirely out of her beloved Daddy's collection of beautiful shirts. My wonderful husband, Harry, died exactly one year ago, and what better way of remembering him than by stitching all those beautiful garments into a quilt, under which his little girl could snuggle at night?"[14]

Gold also recounted that when her daughter Katya saw the quilt, she immediately began recalling events at which her father wore each shirt, saying, "'Look, Mummy, that's the one he wore when he met the Queen. He wore that one in Greece. That's the one from our cruise. That's the one he wore in Moscow.'"[15] Mary said:

> Later I dug out the photo albums and I was astonished to find that she had been right about every single shirt.
>
> I knew that making the quilt would be harrowing for me but for Katya it has turned out to be worth every hour spent on it—about 100, I reckon.[16]

Barb Vlack tells of creating a quilt and a pall to cover her late husband's urn that had both clear and hidden connections to her husband's career:

> I made a quilted pall to cover the urn containing [my husband] Dave's ashes at the memorial service. I used a variation of the LeMoyne Star I had hand-pieced during his illness and made a Morning Star block for the center. Dave was an electrical engineer, and I used quilt fabric that had a circuit board design. I used a silk tie that Dave often wore that also had a circuit board design. The background of this 24" square piece was cut from Dave's monogrammed silk shirt, and the monogram is centered on one of the patches. I made composite beads from resistors from his extensive stash/collection and glass beads from mine to make a fringe around the perimeter. The backing fabric had phrases from our wedding vows (and everyone else's, since this was a widely available fabric at one time). The quilting had some personal notes in it. I had six weeks from the time of Dave's death to his memorial service to make this piece, but I didn't think of doing something like this until a week before the service. All of a sudden it became a must-do, and it was a sad, though comforting, activity. I want to sleep under my mourning quilt because it will remind me of ways to be positive and move on with good memories and bright hope.[17]

Clearly, the activity of sewing facilitated positive feelings for Barb during a profoundly sad time, and she anticipated the power of the completed object to continue to heal her loss.

As another example, Jane R. Johnson of Holt, Michigan, made seven quilts from the shirts of her late husband who passed away in 2002. She, too, incorporated those shirts that particularly represented his vocation and avocations. "I knew I wanted to make quilts from his shirts—beautiful plaid pearl snap-button western shirts, flannel shirts, t-shirts depicting his passion for drag racing and his life-long profession of an ironworker, and his denim jeans."[18]

So popular has the making of memorial quilts become in the early twenty-first century that there are how-to books just on this topic alone, and some quilt artists have specialized in making memory quilts as a business.[19] For some, it was their own experience with grief and making a memory quilt that spurred them to make quilts for others. Longtime quilt artist Linda Sophiasworth of Kalamazoo, Michigan, who has worked as a nurse for thirty years, "knows the value of preserving memories and how important something as tangible as a quilt is to mourn the loss of someone dear."[20] She describes how when her father passed away, she "was left with a closet full of memories. I wanted to create something that would honor him and provide comfort to myself and my sister. I used his clothes to create a beautiful, functional, and comfy quilt, that I still use daily. It was therapeutic to go through his clothing and to piece together my memories of him in this quilt."[21] Today Sophiasworth offers her services to make memory quilts for others through Etsy, the online marketplace for handmade items.

The process of making a memory quilt often entails close and emotional consultation between the artist and her client. Sherri Lyn Wood, who regularly makes what she terms "passage quilts," says:

> Dealing with clothing after [the] death of a loved one can be one of the most difficult and immediate concerns of those in the midst of loss. Knowing there is an alternative between getting rid of all the clothes and keeping them in closets, boxed away indefi-

nitely, can be a comfort in itself. . . . The clothing left behind is the gift that keeps telling the story of the person who gathered them, wore them over time and left them behind. The gift of their clothing will become the expressive material for the beautiful quilt to be made. As you make the quilt from their clothing you are in a way collaborating with the beloved."[22]

Wood reflects on the process of making these quilts: "The external steps of Passage Quilting coincide and reflect the interior states of transition, thus providing a grounded container for the experience of grief. Working with the architecture of the clothing (choosing, cutting, piecing without a predetermined pattern, hand quilting and sharing) provides the maker an opportunity to examine his or her life patterns. The resulting quilts reflect the relationship of the maker to the materials, retain a sense of the body, and in the case of bereavement, carry the consoling essence of the beloved."[23]

Lauryn Martin, another artist who makes memory quilts for others, suggests to clients that they provide her with "a loved one's clothing, a cherished blanket of theirs, a favorite hat, and anything else that brings you joyful memories of them and the past. I take these items, and carefully combine them all together in a quilt that you and your family will be able to hug whenever you want."[24] Martin observes that some of these memory quilts are placed as art on walls, but more often than not they are used as bed coverings or to simply wrap around the shoulders of those left behind. The familiar fabrics and the weight of the textile evoke feelings of receiving personal hugs.

Rhonda Reuter, a member of the Quilters Guild of East Texas, describes making a quilt for a mother who just lost her nineteen-year-old son: "She started to tell me about her son, I could just tell this was one of the most important decisions she had made about cutting up his clothing."[25] Reuter took thirty-six pairs of blue jeans that the son would wear and created a masterpiece of memories. "Don't you know that the mother, when she's sitting on a cold night covered up with this quilt and her hand touches the pockets, the memories that she touches of her son," says Linda Highley, another one of Reuter's clients. "When she invests her heart and her time in it, and turns it around and hands it back, that's making a bond," says Highley.[26]

Makers of memory quilts often speak of how close they feel to the deceased as they cut the fabric and shape the pieces into a whole cloth. Sharron K. Evans of Spring, Texas, says:

Things happen that I can't really explain when I'm working with these clothes. Like the lady who lost her 18 yr old daughter in a car wreck. A passage from Psalms kept playing in my head. It was making me nuts. As I finished piecing I needed an additional block and embroidered the passage. The mother just about had a fit. It was her daughter's favorite passage. My favorite story is from the long-armer [a person who is contracted to quilt finished tops with a long-arm quilting machine] that used to do my quilting for me. I was always telling her how there seemed to be these feelings in the air as I work. She thought I was a loon. I had the opportunity one time to make a quilt for a Scotsman's wife out of the Scotsman's ties. He was quite a card and had some very tasteful but cute ties. My workroom was really filled with sunshine while I worked on that

Figure 3.2. *Laurel's Quilt*, Brianna Bushre, 2015. 80" × 80". Collection of Eric and Katherine Hanson. Photo by Eric Hanson.

> When our special needs daughter, Laurel, died at age 25, one of her caregivers made a quilt for us out of Laurel's clothing. It includes Laurel's favorite shirts, pajamas, jeans and more. Each piece of clothing has a different history and holds powerful memories for us, representing cherished moments, events or feelings. We bring the quilt to our grief therapy sessions and lay it over our laps. The textures, colors and memories bring Laurel's spirit close to us in a way that's difficult to explain. We sleep under the quilt too, the sensation of Laurel's presence comforting us through the night.

(Katherine Hanson, email to Marsha MacDowell, May 25, 2016.)

top. Many, many months after the quilt was finished and delivered, my long-armer confided in me one day. When she had that quilt on the frame she said there was a presence of a man dancing around her sewing room. She hated to share that with me because it bothered her a bit but she finally understood what I was feeling. If I could do nothing but make quilts from loved one's clothes the rest of my life I'd be thrilled.[27]

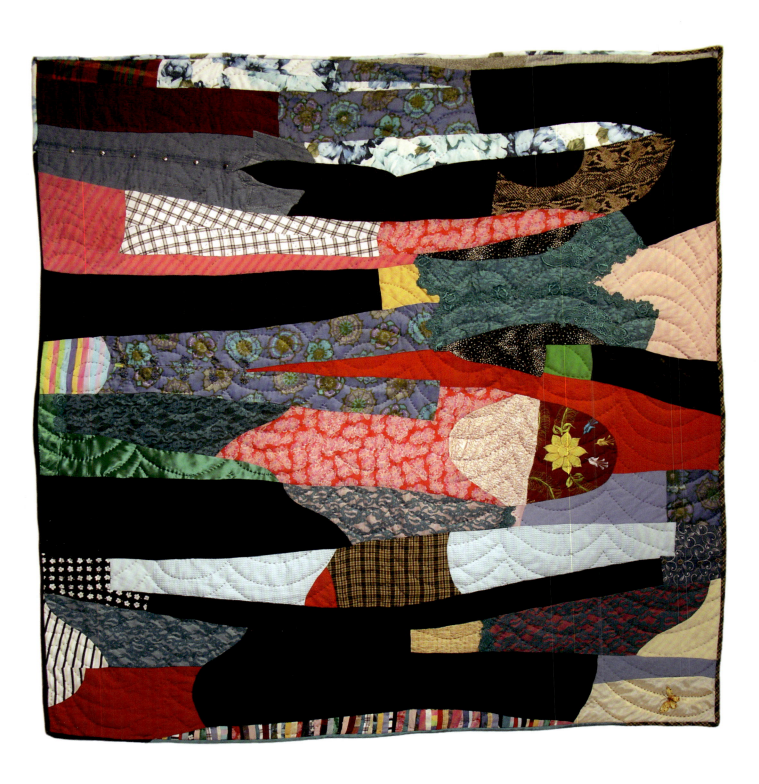

Figure 3.3. *Linda Susan Wood (1943–2003),* Sherri Lynn Wood, Oakland, California, 2006. 73" × 75". Collection of the artist. Photo by Sherri Lynn Wood.

In 2003, both my grandmother and my mother died and so for the first time I experienced the process of Passage Quilting not as a facilitator but as the bereaved. In 2005 I made four quilts, one for myself, and each of my siblings' families and for my father, from my mother's clothes during a winter residency at the MacDowell Colony, in Peterborough, NH.

Before I left for the residency, we had a big family gathering with all of my mother's clothes piled high in the living room. Each family, including nieces and nephews, sorted through her clothing, as well as the memories and feelings they engendered, to choose the items that resonated the strongest. Each family picked a different set of clothing, and each quilt began with the dress that my mother wore to each of our weddings, and for my dad, with the navy blue taffeta formal dress that she wore on an Alaska cruise with him a year before her illness.

Besides the teal lace dress she wore to my wedding 14 years earlier, I chose one of her favorite denim shirts, the robe she wore around the house, some of her Sunday dresses, an old silk kimono that she had worn in her 20's, her favorite leopard-skin bathing suit (she loved the beach!), and one of her blue scrubs that she wore as a nurse.

At age 49, my mom was the oldest to graduate from Central Piedmont Community College and the Mercy School of Nursing in Charlotte, NC. The last ten years of her life working as a charge nurse on the med-surge ward of Charlotte Presbyterian Hospital were perhaps her most fulfilling. She loved being a nurse and was really good at it. She cared for her patients deeply and fiercely. My mother, Linda Susan Wood, was diagnosed with pancreatic cancer in July 2003. She celebrated her 60th birthday and 41st wedding anniversary that fall. She died on her favorite day of the year, Christmas Eve 2003.

(Sherri Lynn Wood, artist statement sent to Marsha MacDowell, Beth Donaldson, and Clare Luz, May 26, 2016.)

The communal nature of the making and gifting of textiles with such personal connections to the deceased engender deeper bonds among individuals. Judy Kinsey of Minnesota sought help with a quilting project to honor her husband, Jim, who died unexpectedly. When going through his clothing, Judy found thirty-five nice shirts. "'Some dress blue or white, but mostly plaid," she said. "Jim loved plaid shirts. I thought it would be nice if we could do something to remember him.'"[28] She turned to seamstress/quilter friends, who ended up making seven quilts. "Each quilt also has a shirt pocket incorporated somewhere in one of the blocks. Judy explained, 'Jim always had a supply of index cards and a pen in his shirt pocket, and he wrote notes, to do lists, things he saw and wanted to remember.'"[29] The quilts were given to family members and close friends in a surprise celebration that included the makers of the quilts. The quilts are now associated with and will carry forward stories of Jim and of the healing and caring concerns and actions of a circle of individuals.

Within Native American communities, especially those of the Great Plains, quilts figure prominently in grieving and mourning. At Sioux funeral services, folded star quilts are often placed on the coffin of a person who has died and are presented to each of the pallbearers as well as the person who conducts the funeral ceremony. Because death is often unexpected, the demand for quilts is sudden and women stay up all hours on the nights preceding the funeral in order to have the appropriate number of quilts completed in time; sometimes this is the only time Sioux women quilt together. Sioux in Montana, North Dakota, and South Dakota also commonly wrap a star quilt and matching pillows around a tombstone until it is unveiled.[30]

On the one-year anniversary of the death of a loved one, family members might honor that person's memory with a ceremony that includes a giveaway in which gifts are given to the attendees at the ceremony. Among traditional Sioux, the gifts often include quilts. When Lakota Sioux quiltmaker Ollie Napesni's son was violently murdered, she went through a particularly hard period of her life. Quilting helped her through this difficult time, especially as she made quilts for the memorial giveaway: "I started to get ready for the memorial. I sat down to sew in January of '94. I took an administrative leave and then every morning I get up at 4:00 and I just cry and sew . . . so a lot of the quilts I have there have teardrops on 'em I'm sure."[31] At his memorial a year after he died, Napesni had one hundred quilts readied to give to those who attended this celebration of her son's life.

The Circle of Healing through Quiltmaking

For some individuals, it is the connection with others through quiltmaking that becomes important to their healing. As an example, Ruth A. White, of Ithaca, New York, is a member of the Tompkins County Quilters Guild and a self-described "cancer fighter." In a newspaper article by Joanne Hindman, White was reported to have "discovered the therapeutic value of quilting almost as soon as she began. She had joined a quilting group while working in College Station, Texas, and the traditional work bees that her Texas quilt group organized freed her to talk about and work through personal issues, particularly her depression and loneliness. 'The camaraderie around quilters, talking through our issues together,' she says,

'worked better than the drugs!'"[32] Later on she said, "When I was first diagnosed, I was told over the phone that I had cancer, though where it originated was not yet known. I went numb when I was told as I live alone and felt even more isolated than before. However, when the doctor told me the specific type of cancer, mucinous adenocarcinoma, the curious, scientific part of my brain kicked in and allowed me to accept the diagnosis without falling apart or becoming disabled with depression. It also allowed me to reach out for help among my quilting sisters-by-choice."[33] She goes on to speak about the importance of her quilting groups to her sense of well-being: "Being around the quilters, meeting once a week to work on our own projects where we also talked through and solved our problems brought me out of the depression better than the antidepressant and the cognitive therapy combined. Quilters are a generous group of people. They are excited about their art form, even if they don't consider what they make as art. And they are happy to welcome new quilters and to share materials and experiences with quilters and quilt enthusiasts alike. It is a very healing environment."[34]

This circle of care that quiltmaking groups provide to members who are undergoing difficulties includes, more often than not, the gifts of quilts to members in need; the care and the gifts of quilts often extend to the family members, neighbors, and friends of a quilt group member. For instance, Karen Alexander, of Lopez Island, Washington, tells how when her mother-in-law in Virginia was diagnosed with ovarian cancer and given only a few months to live, her island quilt friends made and signed heart blocks for a quilt for her:

> During the last month of her life, she kept this quilt at the foot of her bed. The evening she died here at home in her hospital bed in the living room, my husband and I were by her side singing softly to her. After the nurse had come and gone and my husband had gone to bed, I carefully arranged the heart quilt over her. The funeral home would arrive early the next morning on the first ferry to pick up the body. I wanted her body covered with love while it awaited its final physical journey.[35]

Later, at her mother-in-law's memorial service, Alexander arranged the room with her mother-in-law's quilts and sewing tools and her quilting friends provided a potluck dinner.

A quilting group in East Lansing, Michigan, continued to give care to the family of one of their beloved members when she passed away. Claire Vlasin's quilt group friends helped to organize a display of her quilts at her funeral, and the friends who served as ushers at the service wore a bit of Vlasin's fabric stash pinned to their clothes.[36]

Figure 3.5. Above: *Caring Hands*, Members of the Spartan Quilters of the Michigan State University Community Club (left to right, top row: Jean Graham, Dawn Bryde, Kathy Lane, Mary Lou Gast, Dee Williams; middle row: Joan Gilliland, Mary Olson, Carole Cappriotti, Susan Berger, Martha Schwab; and bottom row: Karen Harsh, Molly Greene Haywood, Annette Whims, Mary Ann Dunn, and Beatrice Hughes), East Lansing, Michigan, 2011. 67.5" × 40.5". Collection of the family of Carol LeMense. Photo by Pearl Yee Wong.

Members of the Spartan Quilters of the Michigan State University Community Club (formerly known as the MSU Faculty Folk) made this quilt to show support and bring comfort to fellow member Carol LeMense, who was dealing with breast cancer. "The backing fabric, a flannel, was intended to be warm, soft, and comforting." Each member placed her "Caring Hands" imprinted in acrylic paint onto the block she made. (Quilt Index, http://www.quiltindex.org.)

Figure 3.4. Facing: *Kathy's Chemo Quilt*, blocks made by Eileen Gianodis, Dorothy Jones, Linda Kuhlman, Louise Mueller, Cindy Mielock, Phyllis O'Connor, Carol Schon, Roxie Stark, Jan Gagliano, Terry McKenney-Person, Lisa Wilson, Ruth Dukelow, Bonnie Bus, Georgia Hayden, and Daisy DeHaven; assembled and quilted by Beth Donaldson, Lansing, Michigan. Started in 2011, finished 2016. 45" × 68". Private collection. Photo by Tom Donaldson.

> In 2008 I joined the block exchange group of my friend Ruth Dukelow. In Ruth's block exchange, each member chooses a quilt block pattern, passes out directions and makes color choices. At home we make a block for each member from her pattern, in her colors. In the course of the next nine meetings, during a potluck, we deliver the blocks. In this way, the quiltmaker accumulates enough blocks for a quilt. Many members use the blocks to make quilts for gifts or to donate to charity. In 2011, I chose a square in a square pattern in the colors yellow and blue. I had no plan for the blocks, so I put them with my other unfinished projects. In 2016, my dear friend Kathy was diagnosed with throat cancer. I knew that cancer treatments were grueling and often left the patient constantly cold. Of course I was going to make Kathy a quilt. After surgery she was unable to do much more than sit up in bed. A pretty quilt was one of the few things that might bring a little comfort. I asked her boyfriend what her favorite colors were and found out they were yellow and blue. I remembered my block exchange blocks and was able to finish the quilts in less than two weeks. Thanks to my block exchange pals, I was able to give a little warmth and comfort to my friend Kathy.

(Beth Donaldson, email to Marsha MacDowell, May 25, 2016.)

In 2013 Kathleen Neiley, of Jackson, Wyoming, embarked on a project that used clothes of the living to comfort those undergoing health challenges. To create a quilt for her sister-in-law, who had breast cancer, Neiley used thirty T-shirts from family members, upon which each of them wrote inspirational messages. When all involved were so positive about this method of shared comforting, Neiley was inspired to start a business, Full Circle Quilts, to engage other groups in making T-shirt quilts for someone they knew who was facing health issues and could use the comfort that a collaboratively made quilt could provide. As Neiley says, "The personal connection of the quilt from giver(s) can give an extra measure of comfort and emotional support to the recipient."[37] One of the first activities of her new business was to work with a support group for Brianna Clancy, a nine-year-old competitive athlete who had a brain tumor. Brianna's coach, team members, family members, athletes from the University of Wyoming, and even some Olympian athletes provided the T-shirts. Brianna, now successfully through her surgery, radiation, and chemotherapy treatments, blogs for Neiley's business website.[38]

Figure 3.6. Brianna Clancy with the quilt of T-shirts donated by her family members, gymnastic and swimming teammates, and others who wanted to demonstrate their support of Brianna while she was undergoing cancer treatments. The T-shirts were sewn into the overall top by Kathleen Neiley, and the top was quilted by Vicki Mollett. Photo by David J. Swift.

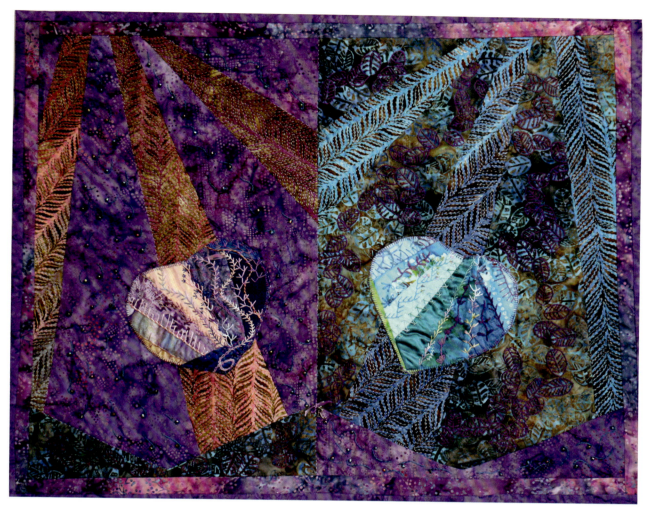

Figure 3.7. *"While There's Life There's Hope" (Cicero)*, Patricia Washburn, Chantilly, Virginia, July/August 2014. 28.5" × 23.25". Private collection. Photo by Patricia Washburn.

My daughter, Michelle, is an Oncology/Hematology Nurse Practitioner who treats people with numerous types of cancer. One of her patients, I will call her Mary, had advanced cancer. Although facing the final days of her life she was upbeat and had the most important medicine available . . . HOPE. The nurses and doctors called her Ms. Mary. She and her sister would arrive at the clinic armed with a bag of handwork to occupy the lengthy treatments she had to endure. She told the staff that she was making a crazy quilt heart for everyone in the clinic.

Cancer claimed Ms. Mary. One day her husband came back with crazy quilt hearts for many in the clinic. Mary wrote names on them and chose special colors for each personality. Michelle's was purple, one of her favorite colors because she graduated from East Carolina University. Michelle was touched. One of the nurses didn't know what to do with her heart and gave it to her. The two lovely little hearts then made their way to me. I designed the quilt with rays depicting the hope that Ms. Mary had even at the end. I added beads to symbolize the sparkle she exhibited.

Her life on earth ended, however, I think her spirit lives on in this little quilt and in the hearts of the people who knew and loved her. I think when patients have a handmade quilt there is a connection between them and the maker, whether they personally know them or not. The idea that someone thought, planned, cut and stitched something colorful, useful and beautiful for them is a lovely thing. It makes them feel loved and remembered. Quilts have a power to comfort even in the worst situations.

(Artist statement submitted to Michigan State University Museum, May 13, 2016.)

When the Artist Is Coping with Illness or Grief

When the maker of the quilt is the one who is dealing with his or her own sudden or chronic illness, disease, or injury, the activity of quilting becomes a solace, a critical tool for facing pain, despair, depression, temporary or long-term loss of abilities, or even impending death. Coping, recovering, and accepting are often interrelated with accounts of patients who quilt. As Karen Mowinski of Tucson, Arizona, so succinctly put it as she coped with a fibromyalgia degenerative disc/joint disease: "Pain is a dirty four letter word. I won't let it stop me, though. Give me a needle, thread, a few yards of fabric and my sewing machine; I'll show pain who's boss."[39]

Terri Kohlbeck of Kalispell, Montana, credits quilting with returning her to physical and mental health after a medical crisis. As she simply states, "That was the thing that saved me."[40]

> Kohlbeck recalls the life-altering moment in 2003 [that] came just minutes after she took her dose of Celebrex, prescribed to ease the pain and inflammation from a broken back.
>
> "I went into anaphylactic [allergic] shock," she said.
>
> Within minutes, Kohlbeck hit the floor unconscious. Her husband, who usually leaves early, was home that morning and heard the thud.
>
> Emergency workers rushed her to the hospital where they revived her several times.
>
> "It was slow-release Celebrex so it kept kicking back in," she said. "I think I had a lot of brain trauma because for a year and a half, I was depressed. I couldn't focus."
>
> By chance, she picked up a magazine, where she saw a quilt and was immediately inspired to make it. . . .
>
> "That quilt won third place in the quilt show," she said. "I made 22 quilts the next year."
>
> [Since then] Kohlbeck has relied on the craft to pull her through many more ups and downs."[41]

The trauma that military personnel experience, and its long-term impact on health, is well documented. Here, too, quilts provide comfort, as Jen (aka SoldierGrrl) testifies:

> When I redeployed home from Iraq, I started a quilt, made in the middle of the nights when ghosts and demons kept me company. It was a fan quilt, with primary colors, and I like to think it helped push some of the ugly memories, sad memories, bittersweet and angry memories out and replaced them with calmer, more creative memories. It's been six years now, and I've finally finished the top. Now, I'll be sending it out to get it long-arm quilted, and maybe that chapter of my life will close for a bit. Well, until deployment next year.[42]

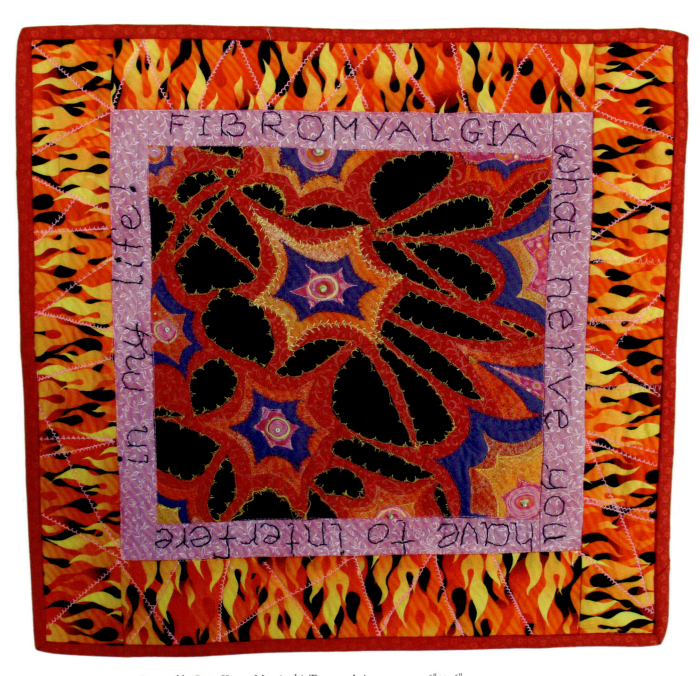

Figure 3.8. *Inspired by Pain*, Karen Mowinski, Tucson, Arizona, 2014. 16″ × 16″.
Private collection. Photo courtesy of the Quilt Alliance.

"Pain has inspired me to seek creative ways to rise above the nocuous nerve stimulus;
fibromyalgia degenerative disc/joint disease and stroke threaten. A positive attitude,
a purposeful life, and inspiration of fellow quilters; pain you don't stand a chance"
(artist statement submitted to Michigan State University Museum, June 10, 2016;
see also Quilt Index, http://www.quiltindex.org).

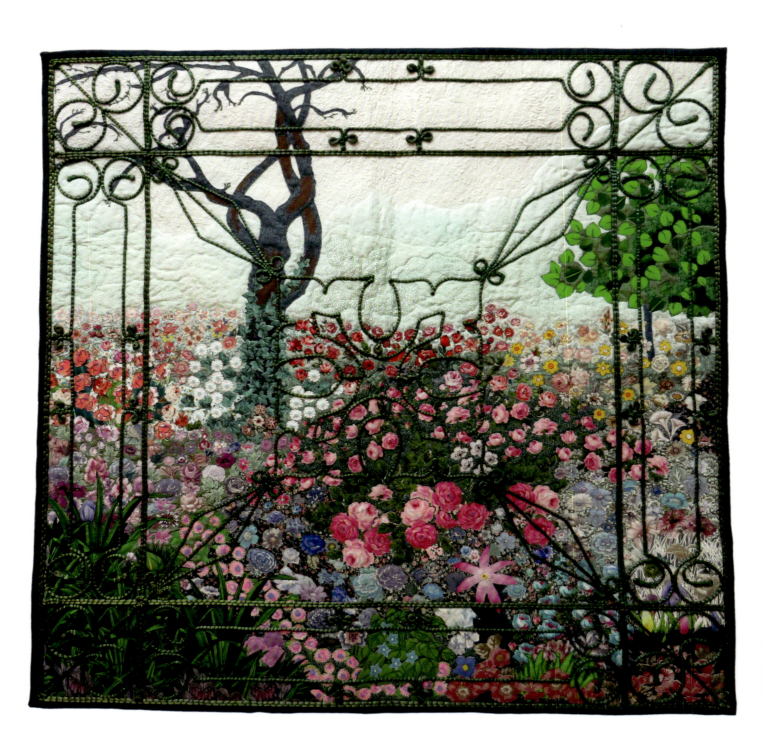

Figure 3.9. *Garden Gate*, Suzanne Mouton Riggio, Wauwatosa, Wisconsin, May 1, 1993–May 1, 2007. 26.25" × 26.25". Collection of Teresa Riggio Jennings. Photo by John Riggio.

> "I had not been quilting for long when I decided to do a garden quilt with a wrought iron gate in front of it. . . .
>
> The longest stretch of time in the making of this quilt was the hand couching. I kept the work in a tote bag that traveled with me to doctor's offices and hospital rooms where I got a few stitches in while I was waiting to be seen or while visiting my heart patient husband. After 12 years, I was hospitalized for spinal surgery. A lengthy convalescence enabled me to finally complete the couching.
>
> The binding proved extremely difficult too. Because I was now a paraplegic, I used my right hand to work the foot pedal of my sewing machine and my left hand to manipulate the fabric. In spite of using the zipper foot, I was unable to close the gap between the outermost rattail and the binding. Yay for perseverance and stitch ripping!"

(Suzanne Mouton Riggio, quoted in Lisa Quintana, "Aullwood: Suzanne Mouton Riggio a Lesson in Perseverance," *Michigoose's Gander at Quilts & Life*, August 7, 2010, http://michigoose-life-quilts .blogspot.com/2010/08/aullwood-suzanne-mouton-riggio-lesson.html.)

Figure 3.10. *June's Dementia—A Life Unraveled*, Debra Bentley, Beavercreek, Ohio, 2011. 43.5" × 35.5". Collection of Debra Bentley. Photo by David Bentley.

Debra Bentley used color and texture to represent how her mother, June, gradually disappeared before her eyes as a result of vascular dementia and how June's life unraveled bit by bit. She describes her thinking in creating the quilt: "I thought about how the plaque in her blood vessels had gradually closed her mind and rusted away her memories. The rust dyed fabric was the perfect backdrop for this quilt. The fading photographs represent her fading away and her fading memories. The unraveled and frayed fabric and loose hanging threads represent her tangled and confused memories and thoughts. The black binding is for my mourning the loss of a beautiful soul." This quilt was Debra's way of dealing with her loss and grief, her way of sharing her love for her mother and her anger at the disease (Debra Bentley, correspondence and artist statement sent to Beth Donaldson, March 13, 2016).

Figure 3.11. *9/11*, Mary Beth Frezon, Brainard, New York, 2001. 42.5" × 22.5". Collection of the artist. Photo by Pearl Yee Wong.

On September 11, 2001, the moment an airplane hit the first of the Twin Towers, hundreds of individuals turned to their quiltmaking to cope with the anxiety and grief of what they were witnessing. Mary Beth Frezon recalls that day:

> The phone rang. I watched my mother talking and prepared myself to hear that someone had died. Who could have imagined? We didn't have a TV where we were so we didn't get the barrage of instant images. All we could do is listen to the phoned reports and wonder.
>
> What struck me about that day was the change. The sky was crystal blue, the Adirondack water still sparkled with the sun, the mountains still held in the lake on all sides. What had changed was me. I felt that someone had knocked a hole in my body or head. That there was a gap between the me of a few minutes before and the me now. I looked at the others and they seemed to have the same problem putting themselves into this new existence.
>
> I've used simple images to portray that turning point where the innocent happiness changed on a moment in time. I've left a suggestion that this will continue to evolve. All grief becomes tempered over time but how long before the memory of that moment is softened?

(Mary Beth [Goodman] Frezon, "Early Statement about Quilt," September 11, 2001, http://mbgoodman.tripod.com/911; see also Mary Beth Frezon, *Orientation::Quilter*, http://www.quiltr.com.)

Figure 3.12. *Trapped in Blue*, Carolyn Castaneda, Santa Fe, New Mexico, March 2016. 30" × 30". Collection of the artist.

There have been many times in my life when I felt sadness and despair. It was like being trapped in a place with no way out. To express these feelings in a quilt, I created collages consisting of maze-like shapes to represent entrapment. I also wanted to create areas of calm where healing and feelings of hope occur. The round, silver shape depicts the presence of a superior being that I felt was with me during these times. I used the color blue since it is often associated with depressive feelings.

(Quoted in Lauren Kingsland, ed., *Sacred Threads Exhibition 2015* [Rockville, MD: CQS Press, 2015], 212.)

Figure 3.13. *Eye of Panic*, Linda Edkins Wyatt, Sag Harbor, New York, September 2010. 24" × 24". Collection of the artist. Photo by Linda Edkins Wyatt.

Eye of Panic celebrates my personal healing from panic disorder, an illness that, for many years, haunted and often debilitated me. I made it because I wanted to use the fabric I had created during several panic attacks. The lighter colored squares in the piece were done with fabric crayons directly onto fabric during a long, intense panic attack. The fabric hung around the studio for a long time and I didn't quite know what to do with it. It occurred to me that if I cut the parts I liked and alternated them with a bright panic scribble it would work well. I felt really good about cutting up the panic fabric, like I was in charge, rather than the panic. The border squares are comprised of alternating pieces of fabric; its geometry is repetitive and soothing—the antithesis of panic. The large central eye, made of fabric painted with water-soluble oil pastels, signifies my newfound strength, health and well-being. Most people really like the quilt, but some find the big eye a little creepy.

I feel like the quilt symbolizes my conquering of panic disorder. I still do get panic attacks but they are few and far between and do not last as long. In creating *Eye of Panic*, I have symbolically cut panic down to size, contained and restrained it, and stitched it shut. I have looked at panic—unafraid—and made it retreat.

I have learned the hard way that it is essential for me to do art. I have also learned that what I make doesn't have to be good, it doesn't have to be pretty. I don't have to sell it to consider myself a success. I don't even have to finish it. Nobody has to like it—not even me. I just have to keep making art to keep myself sane.

Quilts are perfect in many ways for addressing health. They are soft, comforting, and usually beautiful. They are warm and people can wrap themselves up in them. They are usually handmade, or made by hand with a machine stitch. Quilts have history, and remind me of the thousands of women (and men) through the centuries who came together to create them, or worked side by side on their own quilts. They speak of female bonding and caring and comfort.

(Artist statement submitted to Michigan State University Museum, March 8, 2016.)

Figure 3.14. *Suicide Dream*, Anne Triguba, Westerville, Ohio, 2013. 29" × 29".
Collection of the artist. Photo courtesy of the artist.

"After a long serious illness, I thought about suicide constantly. One night I dreamed I was creating a Broadway show called 'Suicide.' In my dream I made a quilt to be the motif for the show. When I woke I made a drawing and then I created the actual quilt from my dream. Upon completion of the quilt, thoughts of suicide ceased" (quoted in Lauren Kingsland, ed., *Sacred Threads Exhibition 2013* [Rockville, MD: CQS Press, 2013], 173).

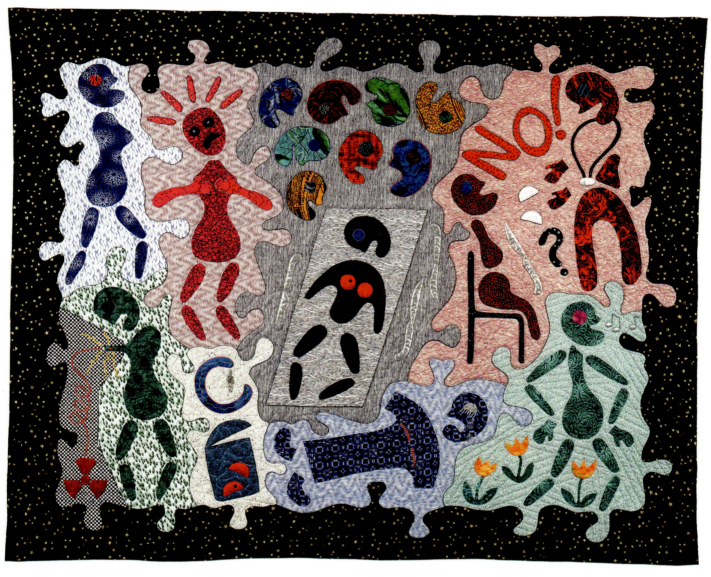

Figure 3.15. *The Mastectomy Quilt*, Suzanne Marshall, Clayton, Missouri, 1992. 64" × 52". Collection of Michigan State University Museum. Photo by Garland Marshall.

After my bilateral mastectomy, I became alarmed when hearing stories about women who found lumps in their breasts but did not seek treatment due to an overwhelming fear of disfigurement. I wondered if I could make a traditional quilt that could send a message—a changed body is not important—LIFE IS! In addition, I had a concern that many women did not realize they have a choice regarding implants or cosmetic surgery. It is not necessary to conform to society's image. The narrative of the quilt reads from left to right. A healthy, whole woman walks along with everything right in her world. Then she gets a mammogram. She registers shock and denial at the diagnosis. Surgery follows. [After her recovery] she goes back to the doctor, who asks if she would like to have more surgery for implants. She says NO! The message of the quilt is enjoyment of life amid flowers and music.

(Suzanne Marshall, artist statement sent to the authors, February 27, 2016; see also http://www .suzannequilts.com/suzannequilt.com/Mastectomy.html; and Suzanne Marshall, artist statement, in *On the Issues Magazine (OTI)* (Winter 1999), http://www.ontheissuesmagazine.com/1999winter /w99art.php).

Figure 3.16. *My Serenity Prayer*, Linda Scholten, Oxford, Ohio, 2015. 27" × 26.5".
Collection of the artist. Photo by the artist.

I am an art quilter and quilt judge who was diagnosed at the end of July 2015 with Parkinson's Disease, stage 1. While in the throes of dealing with the diagnosis and learning as much as I could about the disease (spoiler alert—stages 4 and 5 are very nasty), I began making an art quilt. At the time I started the quilt, I picked out fabrics that seemed right to me, not really knowing what the quilt was about. I ripped the top apart once to make the vertical pieced strips smaller in width. It was only during the making of the quilt that I discerned what it is about. It is about me feeling weak and overwhelmed (those narrow pieced strips), a simple life turned upside down (that center pieced strip), and trying to achieve serenity while facing the beginning obstacles to my independent life (the ripples and stones quilted into the top). I have written my own serenity prayer to go with the piece and my life. I pray for the serenity to accept my diagnosis, that which cannot be changed; the courage to face what lies ahead; and the wisdom to live in the present, doing things now while I am still able. I have always found solace in nature and the base colors of blue, brown and green represent the sky/water, earth, and forests.

(Linda Scholten, artist statement submitted to the Michigan State University Museum, January 1, 2016.)

Figure 3.17. *The Beat Goes On*, Ricky Tims, Arvada, Colorado, 2000. 50" × 53". Private collection. Photo by Jon Bonath.

In 2000, at age forty-four, Ricky Tims, a full-time professional quilt artist and musician, had triple heart bypass surgery. Within days of his surgery and still very much in recovery, he felt he had to be active and to sew something. He created this heart design, with the title drawn from the song made famous by Sonny and Cher, "as a symbol to commemorate his own health event" (Ricky Tims, artist statement submitted to Michigan State University Museum, May 11, 2016; see also http://www.rickytims.com; and Alissa Norton, ed., *One Quilt, One Moment: Quilts That Change Lives* [Golden, CO: Primedia Consumer Magazine & Internet Group, 2000], 43).

Figure 3.18. *Beyond the Obvious (Roses for Sandy Series),* Sandra Branjord, Sun City, Arizona, 2012. 36" × 48". Collection of the artist. Photo by Sandra Branjord.

This quilt deals with the death of our son Bobby, who died at age forty. For ten years I had not dealt with his death, until this quilt. He was my son, but the quilt could have been about any mother's child, as loss is universal. The forty washers represent the circle of his life from birth to death. Petition and layering mirror the depth of my feelings as a mother losing her child. My face at age seven, a photo taken at my mother's funeral, is layered over several of the pictures. This quilt helped me to grieve and heal. I made it because I couldn't not make it.

(Quoted in Lauren Kingsland, ed., *Sacred Threads Exhibition 2015* [Rockville, MD: CQS Press 2015], 210)

Figure 3.19. *Therapeutic Intervention*, Theadra L. Fleming, Detroit, Michigan, 2014. 72.5" × 79". Collection of the artist. Photo by Theadra L. Fleming.

Fleming, a member of the Great Lakes African American Quilt Network, shared this quilt with MSU Museum researchers at the 2015 Great Lakes Folk Festival's "Art and Health" program.

> I was inspired by a quilt in the book The Art Quilt, I purchased in January 2014, that required using a 60 degree triangle ruler to lay out the design. I chose the colors, assembled the layout, and wasn't quite satisfied. The individual triangles sat until December 2014. Letters exchanged with an older sibling in the fall of 2014 regarding his anger issues with our mother and his assertion that he was abused as a child caused both of us a lot of anxiety. Through the letters, we bared our souls of long held feelings about our childhood. I relived many painful moments and episodes of my life as I rearranged the triangles to complete this quilt. I must say that the prior therapy sessions, i.e. the prior 100+ quilts, enabled me to remain peaceful, nonjudgmental, thankful and forgiving about myself, my mom and my brother.

(Theadra L. Fleming, artist statement provided to the Michigan State University Museum November 30, 2015.)

Figure 3.20. *Semi-Colon*, Rayna Gillman, West Orange, New Jersey, 2002. 24" × 24". Collection of the artist. Photo by Rayna Gillman.

In November 2000 I was diagnosed with stage three colon cancer. After surgery and 7 months of chemo, I decided not to go back to my job but instead, to pursue my art full-time. I had discovered that life was too short and I needed to do what I loved. While I was recovering, Lonni Rossi invited me to participate in an exhibit at the Leonard Pearlstein Gallery in Philadelphia, with the challenge of using her hand-painted fabric for 70% of the piece. The theme of her fabric was "Dancing Between the Semicolons." How could I resist? For Lonni, the theme referred to the punctuation mark; for me, it had an entirely different meaning. As I researched images of re-sectioned colons, I realized that they resembled the Hebrew letter Chai, which means life. Lonni's fabric was the background for dancing figures made of my hand-printed cloth; an image of a "semi-colon," and multiple images of the letter Chai. Indeed, my semi-colon had given me life—and this incredibly well-timed challenge became a joyful celebration of life and a healing process for my spirit.

(Rayna Gillman, email correspondence with the authors, December 16, 2015; see also *Rayna Gillman: Studio 78*, http://www.studio78.net/about.php.)

Quilt Art for Health-Related Education and Advocacy

Some individual quilt artists are particularly interested in designing work to advance awareness of health issues and conditions. Some draw on their own experience with the conditions; others simply use their art as an educational and advocacy tool. Often they become aware of exhibition venues where their work can impact viewers' empathy and understanding about particular health conditions. For example, Elizabeth Hendricks created a Wear a Pink Ribbon quilt while she was awaiting breast surgery. In the quilt she included photo transfers of four generations of women in her family with the name of each woman stitched below the image; she used double-stitched lines along the curves of the breast to show the surgeon's cutting lines. The quilt is often displayed at shows next to a basket of pink ribbons. When the quilt is exhibited at shows, Hendricks places a basket of pink ribbons, symbols of breast cancer, next to it. She says, "I enjoy watching hands reach in for a ribbon to wear after they have been touched by the meaning of the quilt."[43]

Figure 3.21. Facing: *Raging Light*, Susan Gray Mason, Walnut Creek, California, 1996–1997. 108" × 108". Collection of the Michigan State University Museum, gift of the artist. Photo by Pearl Yee Wong.

Begun in 1996, the major sewing on this quilt was finished in about 1997. Names continued to be added to the quilt at several breast cancer events over the next several years.

In 1996, inspired by Tibetan prayer flags used on one of the Breast Cancer Fund's expeditions, Susan Gray decided to quilt a small, personal names banner to take along on breast cancer fund-raising activities. The banner included only the names of Susan's own family and friends who had been lost to breast cancer: her mother, two aunts, two dear friends. When Susan began inviting others to contribute names, she was overwhelmed by the response: 'Some days I had to get up my nerve to open my mail, knowing how many difficult stories I'd have to read.' Susan began sewing furiously. Thus Raging Light, named after Dylan Thomas's famous poem, was born.

The first panel of *Raging Light* was completed in October 1996 and was displayed at the Susan G. Komen Foundation's Race for the Cure in San Francisco. At the race, the backing fabric became an interactive canvas as survivors, friends, and family members signed names across the ribbons.

(Alissa Norton, ed., *One Quilt, One Moment: Quilts That Change Lives* [Golden, CO: Primedia Consumer Magazine & Internet Group, 2000], 36.)

According to the artist, "Once it became three panels (Earth, Wind & Fire) it was displayed all over the country at various events and also went along to Japan with their 2000 Climb Against the Odds—Mt. Fuji. I carried it to the top of the mountain in my backpack and then at the top had a ceremony in front of a shoji gate where we lit a fire and burned printed prayers from and for people whose names were on the quilt" (Susan Gray Mason, email to Beth Donaldson, May 4, 2016).

Figure 3.22. *HIV Positive: Reaching for a Cure*, Marion Coleman, Castro Valley, California, 2014. 30″ × 30″. Collection of Michigan State University Museum. Photo by Pearl Yee Wong.

Coleman's work often focuses on issues of human rights, particularly those of African Americans, but she has also made several quilts that pay tribute to the legacies of other people of color. Coleman made this quilt in tribute to Nelson Mandela for his advocacy for research to cure HIV (Quilt Index, http://www.quiltindex.org; information provided by the artist, acquisition files, Michigan State University Museum).

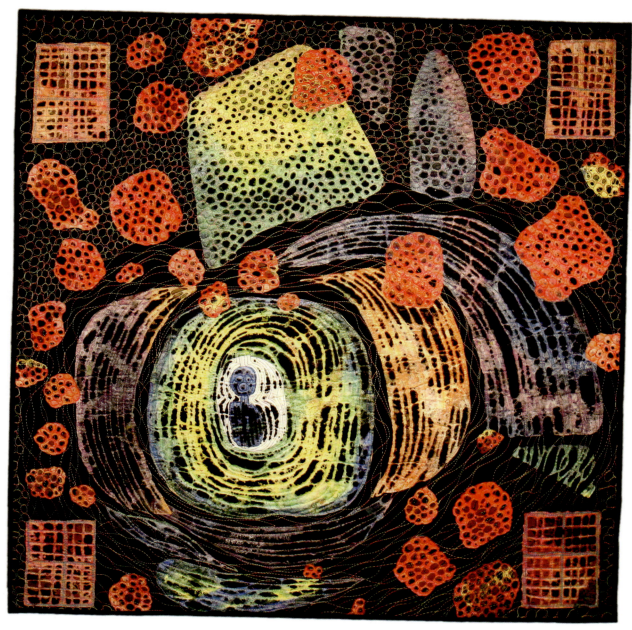

Figure 3.23. *All Alone and Blue*, Cynthia St. Charles, Billings, Montana, 2004. 36″ × 37″. Collection of the artist. Photo by Michelle Shumaker.
This quilt was featured in the 2011 Sacred Threads exhibition in Washington, D.C.

This piece was inspired by the unique style of artist Friedensreich Hundertwasser. His use of color and line influenced the development of this image depicting the loneliness and isolation engulfing a person in the depths of depression. A plasticized wrapping material called Tyvek® . . . was melted slightly with an iron to create texture and depth. . . .

Even though it is essentially about depression—I do not suffer from depression, rather—I spent many years of my career working with individuals struggling with depressive symptoms, among other things. I am very aware of the impact of this disease.

(Cynthia St. Charles, "All Alone and Blue Juried into Sacred Threads 2011," *Living and Dyeing Under the Big Sky*, http://cynthia-stcharles.blogspot.com/2011_04_01_archive.html.)

Figure 3.24. *My Friend Is Bipolar*, Laurie Ceesay, Menominee, Michigan, 2012. 43.5″ × 24.25″.
Collection of the artist. Photo by Laurie Ceesay.

My significant other has Bipolar Disorder. I made this quilt to explore the characteristics of
being bipolar and as the person who lives with and interacts daily with the mood swings
of being manic one day/minute and then being depressed the next. I grieve for the fact that
people with Bipolar Disorder have a hard time being "normal" and often need medications
to balance their moods while taking away another emotion. I learned from the process the
personality traits of the disorder and it helps me better understand how to adapt to the person-
ality and mood fluctuations. I used many descriptive words in the quilt background but purposely
made the colors blend because it is symbolic of the social stigma of not discussing mental health
issues. I over-exaggerated the manic characteristics of over-doing things—the woman's hair,
make-up, jewelry and clothing patterns and colors. With the depressed representation I kept
the colors greyed, sad and subdued, the jewelry dark, and the clothing non-descript. I added the
universal symbol for Bipolar Disorder in the quilt. This quilt helps me understand Bipolar
Disorder better. My significant other is male but I changed the person in my quilt to a woman
for anonymity.

(Artist statement submitted to Michigan State University Museum, March 9, 2016; quoted in
Lauren Kingsland, ed., *Sacred Threads Exhibition 2013* [Rockville, MD: CQS Press, 2013], 133.)

Figure 3.25. *Two Blind Mice and a Wild-Type*, Shannon Conley, Moore, Oklahoma, 2015. 20″ × 30″. Collection of Michigan State University Museum. Photo by Michael L. Cox.

These eye diseases lack effective cures/treatments, due largely to an ongoing lack of knowledge about the underlying disease mechanisms. "Knockout and knockin mice are genetically engineered to carry mutations in their genome to model debilitating diseases, critical since it is difficult to study many diseases in human patients. The scientific and medical advancements that have resulted from use of these models cannot be overstated, and much of our knowledge about these diseases is a direct result of the use of these animal models. This quilt re-interprets my fluorescein angiograms—pictures of the blood vessels in the eye—from mice with diabetic retinopathy (top) and macular dystrophy (bottom), as well as their normal or wild-type counterpart (middle). We use these specialized mice to study the pathobiological mechanisms associated with these blinding retinal degenerations and develop and test novel treatments." I created this piece to help bring to light the crucial role that biomedical research and model systems play in fostering our understanding of critical human diseases.

(Artist statement submitted to Michigan State Museum, February 18, 2016; see also http://www.shannonconleyartquilts.com.)

Figure 3.26. *Swayback*, Karen Rips, Thousand Oaks, California/Douglas, Nevada, 2015. 22" × 50". Collection of the artist. Photo by Ted Rips.

Figure 3.27. *Crossed Arms*, Paula Chung, Thousand Oaks, California/Douglas, Nevada, 2015. 30" × 62". Collection of the artist. Photo by Paula Chung.

Rips, a registered nurse, and Chung, an educator, work on collaborations that explore images of body parts that are diseased or broken. "Body imaging provides a powerful window that allows the doctor dramatic non-invasive images of our anatomy. As artists, we find these images compelling since they can tell a story or be seen simply as shapes, lines, dark and light spaces. These quilts are interpretations of an x-ray showing a condition called Kyphosis" (Karen Rips and Paula Chung, artist statement submitted to Michigan State University Museum, October 20, 2015).

Figure 3.28. *Post Traumatic Stress Demons*, Patricia Anderson Turner, Punta Gorda, Florida, 2014. 34" × 24". Collection of the artist. Photo by Lloyd Begg.

Although Post Traumatic Stress Disorder statistics vary widely, the Congressional Research Service estimates that among Iraq and Afghanistan Army war veterans, PTSD is as high as 67%. Statistics relating to military PTSD may vary but all studies agree on this: PTSD, depression, and suicide have increased at alarming rates among our nation's veterans. Due to woefully inadequate funding, our Veteran's Administration has proved itself incapable of addressing these unseen wounds of war. How long . . . and at what ultimate human cost . . . will we allow these demons to go untreated?

(Patricia Turner, "Gallery," Patricia Turner Art, www.patriciaturnerart.com/gallery.html.)

My art addresses issues of social, cultural, and political concern. Utilizing familiar and iconic imagery, often of conflict and pain, and placing these images within backgrounds that are exuberant and colorful creates tension between the gravity of the subject matter and the cheery playfulness of the presentation. My goal is to disrupt complacency, encourage dialogue, and even provoke the viewer to examine issues that affect us all. The act of creating helps release my frustration over these thorny and complex ailments of our age. . . .

I aim to disrupt, to provoke, perhaps even to aggravate; always using my work as the catalyst for reflective thought. For me, this is the ultimate function of art.

(Patricia Turner, artist statement submitted to Michigan State University Museum, March 11, 2016; Patricia Turner Art, http://www.patriciaturnerart.com/about.html.)

Figure 3.29. *Grieving: An Interactive Quilt*, Margaret Filiatrault, Georgetown, South Carolina, 2013. 35" × 31". Collection of the artist. Photo by Philip Filiatrault.

> Grieving is a natural part of life. However, it is often experienced in private, over an extended period of time. I wanted to create a visual experience of the feeling of grief, and how it varies from moment to moment. This is an interactive piece of work with a working zipper that can be moved up and down to reveal or conceal the amount of grieving one is feeling at any one time. It is nonverbal, and yet communicates clearly. I also wanted to include the red fibers (symbol of the grieving) bubbling out at the top, because grief cannot be completely hidden, but bubbles up even when we do not want it to. The red fibers were purposely chosen for the fragility, softness and tenderness that are in the deepest part of ourselves.

(Quoted in Lauren Kingsland, ed., *Sacred Threads Exhibition 2015* [Rockville, MD: CQS Press, 2015], 216.)

Figure 3.30. Facing: *Homage to the Child's Bath*, Sally Barker, Hillsborough, North Carolina, 2014 2015. 19" × 24". Collection of the artist. Photo by Daniel L. Barker.

Using a variety of textured fabrics and quilting techniques, Sally Barker reproduces art, sometimes well known and sometimes not, originally done in other media, so that sight-challenged individuals can touch and experience a sense of the original work. She invented what she calls the Barker Code, where certain color are represented by certain fabrics; for instance, red is satin and flannel is yellow. The thickness of the batting represents how dark the color is; the thicker the batting, the darker the color. Barker has presented her work to audiences of sight-challenged individuals in schools and at conferences for those working with the sight-challenged. This piece is an homage to the famous work by Mary Cassatt in the collection of the Art Institute of Chicago, which gave permission to the artist to reproduce it.

(Vanessa Shortley, "Touch the Masterpieces: Local Creates Visual Art for Blind, Sighted Alike to Enjoy," *News of Orange County*, January 29, 2014, http://www.newsoforange.com/arts_and_entertainment/article _8f7923da-8903-11e3-84e2-0019bb2963f4.html.)

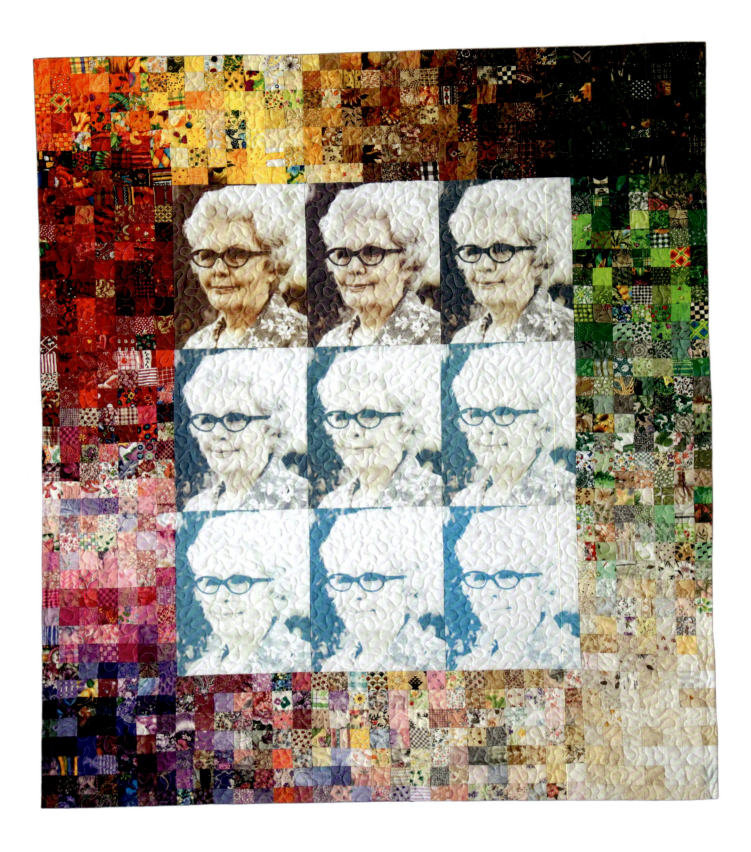

Figure 3.31. *Nevilyn*, Linda J. Huff, Algonquin, Illinois, 2006. 35" × 41". Collection of Michigan State University Museum. Photo by Pearl Yee Wong.

Linda J. Huff made this quilt in tribute to her grandmother, Nevilyn. Huff's story eloquently expresses both the impact of Alzheimer's disease on the individual and the value of the quilt to memorializing and recalling a loved one's life. The quilt was donated to the Alzheimer's Art Quilt Initiative to be sold at auction to raise funds for research on the disease.

In 1999 Grandpa died. Then Grandma was diagnosed with Alzheimer's. The woman who sits in the nursing home today has no memories of friends or family or the special things that she and her husband did especially for this time in her life. Nevilyn was once lively and vibrant. In the end only a ghost of her former self remains. There are 868 small squares in the border. They speak of so many things in my grandmother's life: the fabric that she worked with to make clothes and quilts, her attention to small details, her desire that things be done the "right" way, and her love of color. They also symbolize all of her memories, funny stories, sad times, the trips she took, and the things she has done. All the little pieces of her life are now lost to her forever.

(Quoted in Ami Simms, *Alzheimer's Forgetting Piece by Piece* [Flint, MI: Mallery Press, 2007], 32–33; Quilt Index http://www.quiltindex.org.)

Meaning and Agency of Quilts within Family Health-Care Traditions

Well-known twenty-first-century quilt artist Victoria Findlay Wolfe described an ordinary quilt that played a special role in her and her family's traditions of health care. Without the story, likely no one outside the family would know how deeply connected the quilt was to well-being in her family:

> It was nothing fancy, a red thin cut corduroy quilt with Indian cotton backing with a puffy, pulled cotton-batting fill, and we called it the "Sick quilt." Sick days took on a magical quality in our house, when I was a child. I'm not clear on how it started but whoever was the unfortunate one to be sick enough to stay home from school, got to snuggle up in the "Sick Quilt." And this excited us. . . . I remember laying on the couch with this puffy soft snuggle quilt over me, and my mother sitting next to me in the chair telling me to take a nap, and I'd dutifully lay there for the longest time with my eyes closed, and after a while, saying, "OK, I napped, can I watch T.V. now?" And she'd say, "Nope, go to sleep. . . ." How she knew I didn't nap, I'll never know, but I would then like magic, fall asleep snuggled in that fabulous quilt. Years later, after becoming a mom myself, I asked my mother if I could have the "Sick Quilt" to use in our home. She sent it out, and immediately, my daughter who has always been very particular about the softness of whatever touched her, claimed the quilt, which by now, is 40 some years old, and the thin Indian cotton was melting away from years of snuggles. So much for the family sick quilt!
>
> My daughter slept under the old sick quilt for at least ten years, with the batting falling out, and the rest of the fabrics starting to disintegrate. She insisted we put new fabrics around it, so we put it in to a duvet, and she continued to sleep under it until, finally, it only recently was folded up and set back in the closet . . . tattered and tired, but filled with memories![44]

Because Wolfe makes art quilts, those designed to be shown on walls, not beds, it was no surprise that when the original "Sick Quilt" was retired, she sought to make a new and uniquely designed one.

Figure 3.32. *Chicken Soup, Rest, GET WELL SOON*, Victoria Findlay Wolfe, New York City, 2008. 60" × 80". Collection of Victoria Findlay Wolfe. Photo by Victoria Findlay Wolfe.

> I was a newly obsessed quilter, and was playing along online with Tonya Riccuci's [a quilt artist contemporary of Findlay] challenges. And I thought, well, that Sick quilt is not going to last, having repaired it many times, so I jumped in to make a new one for my family. Tonya's challenge was to using words, jars, houses etc. . . . I started free form piecing a Nurse pouring medicine on her spoon, with her bottles of medicines, houses, crosses, Words that said, Chicken Soup, Rest, GET WELL SOON. I then went out and searched for the same red corduroy, and planned on hand quilting it, but found that that was not going to happen! And quickly machine quilted it. Through making the new Sick quilt, the family tradition is carried on. Since I make and sell my quilts, my daughter handed me a list of quilts that I can not sell. At the top of that list is the SICK QUILT. Thankfully, we, as a family, have been very healthy so far, and it has not gotten as much use as our original did. But she (The Nurse) sits folded, waiting at the ready to be there to wrap us up in love, good health and happy stitches if the need arises. It's a happy family tradition sewn into fabric, that makes being sick just slightly better, being wrapped up in the magic quilt. It works! I always feel better wrapping up in it. In fact, it makes me happy just knowing my daughter will keep it and use it for her family one day.

(Victoria Findlay Wolfe, email correspondence with authors, January 15, 2016.)

Quiltmaking as a Means of Maintaining Well-being

Quiltmaking is for many not only a way to achieve well-being in response to illness but also a way to maintain a sense of well-being and good health in the absence of illness or disaster. Artists in all types of fiber arts—crocheting, knitting, embroidery, quiltmaking, and more—share stories of how working on their craft helps them maintain a healthy life. The Slow Stitching Movement, developed to engage individuals in fiber arts to create mindfulness, is one organized manifestation of the realization of how centering on the work at the moment can be important to healthy living.[45] Fiber artist Lisa Binkley, for instance, describes how quilting is meditative, helping her to stay centered and able to cope with a fast-paced world:

> Since early childhood I have spent countless hours immersed in thread and beads and in stitching them onto fabric. Throughout my life I have also been a self-guided student of the natural world, the spiritual quest, and poetry. For tens of thousands of years and across much of the globe, others have shared these material and intellectual passions. Like me, they have sought to contemplate and celebrate life's questions and wonders through the slow process of hand stitching with beads and thread. As I carry on my part of this tradition, I work to create meticulously crafted art objects. Whether I stitch them by hand or by machine, I see these objects as forms of visual poetry. Through them I seek to speak to viewers quietly, reverently, and often whimsically of the mystery and beauty of our universe. . . . I love that the tools of my trade are so simple—needles, threads, fabrics, beads, scissors, and occasionally my sewing machine. The techniques are also fairly simple, and so the real challenge comes through the design process and the selection of beautiful, engaging materials from the amazing array available today. While I do create large art quilts, which are pieced, appliqued and quilted entirely on my sewing machine, I also love and couldn't live without hand work. Stitching thread and beads by hand is a meditative process, and it puts my mind in a great place. It forces me to slow down, to be present in my work, and to contemplate. What a great antidote to a culture full of ever-accelerating flash and speed.[46]

Figure 3.33. Facing: *The Quiet Place*, Lisa Binkley, Madison, Wisconsin, 2007. 26" × 36". Collection of the artist. Photo by Ed Binkley.

"While creating this quilt I was thinking a lot about the fact that the world, with all of its beauty, can also be loud and overwhelming at times. I think we all need a quiet place—either within ourselves or a physical space—in which to calm our minds and center ourselves. From that place, hopefully, we can go back out into the world and go about our lives and work with patience and joy."

(Lisa Binkley, artist statement and materials sent to Beth Donaldson, May 20, 2016.)

Figure 3.34. *It All Starts in the Water: The Five Elements in Flowers*, Anne Smyers, Reston, Virginia, 2013. 39" d. Collection of the artist. Photo by Karen Kohlhass.

Classical Chinese medicine has kept my family and me healthy for decades. It's based on the beautiful and elegant Five-Element Theory, which sees humans as an integral part of nature, and nature reflected in us. It seeks to balance our energies for optimum health and well-being. My quilt depicts the five elements in flowers, reflecting some of the many qualities specific to each element: Water (blue, winter, gestation), Wood (green, spring, power of growth), Fire (red, summer, power of maturity), Earth (yellow, late summer, ripening), and Metal (white, autumn, letting go).

(Quoted in Lauren Kingsland, ed., *Sacred Threads Exhibition 2015* [Rockville, MD: CQS Press, 2015], 103; see also http://annesmyers.com/it-all-starts-in-the-water-the-five-elements-in-flowers.)

Over and again, quilt artists speak of their awareness of the interconnectedness of making art and health and well-being. Jeanette Thompson expresses her mindfulness of the relationship of art production to health, particularly of the connections of mental health and manipulating materials into artistic products:

I believe all art making is important to health. Whether it is quilting, knitting, cooking, or gardening, we all need a tangible way to meditate using our hands. We all possess a need to transform materials, to create something unique, to work materials through our hands. There is something so satisfying to one's soul when a project is completed.

For me personally, the process of making a quilt connects to my mental health on many levels. As I work on the piece I lose track of time and space. This is how creating is like a meditation. As I work the physical material through my hands and sewing machine I get lost in thought. The experience of focusing on a single task, such as the rhythm of the sewing machine, or the cutting of pieces of fabric allow me to get lost in a world without stress. To be calm, focused, and centered for a duration of time helps my mind, body, and soul heal.[47]

Figure 3.35. *Primary Chairs*, Jeanette Thompson, Chicago, Illinois, August 2010. 22.5" × 29.75" (each). Collection of the artist. Photo by Jeanette Thompson.

"This series focuses on illustrating the many ways we can reformulate and recommit in response to change or loss in our lives. We find the strength to forge ahead, either through the love and encouragement of friends and family, our faith to maintain balance, or our own inner strength to anchor ourselves. All three pieces were made using repurposed fabric from men's shirts purchased at thrift stores" (Jeanette Thompson, email statement to Beth Donaldson, May 23, 2016).

Individual Agency and Well-being through Making Quilts for Others

Many individuals who make health-related quilts for others do so because they say it gives meaning and joy to their lives; quilting contributes to their own well-being at the same time that it contributes to the quality of life of those who receive the gifts of their handiwork. Most quilters volunteer their time as well as underwrite the purchase of needed materials such as fabric, thread, and batting. Some make the occasional quilt to give to those in need, but there are stories upon stories of individuals who have made hundreds of quilts. The artists, quilts, and stories included in this book are only a small sampling of an amazing output of generosity. Mary Edwards, for example, created more than two thousand quilts for newborn babies at Sheridan Memorial Hospital in Oregon City, Oregon, explaining that it "gave her a purpose in life and kept her out of trouble." According to hospital community relations representative Cecile Pattison, Mary "loved helping people and developed quite an affection for Sheridan Memorial Hospital and the people here. Over the years, hospital physicians, employees and volunteers periodically sent her fabric or monetary donations, but for the most part Mary purchased the materials for the quilts herself."[48] In a comment posted in an online article about her death, one reader noted the lasting impact that Mary's quilt gifts had on her own life: "I met Mary in January 2005 when my son received the first quilt she made for the babies in Sheridan. I remember the morning Mary presented it to my son. I knew it was special, but it holds much more than I ever expected. When my son passed away, I slept with the quilt and it gave me the peace I needed. Mary was and always will be an angel."[49]

Figure 3.36. Facing: *Radiant Light*, Doris A. Lovadina-Lee (designer) and Sandy Lindal (quilter), Toronto, Ontario, Canada, 2013. 54.50" × 68.50". Private collection. Photo by Doris A. Lovadina-Lee.

Radiant Light is the third in a series of chakra quilts I have created. Chakra is a Sanskrit word that means wheel of light. With Radiant Light, chakras are superimposed on a female figure, which honors the divine life force in women. These spiraling centers of vibrational energy channel the flow of energy up through our bodies. When this vital force flows easily, the body remains in physical, spiritual and emotional alignment/harmony. I wanted to portray a feminine spirit and vitality, creating an ethereal effect through color. This quilt serves as a reminder to us all to be nurturing of ourselves, to be present in the moment, and to be in tune with the creative life force within us.

(Artist statement submitted to Michigan State University Museum, March 30, 2016.)

Figure 3.37. *Step-by-Step*, Dorothy Ives, Portland, Oregon, 2003. 25" × 41". Collection of the artist. Photo by Kit Dunsmore.

We move through our lives step by step, through a continuous stream of nows, as intentionally as we choose. Spiritual growth happens where we allow it. The walking meditation possible within a labyrinth allows me to understand my intentions and approach living them. The geometry soothes me, centers my thoughts, and opens my mind to change. This labyrinth's "walls" consist of works that guide me—Thich Nhat Hanh's rendering of the five mindfulness trainings in his book, Being Peace. It could easily be whatever form and whichever feeds your soul.

(Artist statement submitted to Michigan State University Museum, April 20, 2016.)

In 2015 two sisters, Joyce Lynn, eighty-six, and Joann Bentz, eighty-four, of Powell, Wyoming, finished their one thousandth quilt over a period of a little over eleven years. As reporter Ilene Olsen noted:

> All 1,000 quilts have been, or soon will be, donated to hospitals and other organizations where they are given to children suffering from life-threatening conditions.
>
> Bentz and Lynn started the project jointly in July 2004 at Bentz's suggestion that they make "a few quilts" and send them to St. Jude's Research Hospital to comfort children who were being treated for cancer....
>
> But they soon found that..., "Once you get started, you just can't quit," Bentz said.
>
> ...
>
> Much of the fabric the sisters used in the quilts was donated... and some of the millions of yards of thread used to embroider and construct the quilts was paid for by three separate donations from the local Order of the Eastern Star.

The sisters cut, piece, add batting to, and machine quilt fabric that they embroider by machine; they keep "their embroidery machines running, with the aid of computerized designs, for six to eight hours per day.... Bentz's machine has more than 5,000 hours and approximately 131 million stitches on it, and the counter on Lynn's machine shows 4,322 hours and more than 113 million stitches. The machines were new when the sisters started their project." In a phone conversation with the sisters, they reported that they had made at least an additional one thousand quilts that they gave to many other individuals and organizations.[50]

Generosity and its association with purpose, well-being, and a connection to others is found in a great diversity of settings and levels of participation—from solitary artists, quilt guilds, and church groups to elementary classrooms and prison reform programs. Contrary to common wisdom, not all quilters have been quilting for a lifetime. Many start later in life, in response to an illness or difficult life event, and then discover that it's a tonic, a balm that satisfies multiple needs. The profile of quilters is as diverse as the quilts themselves. There seems to be no gender, education, ethnicity, or age limits on learning. Everett Drevs provides just one example of someone who doesn't fit the common stereotype of a quiltmaker. A retired community college biology teacher in Estherville, Iowa, he learned quilting from his wife, Teddy, in 1996 when she was diagnosed with non-Hodgkin's lymphoma and he was diagnosed with prostate cancer. Using fabric left by his mother and grandmother as well as the clothing of Teddy after she passed away, Drevs took up sewing and found it relaxing. He is now an avid quilter and a member of the local North Star Quilt Guild, which makes quilts for local hospice patients. Drevs also makes them for hospice patients on his own, because they helped his wife in her last days.[51]

Likewise, Nadine Kelly of Topeka, Kansas, took up quilting at age seventy-eight after her husband died. She joined a group of quilters at her church who have been making quilts for years to donate to Topeka North Outreach, a social service agency that provides food, quilts, and financial assistance to families in need. She was motivated in part by childhood memories of being cold at night. The solution was to put another blanket or quilts on the bed: "I can remember as a child when times were hard and we didn't always sleep well because it was cold, so I hope the quilts will help a lot." In testimony to the simple impact of quilts on one's

Figure 3.38. Sisters and octogenarians Joyce Lynn and Joann Bentz in a pile of some of the more than one thousand quilts they have made. Photo by Ilene Olson, *Powell (Wyoming) Tribune.*

mood, when in 2014 some of the group's quilts were on display in the church sanctuary before being donated, one of the quilters said, "We were proud to see them hanging there. . . . They are so pretty. It makes you smile to look at them."[52]

Whether they are lifelong or novice quilters, people find ways to engage in this creative art form and reap its healing benefits. They seek out existing outlets, and when opportunities are limited, they forge ahead on their own or create spaces where people can come together in community. When Leona Scharfenberg, age ninety, moved into the Homestead at Hickory View Retirement Community in Washington, Missouri, she was disappointed to find that they didn't have a quilting group, so she decided to start one. She transformed her apartment into a gathering place for the "Homestead Stitchers," a group of women ranging in age from seventy-five to ninety-five. They make and donate quilts to Grace's Place, an organization that offers no-cost child care for families during a crisis. One of the group members said, "It's volunteer work. It's just a way of living to do it. . . . That's what life is all about." Another said, "It feels really good. . . . There's satisfaction, and keeping busy and knowing you're doing something that's making a difference."[53]

Notes

1. Marsha MacDowell and Wolfgang Mieder, "When Life Hands You Scraps, Make a Quilt: Quiltmakers and the Tradition of Proverbial Inscriptions," *Proverbium: Yearbook of International Proverb Scholarship* 27 (2010): 130.

2. Michele Bilyeu, "The Healing Art of Sewing and Quilting," Michele Bilyeu Creates *With Heart and Hands*, http://www.with-heart-and-hands.com/p/quilters-who-make-difference.html.

3. Patricia Cooper and Norma Bradley Burferd, *The Quilters: Women and Domestic Art, An Oral History* (Garden City, NY: Anchor Press/Doubleday, 1978), 107.

4. Merrilee J. Tieche, artist statement in *Gallery—Sacred Threads 2013*, http://www.sacredthreads quilts.com/html/gallery2013.html.

5. Lisa Garlick, quoted in Michelle Lehnardt, "Quilts, Bees, and Lip Balm: Healing from the Loss of a Child," KSL.com, November 22, 2012, http://www.ksl.com/?nid=1010&sid=23051616.

6. Ibid.

7. Virginia Berger, October 26, 2011, comment on: "RE: re Polly's note on mourning quilts," Quilt History Listserv Archives, http://www.quilthistory.com/2011/289.htm.

8. Carol Gebel, October 26, 2011, comment on: "RE: qhl digest," Quilt History Listserv Archives, http://www.quilthistory.com/2011/289.htm.

9. Ibid.

10. Ibid.

11. Ibid.

12. Jeanne Henry, October 27, 2011, comment on "Re: wondering . . . ," Quilt History Listserv Archives, http://quilthistory.com/2011/289.htm.

13. Pat Kyser, October 26, 2011, comment on: "Re: Barb Vlack's mourning quilt," Quilt History Listserv Archives, http://quilthistory.com/2011/289.htm.

14. Mary Gold, "Why I Made My Late Husband's Shirts into a Quilt for Our Little Girl: Woman Spent 100 Hours Stitching a Touching Tribute so Her Ten-Year-Old Daughter Could Remember Her Father," *Daily Mail.com*, November 11, 2015, http://www.dailymail.co.uk/femail/article-3314471/Why-late -husband-s-shirts-quilt-little-girl-knew-harrowing-worth-hour-daughter.html.

15. Ibid.

16. Ibid.

17. Barb Vlack, October 25, 2011, "Mourning quilts," Quilt History Listserv Archives, http://quilt history.com/2011/289.htm.

18. Jane Johnson, Quilts and Health form submission, January 28, 2016.

19. For instance, see Linda Giesler Carlson, *Quilting to Soothe the Soul: Create Memories for Today, Tomorrow & Forever* (Iola, WI: Krause Publications, 2003); Lesley Riley, *Quilted Memories: Journaling, Scrapbooking & Creating Keepsakes with Fabric* (New York: Sterling/Chapelle, 2006); and Sherri Lynn Wood, *Passage Quilting*, http://www.passagequilts.com/process.html.

20. Linda Sophiasworth, "Profile," *Etsy*, https://www.etsy.com/people/lcsrn927?ref=owner_profile _leftnav.

21. Linda Sophiasworth, "Memory Quilt from Dad's Shirts," Worthquilts, *Etsy*, https://www.etsy.com /listing/91887855/memory-quilt-from-dads-shirts?ref=shop_home_active_20.

22. Wood, *Passage Quilting*. See her blog, *Daintytime*, www.daintytime.net.

23. Wood, *Passage Quilting*.

24. Lauryn Martin, *Memory Quilts by Lauryn Martin*, http://laurynmartin.com/memory-quilts-2 /in-memory-of-quilts.

25. "ETX Woman Quilts together Memories," KLTV.com, March 21, 2013, http://www.kltv.com /story/21754849/ext-woman-quilts-together-memories.

26. Ibid.

27. Sharron K. Evans (October 25, 2011), "RE: re: Polly's note on mourning quilts," Quilt History List-serv Archives, http://quilthistory.com/2011/289.htm.

28. Marilyn Anderson, "Area Women Transform Shirts into Quilts in Memory of a Friend," *News Record*, February 18, 2015, http://www.zumbrota.com/articles/2015/02/18/area-women-transform-shirts-quilts-memory-friend.

29. Ibid.

30. Marla Powers, *Oglala Women: Myth, Ritual, and Reality* (Chicago: University of Chicago Press, 1986), 139.

31. Ollie Napesni, interview by Yvonne Lockwood, East Lansing, Michigan, November 23, 1996.

32. Joanne Hindman, "Witness to Fatal Ithaca Crash Turns to Quilting after Trauma," *Ithaca Voice*, September 21, 2015, http://ithacavoice.com/2015/09/witness-to-fatal-ithaca-crash-turns-to-quilting-after-trauma.

33. Ruth White, artist statement, submitted to Beth Donaldson, Clare Luz, and Marsha MacDowell, March 15, 2016.

34. Ibid.

35. Karen B. Alexander, November 5, 2011, "Quilts and Passages," Quilt History Listserv Archives, http://quilthistory.com/2011/295.htm.

36. Marsha MacDowell, personal observation at funeral service for Helen Claire Vlasin, East Lansing, Michigan, December 4, 2012. In honor of Claire's life work, her husband, Raymond, underwrote research for the development of the Quilt Index Legacy Project, which enables collections of quilts made or owned by individuals, along with photographs and biographical information about the individual, to be placed into the Quilt Index. The Claire Vlasin Quilt Legacy Collection was the first to be presented.

37. Kathleen Neiley, email to Beth Donaldson, December 23, 2015.

38. Ibid.

39. Karen Mowinski, *Inspired by Pain*, http://www.allianceforamericanquilts.org/projects/galleries/Inspired%20By/1-6-2EA/Inspired%20By%20Pain; and Quilt Index, http://www.quiltindex.org/basicdispaly.php?kid=1-6-2EA.

40. Candace Chase, "Woman's Near-Death Experience Leads to Success in Quilting World," *Daily Inter Lake.com*, September 26, 2012, http://www.dailyinterlake.com/members/woman-s-near-death-experience-leads-to-success-in-quilting/article_0b1ac438-078e-11e2-b41d-001a4bcf887a.html.

41. Ibid.

42. Jen [no last name given], October 26, 2011, comment on: "RE: qhl digest," Quilt History Listserv Archives, http://www.quilthistory.com/2011/289.htm.

43. Elizabeth Hendricks, artist statement in Alissa Norton, ed., *One Quilt, One Moment: Quilts That Change Lives* (Golden, CO: Primedia Consumer Magazine & Internet Group, 2000), 35.

44. Victoria Findlay Wolfe, email correspondence with authors, 2016.

45. Slow Stitching Movement, https://theslowstitchingmovement.wordpresscom/2014/06/10/welcome-to-the-slow-stitching-blog.

46. Lisa Binkley, artist statement and materials sent to Beth Donaldson, May 20, 2016.

47. Jeanette Thompson, email communication to Beth Donaldson, May 23, 2016.

48. Brad Estes, "Grandma Mary: A Quilt for Every Baby at Sheridan Hospital," *Sheridan Media.com*, March 31, 2012, http://www.sheridanmedia.com/news/grandma-mary-quilt-every-baby-sheridan-memoria128502. Also Cecile Pattison, "Grandma Mary Was Our Hospital Angel," *Sheridan Press*, March 31, 2012, https://www.sheridanhospital.org/documents/GrandmaMary3-31-12.pdf.

49. Pegsweber, March 31, 2012, comment on Estes, "Grandma Mary."

50. Ilene Olson, "Quilting Sisters: 1,000-Quilt Goal Reached," *Powell Tribune*, December 29, 2015, http://www.powelltribune.com/news/item/14370-quilting-sisters-1-000-quilt-goal-reached.

51. Mike Kilen, "Widower's Quilts Piece together Family Stories," *Des Moines Register*, April 20, 2014, http://www.desmoinesregister.com/story/life/2014/04/19/everett-drevs-quilts/7907693.

52. Phil Anderson, "Church Makes Quilts for North-Side Agency," *Topeka Capital-Journal*, December 14, 2014, http://m.cjonline.com/news/2014-12-14/church-makes-quilts-north-side-agency.

53. Karen Butterfield, "Homestead Stitchers Delight in Donating Handmade Quilts," *Missourian*, May 6, 2013, http:/www.emissourian.com/more_news/senior_lifetimes/article_eb65d4.

four

Public and Collective Quiltmaking for Health and Well-being

Thousands of quiltmakers—whether as individuals or as members of quilt guilds or faith-based organizations—have joined with others to make what is broadly termed "charity" or "service quilts" to provide material and emotional comfort to those in need and to raise awareness about or funds for causes, including those related to health and well-being. Organized quilt projects target needs that cover nearly every imaginable situation in which quilts can provide emotional and physical comfort. There are quilt projects designed for survivors of human-made or natural disasters and for victims in emergencies such as domestic violence situations, fires, or car accidents. Whether the need is local or far away, quiltmakers are using their time and skills to address the needs of others who are hurting.

Often these projects are linked to assistance efforts spearheaded by veterans organizations, religious organizations, medical professional organizations, groups of illness and trauma survivors, and patient advocacy and health education groups. This collective action is massive in terms of the numbers of quilts made, individuals comforted or educated about issues, and dollars raised for health needs. Such work underscores the magnitude of the impact of disaster, trauma, and disease not only on the individual but also on society as a whole.

Quilts and Comforting on Both Local and Global Scales

Twenty-first-century fiber artist Linda S. Schmidt sees this realm of quilting activity as a form of "resistance against mass production, shoddy workmanship, and an uncaring world."[1] In an extended essay on her website, she eloquently describes the work of what she terms "resistance quiltmakers":

> My quilt guild, and your guild, and guilds all over the world are putting little scraps of leftover fabric, brand new fabric, stolen time and scavenged batting together to make quilts for people who need to have something given to them made by caring hands that they can call their own, when all else has been taken from them, even their dignity. Our guilds give these quilts to people who are on the run from abusive spouses and intolerable living conditions, suffering from terminal illness, or are carrying their few possessions in garbage bags. We are making AIDS quilts and cancer quilts, preemie baby quilts, lap quilts, Quilts of Valor, and raffling quilts to make money for the poor and forgotten ones. We're out there, all over the world, doing our best to put the mes-

sage out that there are still caring people in the world; people who know the importance of people helping other people, people who know about quilts.[2]

Schmidt realizes that her own individual action and her point action with others in making quilts for causes has the potential to make a difference. In describing a quilt she made to advocate for peace, she said:

> Like many people, I am a person that has never marched in a peace rally or stood up to be counted or ever really took a stand on anything that meant commitment to a cause. . . .
>
> I got to thinking—what if everybody did? What if every person who *could* do something, *did*? Something, *anything*, to help bring about peace in our time. I'm not good at a lot of things, but I can make quilts."[3]

Like tens of thousands of individuals around the world, Schmidt has made quilts for causes, including health and wellness, about which she is passionate.

History and Growth of Charity or Service Quiltmaking

It was in nineteenth-century America that women really began to collectively mobilize their needle skills toward the needs of others outside of their own domestic households. It was a period in which the upper- and middle-class notion of a woman's realm (in which women were expected to operate only within a domestic sphere and their work was deemed of low value) was gradually diminishing, manufactured cloth was more readily available, households were no longer dependent on creating their own textiles, and opportunities were increasing for women to gain education and be engaged in meaningful work outside the home.[4] With the advent in America of the second Great Awakening, the religious revival that swept the nation, women were able to find positions of leadership and influence within their religious communities and actively formed and managed missionary, ladies aid, and auxiliary societies.[5] In these new societal contexts, women began to make textiles for causes, whether local or global, that had meaning to them personally or to the groups to which they belonged. The majority of the textile work was done by individuals within their own homes and then shared with others through organized efforts. Much of this early "textiles for good" activity was church-affiliated, and members of religious-based societies made clothing for the poor, socks and bandages for soldiers, or quilts that could be given to the needy or sold to raise funds for the societies' identified local and world causes.[6]

The Civil War prompted perhaps the first large-scale organized efforts in which quilts prominently figured. As many as seven thousand Ladies' Aid Societies were formed to raise funds and provide supplies for the Union Army. By 1862 many of these groups were organized under umbrella organizations, often called "commissions," with the United States Sanitary Commission the largest. Specific calls were made for sheets, comforters, and quilts needed in the battlefields and hospitals, and it is estimated that over 250,000 quilts, both newly made and family heirlooms, were donated to support the commission's activities.[7] Many of the quilts went directly to soldiers; other were used in fund-raisers. The dollars raised by the sale of those quilts exhibited at commission fairs were tremendous and underwrote major needs of the Union Army. Meticulous records were kept of the source and value of items made for

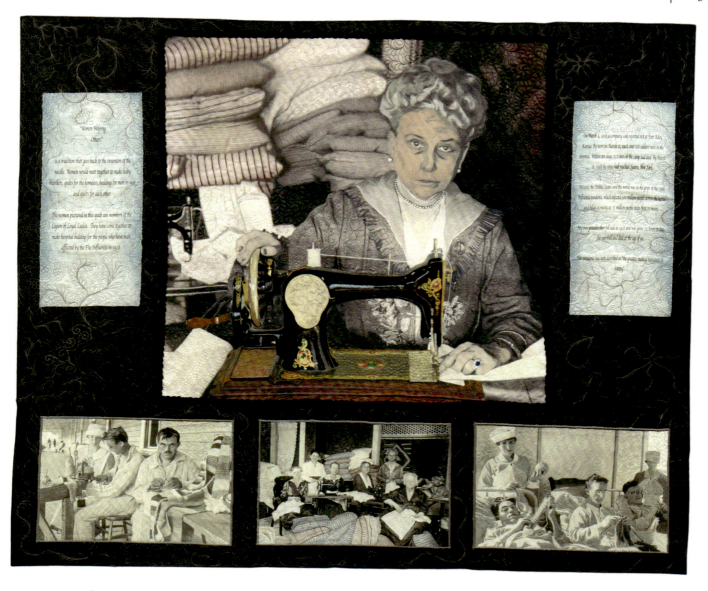

Figure 4.1. *Women Helping Others*, Jennifer Day, Santa Fe, New Mexico, 2014. 59" × 50". Collection of the Michigan State University Museum. Photo by Pearl Yee Wong.

The women pictured in this quilt are members of the Legion of Loyal Ladies. They have come together to make hospital bedding for the people who had been afflicted by influenza in 1918. On March 4, 1918, a company cook reported sick at Fort Riley, Kansas. By noon on March 11, 1918, over 100 soldiers were in the hospital. Within ten days, 522 men at the camp had died. By March 18, 1918, the virus had reached Queens, New York. In 1918, the United States and the world were in the grips of the 1918 influenza pandemic, which infected 500 million people across the world and killed as many as 25 million people in its first 25 weeks. My own grandmother fell sick in 1918 and was given 24 hours to live. She survived and died at the age of 96. This pandemic has been described as "the greatest medical holocaust in history."

The photographs at the bottom of the quilt are men in recovery at Walter Reed Hospital. (Jennifer Day, "Women Helping Others," *Jennifer Day Thread Stories*. http://www.jdaydesign.com /artquilting/women-helping-others.)

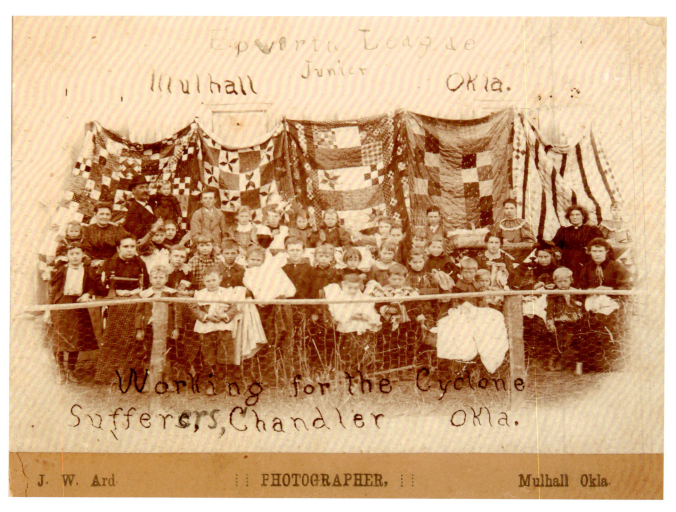

Figure 4.2. Members of the Epworth Junior League, a young persons' service organization of the Methodist Episcopal Church, in Mulhall, Oklahoma, display the quilts they made for the sufferers of a devastating tornado in 1897 in Chandler, Oklahoma. Photo by J. W. Ard, courtesy of Janet E. Finley. (See Janet E. Finley, *Quilts in Everyday Life, 1855–1955* [Atglen, PA: Schiffer Publishing], 2012, 85.)

or donated to the fairs. Based on those records, one estimate valued women's overall contributions made through the Commissions at $25 million.[8]

A little over fifty years later, during World War I, quilts again figured into wartime efforts to provide warmth and comfort to those serving in the military and to raise funds that were critical to caring for wounded soldiers. Quilt historian Sue Reich reports, "In December, 1917, *Modern Priscilla* magazine responded to President Wilson's call for increased fundraising for the war effort. The magazine encouraged a Quilt Campaign be conducted using the Red Cross pattern in order to raise approximately $1,000 for the purchase of ambulances, emergency equipment and yarn for the war effort. By paying a small sum of money, your name would be signed on the quilt. The quilt would then be raffled to increase the monetary take."[9] Red Cross organizations in several countries promoted the making of such quilts, and thousands of them were made, usually rendered in red-and-white quilt patterns, often with a red cross, and, in the white sections, covered with names of magazine subscribers embroidered in red thread.[10] During World War II the tradition of sending quilts to soldiers endured; although the exact number is not known, it was clearly in the thousands. One newspaper account, reported that "in just one six-week period during the fall of 1944, the Canadian Red Cross sent 25,000 quilts to Britain and Europe."[11]

By the twentieth century, making quilts for both local and global causes had become commonplace across the United States and in many other countries where quiltmaking was popular. Charity quiltmaking activity continues today. When a disaster occurs or assistance is needed for a particular cause or individual, whether in one's own community or far afield, quilters employ their needle skills to make a difference. While individual quiltmakers contribute directly to these efforts, more often they are members of committees of charity quiltmakers within larger quilt guilds or affiliated with church groups. Names of groups often bear testimony to the intentionality of the makers: Comfort Quilters, Hug Quilters, Hopes and Dreams Quilters, and Forever Warm are but a sampling. Patricia E. Brown, who started Comfort Quilters, relays the impact such charitable gifts can have, indicated by the feedback and requests the group receives. She notes that they have received requests as far away as Poland and says she has been told of cancer victims who asked to be buried with their quilt because they were so touched by the gift.[12]

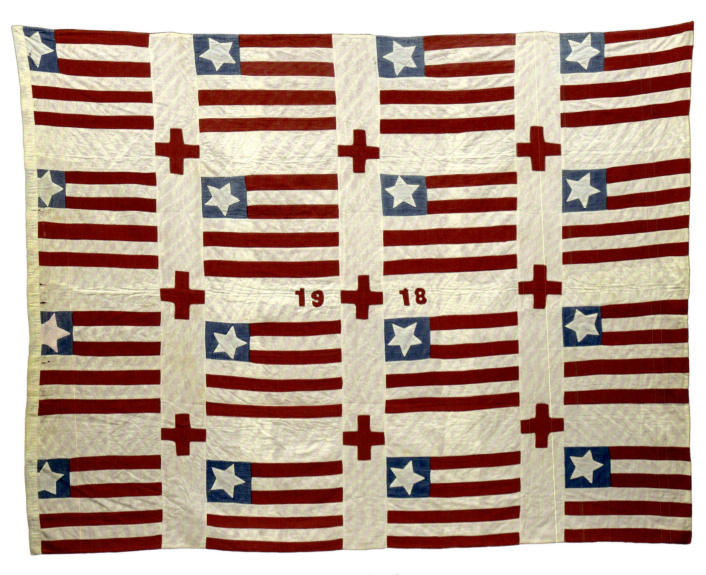

Figure 4.3. Red Cross Quilt, maker unknown, 1918, 77" × 62".
Collection of Michigan State University Museum. Photo by Pearl Yee Wong.

A note pinned to the quilt when the MSU Museum acquired it reads "Made in Ionia [Michigan] in 1918 for a fund drive to help raise money for the American Red Cross" (Quilt Index, http://www.quiltindex.org).

Figure 4.4. In this black-and-white photo (c. 1917–1918), young volunteers pose with two quilts of alternating light and dark colors, likely Turkey Red and white. The girls were members of what they called the Soldiers' Friends Club. Because their uniforms are suggestive of Red Cross workers, it might be surmised that their sewing was destined for the World War I support effort. Photo by Charles Osgood, Osgood Photo Supply Co., Galesburg, Illinois, courtesy of Janet E. Finley. (See also Janet E. Finley, *Quilts in Everyday Life, 1855–1955* [Atglen, PA: Schiffer Publishing], 2012, 163.)

Charity Quilting in the Age of the Internet

The growth of the Internet has helped to catapult the number of individuals and the number of organizations involved in charity quiltmaking. Electronic communications facilitate the quick identification of needs and the creation of new organizations to address any need from anywhere. In addition, the Internet has enabled the formation of strategies to recruit makers for specific causes and to get quilts expeditiously delivered from artists to those in need. Online resources for charity quilt projects have made it easy for individuals to find not only projects to which they would like to contribute quilts but also free patterns and tutorials for making quilts that are specific to the cause.[13] The Internet facilitates the spread of variations of charity quiltmaking, such as providing information on forming interfaith prayer quilt ministry groups; as a result, some groups, such as Prayers & Squares, have become international, interdenominational ministries with local church-based chapters.[14] Organizations such as Quilt for Change use the Internet to connect quiltmakers to a variety of global issues, especially those that affect women, and facilitate the quiltmakers' becoming "agents for social change."[15] The Disaster Quilting Project serves as a clearinghouse for information on individual and organized groups of quiltmakers who are what they call "disaster quiltmakers," those who are largely unrecognized crisis responders and who "support closer working relationships in future between disaster managers and humanitarian relief organizations active in disasters and community-based sustained quilting networks."[16] The impact of the Internet on quiltmaking has been tremendous as notions of tradition, community, aesthetics, and meaning have expanded, strengthened, and reconfigured quickly over time and space. This impact has begun to be explored by those interested in folklore, history, sociology, technology, communications, and women's studies.[17] As scholar Jessica Haak suggests, "Quilting is a fertile ground for exploring socio-historical issues related to women in society as they are shaped by greater access to online tools and environments."[18]

Collective Quiltmaking to Support Health and Well-being Causes

In thousands of communities in the United States it is highly likely that there is at least one individual and often a group of individuals who are making quilts for charitable, health-related purposed. Time and again there are newspaper accounts of groups making hundreds of quilts annually for their favored causes. This work is supported not only by the volunteer efforts of the makers but also by funding from guild membership fees. Other community members and businesses often supplement the cost of making the quilts by donating used clothing, fabric, batting, thread, and other supplies or providing assistance in shipping finished quilts to distribution centers used by larger quilt projects. Still, many quilts are simply underwritten out of the makers' own pockets and volunteer time. Given that even a small quilt in a simple block pattern might require cash expenditures of at minimum one hundred dollars and an in-kind contribution of a minimum of sixty hours of labor, the contributions quiltmakers are making to various causes is remarkable.[19] The direct financial impact of these local efforts on local and global health services is notable, as these sample stories, drawn from hundreds, attest.

In the late 1960s a small group of Marquette, Michigan, women came together to make quilts for the needy. Initially, they made about 25 a year. Today the Messiah Quilters ship about 700 quilts a year by boxcar to the Lutheran World Relief distribution center and make quilts for local organizations, charities, and fundraisers. As of October, 2003, they had completed 11,233 quilts.

Although most efforts such as these go relatively unnoticed outside their communities, the Messiah Quilters were honored in 2004 with a Michigan Heritage Award.[20]

Another group of quilters in Provo, Utah, meets regularly with a similar purpose:

Each week for more than four decades, the Retired Senior Volunteer Program (RSVP) quilters have been meeting to bind quilts to earn money for medical supplies or services for Utah State Hospital patients who can't afford them.

Every penny they make goes toward medical expenses.

Last year the group spent more than $4,000 to buy wheelchairs, diabetic shoes and hearing aids. They also donated money to the Forgotten Patients Christmas Project, which pays for Christmas presents for patients who have no family.

If there were no quilting group then many patients wouldn't have the supplies they need. Last year alone, they paid for 19 pairs of glasses.

"We love to quilt but the companionship and the fact that we do something good, well, that's just a bonus," said Delora Blanchard."[21]

Since 2000, a small group of local women in Ohio, who call themselves the Quilting Crew, has annually created a homemade, queen-size quilt to raffle off in order to raise funds to provide free mammograms for area women and men who otherwise might not have access to or can't afford the screenings, each of which is estimated to cost between $85 and $150. Each year the raffle has realized about $4,000 (over $60,000 in a fifteen-year period) that has been donated to the Fisher-Titus Medical Center of Norwalk, Ohio, to provide the screenings. For two members of the group who have had breast cancer, the activity has personal resonance. As Pat Scheid said, "This year, as I was designing and piecing the quilt, it became a path toward healing for me."[22]

The number of quilts made by groups and the amount of funds raised, sometimes on a yearly basis, is impressive. Many quiltmakers target services and equipment that especially pertain to women and children with these fundraising efforts:

Tucson quilters, under the leadership of Jeannie Coleman . . . and with the support from the Tucson Quilters Guild, Inc., first organized a "Quilt for a Cause" fundraiser on the Tucson Medical Center campus on November 15, 2003. Quilters throughout the state of Arizona as well as quilters in California and other western states donated a total of 208 handmade quilts that were auctioned to raise $53,000.00. The proceeds were divided evenly between two Tucson 501c3 organizations: The American Cancer Society and the Tucson Medical Center Foundation's Joel Childers M.D. Fund.

In 2006, we did it again. Overall, 545 donated quilts raised approximately $120,000; expenses were kept to less than 1%. The Women's Division of the Cancer Center at

Figure 4.5. *"Hope Is . . . ,"* Lauren Kingsland, Bethesda, Maryland, 2015. 50" × 60". Private collection. Staff photograph, courtesy the Children's Inn.

At the Children's Inn (TCI) at the National Institutes of Health, resident artist Lauren Kingsland works with young patients in the creation of quilts that convey what is happening at TCI. These quilts are then auctioned off at a live auction at an annual fund-raising gala. and as of 2015 over $300,000 in proceeds from the auction have benefited the work of TCI (Lauren Kingsland, email statement to Marsha MacDowell, February 15, 2016).

UMC received $63,000 with funds restricted for breast & gynecological cancer research. The Tucson Medical Center Foundation received $55,000 for a digital specimen radiography system and $8,000 to help uninsured women under 40 who have had a mastectomy with breast surgery construction. . . .

The success of these auctions could not have been successful without the generosity of everyone involved.[23]

For the 2016 auction, Senator Gabby Giffords donated some of the many quilts she received from others while healing from gunshot wounds suffered in an attempted assassination.[24]

In 2006 when Tamera Ehlinger was managing Quilted Expression, a fabric shop in Lynchburg, Virginia, she initiated a community quilt project, based at the shop, to benefit a local hospice. By 2015 the project, now called Rainbow of Hope, had raised over $400,000 to support the hospice needs. Many of the quilts donated to the annual auction are made by individuals who themselves have endured health challenges or have had close friends and families who needed hospice care.[25]

Likely the numbers of quilts made or dollars raised don't always get recorded in the minutes of quilt guilds, project reports, or news accounts. By extrapolation from just a few projects, it is clear that millions of quilts are being annually made for causes and that this work provides millions of dollars of in-kind and direct support for health needs.

Exhibitions of Health-Related Quilts

Individuals who make quilts as intentional artistic personal expressions often seek ways to publicly show their work to others. It is yet another way to raise awareness of various illnesses and causes, and for the community at large to participate in a community of quilters. They present their work in online galleries on their personal websites or blogs, in online group shows, in quilt expositions, and in art galleries and museums. There has been a rise in the development of entire exhibitions of health-related quilts organized by hospital auxiliary groups, medical and health-care professionals, art quilt associations, patient advocates and educators, or individuals who are passionate about the connections between art and well-being. For instance, in 2009 sixteen quiltmakers responded to a call from the U.S. Mission to the United Nations in Geneva, Switzerland, to make quilts on the theme "Making a Healthier World for our Children" to help promote the work of the Global Fund in addressing AIDS, tuberculosis, and malaria. The quilts were shown at the European headquarters of the United Nations in Geneva and have subsequently been shown at quilt festivals in the United States.[26] The Studio Art Quilt Associates has organized juried exhibitions of health-related quilts, such as "Metaphors on Aging" and "I'm Not Crazy."[27] One group of artists, Fiber Artists @ Loose Ends, coordinates a program called Healing Quilts in Medicine in which member artists create quilts on different themes such as diabetes, cancer, or the use of plants in healing and wellness. The exhibitions are shown in medical institution contexts, and all are aimed at "making a difference in the lives of patients and their families."[28] Some exhibitions of quilts are intentionally showcased in community locations where people congregate every day such that expanded or new audiences are made aware of health issues. For instance, social work graduate student Adelina Tancioco organized the production of a mental health wellness quilt as a community art project. The quilt then toured to many

Figure 4.6. Left: The fall 2015 production of charity quilts packed and ready to deliver, made by the Black Gold Quilt Patch Guild of Leduc, Alberta, Canada. Photo by Cecile Sigfuson.

Figure 4.7 and Figure 4.8.
Above and right: Charity quilts made for Operation Snuggles by quilt guilds in southeast Wisconsin. Photos by Barbara Vallone.

Figure 4.9.
Concord Piecemakers Quilt Guild of Middlesex, Massachusetts, February 2013, at their annual Quilt-a-Thon. Photo courtesy of Sheila Macauley.

different venues in San Francisco's East Bay area to build awareness of and empathy for those with mental health challenges, and to encourage them to get the help they need.

Groups of quiltmakers who make charity quilts often temporarily display their work at their meeting places or local churches, libraries, or other community centers before the quilts are given to the intended individual recipients or to the organizations that in turn will distribute them. Many images can be found in newspaper accounts or on the Internet of quilts displayed informally draped over church pews or hung on clotheslines or over fence rails. Makers, members of the group the makers belong to, and members of the general community are able to see the quilts and these public displays, especially when accompanied by presentation ceremonies. These are often occasions when the quiltmakers receive informal and formal appreciation for their art and the charity activity in which they are engaged.

Quilts made for charitable purposes are public declarations of political stances, values and beliefs, and priorities of philanthropic action, and, following Matthew 7:16—"by their work they shall be known"—quiltmakers find agency and recognition in their work.[30] Women's studies scholar Karen Smith has commented on the politics of public displays of quilts:

> Though quilts are utilitarian in origin, their circulation and display take them far beyond the home—to art galleries, history museums, state fairs, quilt shows, and philanthropic auctions. As they move, individuals and institutions make significant intellectual and emotional investments in how quilts are classified, judged, and valued. In this highly politicized work, individuals and institutions shape public culture through debates about quilts' utility, workmanship, and aesthetics; they create and display quilts to further their cultural heritage, manifest their faith, delineate aesthetic values, reinforce disciplinary boundaries, and elevate their artistic status.[31]

Through the displays of charity quilts, whether it be in local contexts or in exhibitions that tour to widespread venues, the quiltmakers, exhibition organizers, staff of exhibition venues, and the media that write about these displays make strong statements of the aesthetic, social, political, educational, and cultural value and meaning of the work.

Quilt Projects Devoted to Specific Health Issues

Perhaps the best-known public display and health-related quilt project is the NAMES Project Foundation's AIDS Memorial Quilt, which is intended to "foster healing, heighten awareness, and inspire action in the struggle against HIV and AIDS."[32] Often referred to as the world's largest quilt, it consists of over 48,000 panels sewn into blocks of eight; when spread out on the ground, the panels form an enormous quilt that is 1.2 million square feet (over 110,000 square meters) and weighs more than fifty tons.[33] Each panel, made sometimes by just one person or by a group of individuals, is 3' × 6' (the approximate size of a grave) and represents at least one person, often someone who died of AIDS. Sections of the quilt are loaned out, especially on December 1, World AIDS Day, to organizations around the world to continue bringing attention to this pandemic. Digital images of the panels along with associated stories are being made available through the Quilt Index, and new tools such as AIDS Quilt Touch are providing new ways for individuals to not only access the images and stories but to also contribute new stories and to use the quilt in new ways for education.[34]

Figure 4.10. The AIDS Memorial Quilt (The Quilt), collection of the NAMES Project Foundation. Photo courtesy the NAMES Project Foundation.

Perhaps lesser known but also sizable are numerous other projects that have recorded thousands of quilts made for health and well-being or have used quilts to raise thousands of dollars for health organizations, research, and education. For instance, Project Linus is a nonprofit organization that brings handmade blankets to children in need. Since 1995 the organization has grown to four hundred chapters nationally (in all fifty states) and many international locations; as of February 2016, volunteers have made and donated nearly six million quilts.[35] Quilts for Kids is another nonprofit organization that engages volunteers in making over thirty thousand patchwork quilts "to comfort children with life-threatening illnesses, children of abuse, and children living at poverty level and below."[36] Photographs and stories of recipients on the organization's website attest to the profound comfort that these quilts provide children and their parents. In 1987 Ellen Ahlgren founded ABC (At-Risk-Babies and Children) Quilts, at the height of the AIDS epidemic, to give comfort to infants born with AIDS. The first six quilts she gave away carried a label reading "with love and comfort to

Figure 4.11. Quiltmaker Jackson Cloyd and his father, Myron Cloyd.
Photo by Craig Hartley, for the *Houston Chronicle*.

In order to fulfill his community service requirement to become an Eagle Scout, thirteen-year-old Jackson Cloyd of Houston, Texas, began to make quilts for premature babies at Guy's Hospital in London, England, where he, as a premature baby himself, was born. While monitoring his precarious development, in the hospital's neonatal unit, his parents stayed next door in a Ronald McDonald House, where they were presented with a baby quilt made by Mary Mulkerrins, a midwife and social worker. Jackson's mother, Gwendolyn, died of cancer, and her son knew that the quilt was one of his mother's treasures and that by making quilts for other babies, he would honor her memory. Members of the Jubilee Quilt Circle at the Community Artist's Collective in Houston taught Jackson the sewing skills he needed and when he had finished eight tiny quilts, he and his father Myron flew to London and presented the quilts to Mulkerrins. On each quilt Jackson put a label that says "From One Preemie to Another" (Elizabeth Pudwill, "Scout's Small Effort Has a Huge Impact," *Houston Chronicle*, March 21, 2014; see also Wimp.com, "Preemie Baby Nearly Dies But Returns to the Hospital 13 Years Later to Repay a Kindness," http://www.wimp.com /preemie-baby-nearly-dies-but-returns-to-the-hospital-13-years-later-to-repay-a-kindness; Kevin Reece, "1 Pound 10 Oz. Miracle Pays It Forward One Stitch at a Time," *KHOU11News*, March 17, 2014, http://www.quiltersclubofamerica.com/forums/p/46409/619912.aspx).

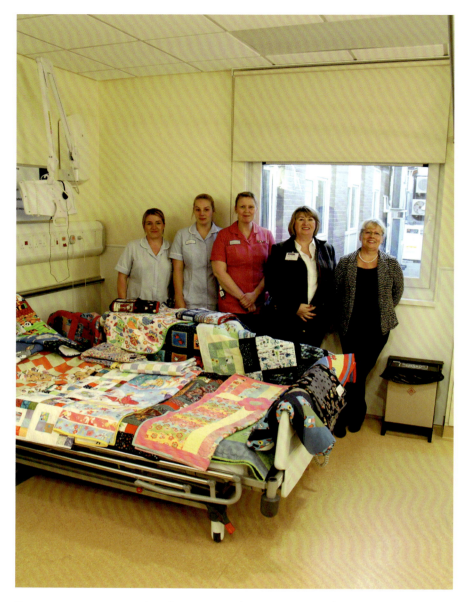

Figure 4.12. Marjorie Cook and Irene Carter (pictured with staff) donating quilts. Photo by John Hugill, communications assistant, North Tees and Hartepool, National Health Service (NHS) Foundation.

Marjorie Cook and Irene Carter from Project Linus (pictured with staff) visited the children's ward and the neonatal unit at the University Hospital of North Tees to donate 42 quilts.

The not for profit group accepts donations of quilts and blankets, then supply these to sick or disadvantaged babies and children.

Marjorie, the coordinator for the Stockton on Tees branch of Project Linus, said: "Project Linus is a volunteer organisation, where we aim to provide a sense of security to sick and distressed children across the UK through the provision of homemade patchwork quilts. All of our quilts are donated and lovingly made by the local residents and distributed to the local community.

"It's fantastic to know that these quilts will be given to these brave children who will really appreciate them."

(North Tees and Hartepool NHS Foundation Trust, "A Quilt Is a Hug You Can Keep," November 12, 2015.)

you." Thousands of individuals quickly joined Ahlgren, and in 2006 the organization American Mothers adopted the project as their own. As of 2016 over five hundred thousand quilts have been delivered to babies and children deemed at risk; some are born with AIDS or are HIV positive, others have been abandoned or affected by a parent's drug or alcohol abuse.[37] The Wrap Them in Love Foundation, a nonprofit, tax-exempt organization created in 1999, is another effort through which hundreds of quilts have been collected and distributed to children of all ages. Their website states what so many other project leaders and individual charitable quiltmakers believe: "A quilt is a very special thing. It isn't just a blanket; it has been lovingly created by a real person. A quilter leaves a part of themselves in every quilt they make. The child [or person of any age] who receives it will be able to snuggle up in all the love and comfort that comes in that quilt.[38]

Hundreds, if not thousands, of individual church-based quiltmaking groups in communities make quilts for charitable purposes but two large organized religious groups have major quiltmaking initiatives that have widespread engagement and international impact. Each year quiltmakers across the United States donate an average of four hundred thousand mission quilts to the Lutheran World Relief (LWR) to be distributed to overseas partners. In 2013 nearly five hundred thousand quilts were donated to the LWR Quilt Campaign and sent to partner organizations around the world that had requested them; even that many quilts did not meet all of the requests.[39] Donors can even print out a special bar code to put on their shipment and then track where their quilts are sent.[40] Annual relief sales featuring quilt auctions raise hundreds of thousands of dollars for relief efforts of the Mennonite Central Committee through members making and auctioning off quilts.[41] During their research for the

Figure 4.13. Quilts bundled for shipping overseas at the Lutheran World Relief warehouse. Photo by Bernhard Gallant for Lutheran World Relief.

Figure 4.14. The total amount realized by quilt sales at the fifty-ninth annual Pennsylvania Relief Sale Quilt Auction was $112,860. Photo by Kelsey Weaver (Pennsylvania Relief Sale, "2015 Quilt Auction Photo Gallery," http://pareliefsale.org/auctions/2015-quilt-auction-photo -gallery; see also http://pareliefsale.org/auctions).

Mennonite Relief Sale Quilt Project, Marilyn Klaus and Sharon Sawatzky tracked amounts raised by individual quilts as well as overall number of donated quilts at many relief sales in the mid-2000s. One quilt alone brought in over $44,000 at the 2003 Ontario Mennonite Relief Sale.[42] In 2015 the Pennsylvania Relief Sale donated $478,000 to the Mennonite Central Committee.[43]

Many of the health-related quilt projects are associated with specific illnesses or diseases, and it is difficult to find a health condition that does not have a related quilt project. Dissociative identity disorder/multiple personality disorder, endometriosis, irritable bowel syndrome, histiocytosis disorders, and Crigler-Najjar syndrome (a heredity disorder impacting bilirubin metabolism that is afflicting small populations of Amish children) are but a few of the relatively little known or rarely discussed diseases for which quilts are being used in advocacy, education, fund-raising, and as vehicles for patient and survivor experiences.[44] Diseases that already are well known or that have highly active marketing and public relations campaigns typically include robust related quilt activities. This is true especially for many different types of cancer, Alzheimer's disease, Parkinson's disease, dementia, women's heart disease, and kidney diseases. These organized projects provide a mechanism for individuals, including those who do not regularly quilt, to tangibly participate in memory making, fund-raising, and advocacy for these specific health conditions.

Figure 4.15. *50 State Block Exchange.* Blocks created by Nifty Fifty Quilters members; quilted by Joyce Neyers, begun July 1995, finished April 1998. Collection of Michigan State University Museum. Photo by Pearl Yee Wong.

Members of the Nifty Fifty Quilters of America participate in quilt block swaps with others in the fifty states and then create charity quilts for Breast Cancer Awareness campaigns. Cancer survivors and individuals who lost loved ones to the disease signed the back of the quilt when the Nifty Fifty Quilters exhibited the quilt at quilt shows in many different locations (Quilt Index, http://www.quiltindex.org /fulldisplay.php?kid=1E-3D-261F; see also Nifty Fifty Quilters of America, http://www.niftyfiftyquilters .com/nfcharity.html).

Many of these collective quilt projects are intended to produce memory quilts, a traditional style of quilt consisting of blocks or squares, each of which has been made by an individual who is recording and telling their own story of a disease, memorializing those who have died, or, as is the case of organ donor quilts, honoring those who have played critical roles in health care.

The activity of making a square and having it joined, whether physically or virtually, with other squares representing the experiences of others helps individuals work through and heal emotional scars. Kathleen Broaddus was diagnosed with Parkinson's disease and says when it comes to her work on the Parkinson's Quilt Project, what matters is the chance to take part. Despite coping with muscle tremors that make control of sewing a challenge, she sees the struggle to get the quilt done like the struggle to coexist with her disease. "Just got to have the determination to go ahead and live your life and not just sit around and wallow in your misery," she said. "It's about hope."[45] Typically the squares are combined into bed-size quilts that, following the model of the NAMES Project Foundation, are loaned to a variety of community-based venues for temporary educational events.[46] In 2016, portions of the Parkinson's Quilt were displayed at the Great Lakes Folk Festival in East Lansing, Michigan, as part of its "Art and Health" program component.[47] Often the quilt squares and their accompanying stories are accessible online, sometimes even represented as digital quilts. A growing number of health organizations are creating online quilts as tributes to those who have donated eyes, kidneys, and other organs.[48] As records of the victims or others affected, often with the names or images of each person rendered in the textiles, these virtual memory quilts also bear mute but emotionally powerful testimonies about the impacts of the disease.

The IBD Quilt Project is an example of how quilts are used to promote awareness of inflammatory bowel disease (IBD), a medical condition that is poorly understood by many and that those living with IBD often find difficult to talk about. Crafted by and for the IBD community, the quilts provide an outlet to express the thoughts and experiences of living with chronic disease. When the IBD quilts are displayed at various events around the world, they serve as powerful tools to help viewers understand the devastating impact of Crohn's disease and ulcerative colitis. By helping to educate and create awareness of the challenges of living with IBD, they give a voice to real people.[49]

Figure 4.16. Facing: *Virtual Memory People ™ Faces of Dementia Quilt.* Photos by family and friends of honorees, used with permission from Memory People.

The online Facebook group called "Memory People: Faces of Dementia" asked people worldwide who have been affected by dementia to participate in the virtual quilt, which is comprised of over two hundred people affected by Alzheimer's disease and dementia. The virtual quilt includes the faces and names of those living with dementia, people who have died from dementia, caregivers, healthcare professionals and family members—anyone who has been touched by dementia in any way. The quilt was sponsored by Memory People, an online Alzheimer's and dementia support group. The virtual quilt launched on November 7, 2013 (Alzheimers.net; see also San Antonio Eye Bank, "Memorial Quilts," http://www.saeyebank.org/search-memorial-quilts.php?page=0).

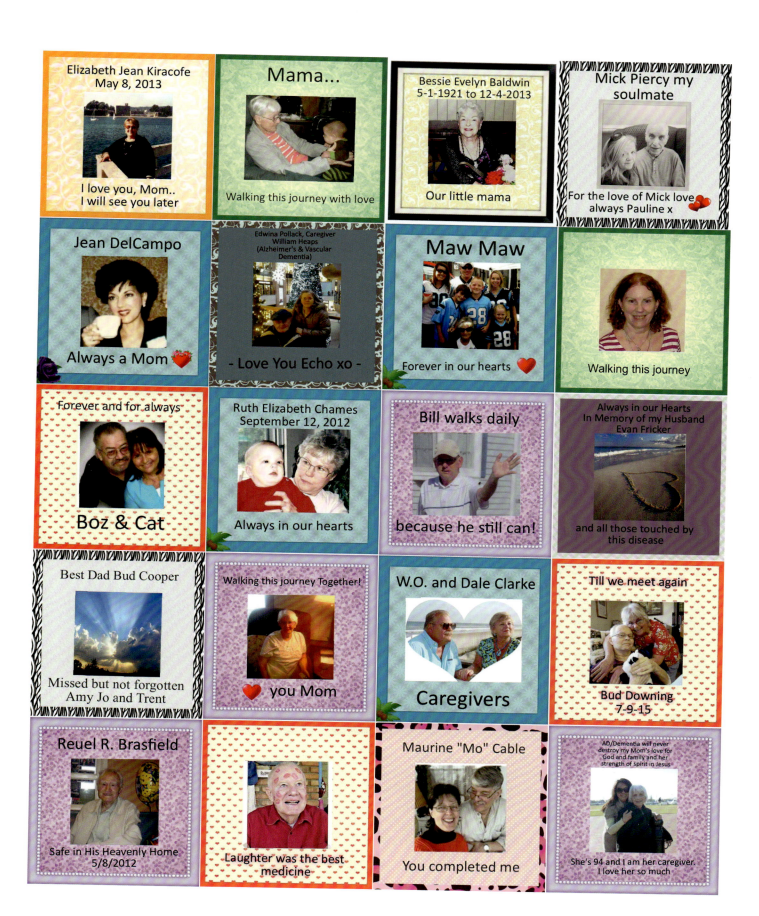

Elizabeth Jean Kiracofe
May 8, 2013

I love you, Mom..
I will see you later

Mama...

Walking this journey with love

Bessie Evelyn Baldwin
5-1-1921 to 12-4-2013

Our little mama

Mick Piercy my
soulmate

For the love of Mick love
always Pauline x

Jean DelCampo

Always a Mom

Edwina Pollack, Caregiver
William Heaps
(Alzheimer's & Vascular
Dementia)

- Love You Echo xo -

Maw Maw

Forever in our hearts

Walking this journey

Forever and for always

Boz & Cat

Ruth Elizabeth Chames
September 12, 2012

Always in our hearts

Bill walks daily

because he still can!

Always in our Hearts
In Memory of my Husband
Evan Fricker

and all those touched by
this disease

Best Dad Bud Cooper

Missed but not forgotten
Amy Jo and Trent

Walking this journey Together!

you Mom

W.O. and Dale Clarke

Caregivers

Till we meet again

Bud Downing
7-9-15

Reuel R. Brasfield

Safe in His Heavenly Home
5/8/2012

Laughter was the best
medicine

Maurine "Mo" Cable

You completed me

AD/Dementia will never
destroy my Mom's love for
God and family and her
strength of spirit in Jesus

She's 94 and I am her caregiver.
I love her so much

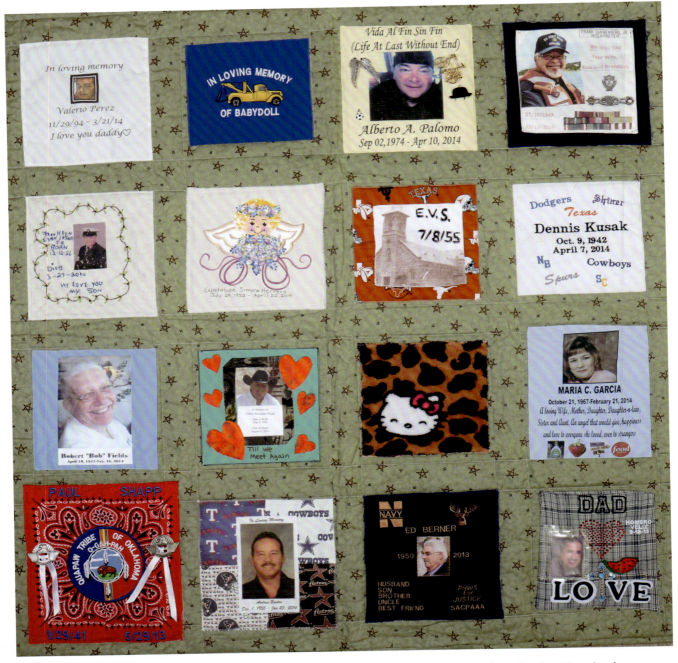

Figure 4.17. *Gift of Sight Memorial Quilt,* Individual blocks made by members of donor families. Pieced and quilted by Marilyn Bellow and J. Larry Beauchamp of the Greater San Antonio Quilt Guild, San Antonio, Texas, 2015. Collection of the San Antonio Eye Bank.

The San Antonio Eye Bank in Texas encouraged transplant recipients to honor and remember donors by making individual blocks. The physical quilt is used in display across the country to educate others "about how lives are touched by donation and transplantation." Digital images of all the individual blocks are displayed online in a virtual quilt where viewers can browse or search the blocks by donor name (San Antonio Eye Bank, "Memorial Quilts," http://www.saeyebank.org/search-memorial-quilts.php?page=0).

Figure 4.18. *Crigler-Najjar Syndrome Quilt*, Emma Petersheim, Marlette, Michigan, Cotton, machine pieced, hand quilted, 105" × 112". Collection of the Michigan State University Museum. Photo by Pearl Yee Wong.

Petersheim made this quilt to raise awareness and funds to benefit Amish children with Crigler-Najjar syndrome. She and other Amish and Mennonite quiltmakers pass their quilts on to Carey Harrison, a non-Amish woman who grew up with the Amish in Ohio and Pennsylvania and sells the quilts in her store in Horseshoe Bend, Idaho, or on eBay. Carey says, "Crigler-Najjar is my project to help these very special children. When my husband passed away from prostate, bone and brain cancer this past year he was covered with a quilt made by my Amish friend Ada Miller of Shipshewana, Indiana. When I pass away I want to be covered with this same quilt. My Amish friends are very special to me and pray for me and others all the time. I am blessed to know them" (Carey Harrison, eBay correspondence with Marsha MacDowell, February 24, 2015;)

Some of the best-known organizations devoted to raising awareness of and funding for diseases use quiltmaking as one of their strategies to address their mission. The Susan G. Komen Foundation is dedicated to breast cancer research and education and has effectively connected the color pink to breast cancer as a marketing strategy. Because breast cancer is overwhelmingly a disease affecting women, it is not surprising that there are multiple ways in which quilts are used to advance breast cancer issues. A Google image search reveals hundreds of "breast cancer" quilts made of pink fabric, some of which are even expressly designed and produced for these quilts, incorporate the pink ribbon symbol into their design, and carry images and names of those who are supportive of breast cancer research and

Figure 4.19. *They Are Just Boobs Until You Lose Them*, Debbie Rolek, Waukee, Iowa, 2006. 40.5" × 41.5". Collection of the artist. Photo by Terry Snyder Photography, Waukee, Iowa.

Debbie Rolek worked for years as a registered nurse on a medical/surgical, plastic surgery floor at Mercy Hospital, Des Moines, Iowa, and has been making quilts most of her life. She believes that "quilts, as any piece of art, can represent health awareness [and that for her] . . . the cutting of clothing, designing a pattern, piecing and quilting is very therapeutic even if it is for a customer." She has made a number of memory quilts, but her "own personal favorites are my breast cancer awareness quilts as they made a difference in people's lives." Of this particular quilt she says:

> I did this quilt in honor of those who have lost their battle with breast cancer. A good friend, Laurie, in Canada was going through chemotherapy and volunteered to do a challenge [quilt] for the 2006 Machine Quilters Expo in New Hampshire. I joined the challenge and made this quilt. Four blocks contain the Breast Cancer Ribbon pattern. The Center block contains the inspirational message of: "Get them Checked, . . . Get them Checked Often." The center block has the Breast Cancer Ribbon, the American Sign Language symbol of "I love you" with the words below, and a pair of breasts. . . . Breast Cancer Awareness is an important fact for women and men. Breast self exams, doctor checks and mammograms help reduce the devastation of breast cancer advancement.
>
> These words were quilted into this quilt with [the] trapunto/cutaway method. To tie them together, I quilted breasts of all different sizes—a few with mastectomies. I painted the words and included breast cancer statistics for difference races. Crosses were made from the backside of Breast Cancer bracelets, and 4 people's names and date of death were added. Four different style bracelets appear on the border with words of "courage, hope, strength and endurance." Breast Cancer ribbon pins were applied in the main Breast Cancer Ribbon. Four Angel pins were applied to the quilt to watch over all. Happy face heart erasers were applied to make you smile. I created a "stop breast cancer" sign with a ribbon in the center. . . . Remember, get them checked, and do it often, so your name will never end up on my quilt.

For another cancer education quilt, Rolek worked hard to attach fabric breasts that she intended to be touched or palpated when the quilt was on exhibition. She also added statistics, including about men with breast cancer. She says, "My hope is that the viewers of this quilt will read at least one fact, and men and women would become regular examiners of their body. It is for education and humor, so people won't forget about breast cancer." She believes that she is making a difference through this unique educational art and that people remember them. She has been "told by more than one quilter that they did feel for the nodules on the quilt, and that they also then scheduled mammograms that were way overdue because of these quilts, . . . I have been called the 'boob quilt lady' [and it is] a title I wear proudly."

(Debbie Rolek, artist statement sent to Beth Donaldson, May 22, 2016; see also Janet Wickell, "Pictures of Comfort and Charity Quilts," *The Spruce*, January 25, 2017, https://www.thespruce.com/pictures-of-comfort-and-charity-quilts-4051126.)

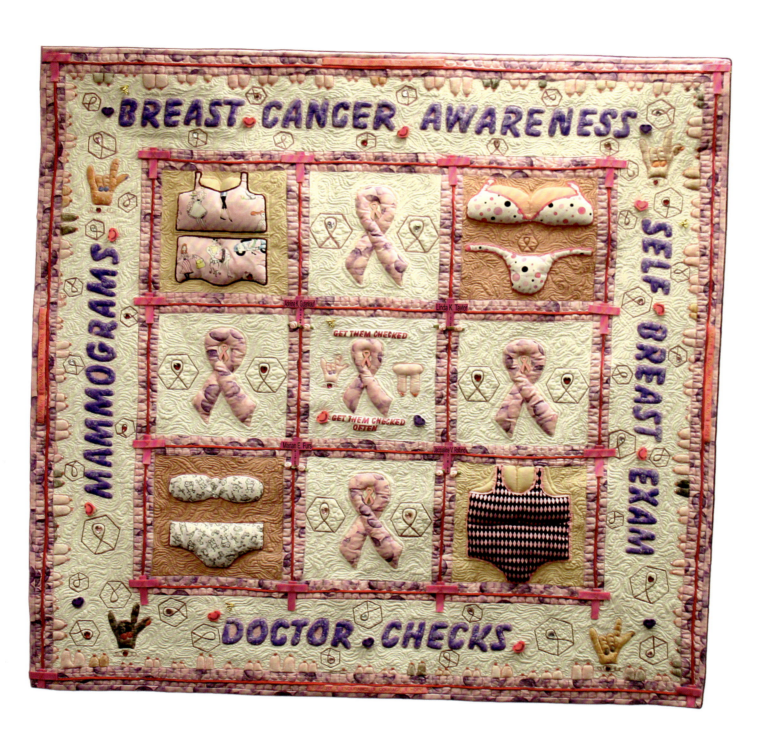

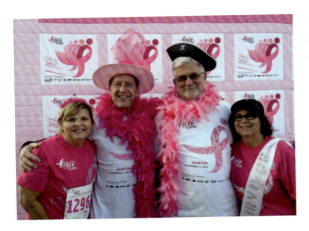

Figure 4.20. For the 2013 Race for the Cure held in Austin, Texas, Martta Howard made a quilt from T-shirts from past races. Finished the night before the race, it measured 117" × 97" and was hung in the Survivors' tent at the event. During the day, survivors and friends adorned themselves with Photobooth props and enjoyed having their pictures taken in front of the quilt. The quilt further benefited breast cancer research and education when it was auctioned off at the Komen Austin annual Perfectly Pink Party later that year. Photo by Martta Howard, courtesy of Susan G. Komen, Austin, Texas. (See also Martta Howard, "Race for the Cure Quilt," *HMH Designs*, January 23, 2013, https://hmhdesigns.wordpress.com/tag/race-for-the-cure-2).

education. The foundation has also organized "Race for the Cure" held in all states in America and in several countries. These races are important tools for survivors and their friends and families joining with local and regional businesses and organizations to raise funds and awareness about breast cancer.[50] A Warrior Quilt Project, related to the Komen race held in Pittsburgh, was started in 2009 as part of support given to the Susan G. Komen Foundation by the Neighborhood Ford Store, a group of eighty-one Ford dealers in southwest Pennsylvania, southeast Ohio, and the panhandles of Maryland and West Virginia. The Neighborhood Ford Store teams with local chapter race organizers to host an annual "Patchwork Station" at the race. Racers and their friends and family sign patches of fabric that are later made into "Warrior" or "Warrior in Pink" quilts that are then presented to regional educational institutions, hospitals, and other medical facilities.[51]

The American Heart Association (AHA) is another health organization that has cultivated links to quilts as tools for advocacy, education, and fund-raising. Their "Go Red for Women" campaign encourages awareness of heart diseases that impact women.[52] Accuquilt, a company specializing in quilt equipment, has teamed with AHA in a "Have a Heart, Make a Quilt" campaign to promote making red and white quilts for display at Go Red for Women expos.[53] In 2016 AHA sponsored a juried quilt show called "Affairs of the Heart" at the New England Quilt Museum.[54] Helen Martin, a quiltmaker and a nurse at University of Wisconsin Hospital, has made a Go Red for Women quilt, has spoken about women's health disease to many quilt guilds, and has organized a "Love Your Heart, It's Sew Important" exhibition of Go Red for Women quilts that has been shown in Wisconsin hospitals and other venues.[55] Quiltmakers have also designed blocks and patterns specifically for use in making Go Red for Women quilts, and many who blog have mentioned the campaign on their sites.[56] In conjunction with the campaign's National Wear Red Day, held on the first Friday in February, quilt fabric shops often feature sales or displays of red and white fabrics and sometimes host exhibitions of red and white quilts.[57]

Another major international health foundation that actively uses quilts is the National Kidney Foundation. Through its National Donor Family Council, the foundation collaborates with organ and tissue donation organizations in states and regions in developing and promoting the making of quilts as an opportunity for donor families to honor loved ones. Like the original "Patches of Love—The National Donor Family Quilt," local quilts raise awareness of organ and tissue donation and pay tribute to those who have given the gift of life.[58] Thousands of families have contributed quilt squares to honor those who "gave the gift

Figure 4.21. *Women's Heart Health*, Sue Reich, Washington Depot, Connecticut, 2010. 65" × 64". Collection of Sue Reich. Photo by Pearl Yee Wong.

This quilt was made as a sample in a series to focus on women's health. Included in the series were quilts related to eating beautiful food, exercise, the inherited body types, breast cancer and "Go Red for Heart Health." The quilts have been exhibited at hospitals and women's health fairs. (Sue Reich, email to authors, January 7, 2016; Sue Reich, email to Beth Donaldson, Wednesday, May 04, 2016.)

of life," those who wanted to donate organs but could not because of medical reasons, and those who did not donate but would have if they had been given the chance. Quilt squares honoring individuals can be searched online, and dozens of quilts made from the squares are displayed at events where the textiles and their associated stories spread the word about organ and tissue donations.[59]

There are remarkable stories of individual patient advocates or caregivers of family members or friends impacted by a disease establishing grassroots quilt and health initiatives that have grown to worldwide proportions. The Alzheimer's Art Quilt Initiative (AAQI) is one such initiative, whose mission was to raise awareness and fund Alzheimer's research. Founder, executive director, and quilt artist Ami Simms, of Flint, Michigan, was inspired to start AAQI when her mother had Alzheimer's disease. She recognized the power of quilts to advance research focused on a disease that is expanding at an astronomical rate and is projected to affect 7.1 million people in the United States by the year 2025, a 40 percent increase from the 5.1 million age sixty-five and older affected in 2015.[60] Overseen by Simms and operated entirely by volunteers from 2006 to 2013, AAQI gathered and sold donated quilts through online auctions; sponsored a nationally touring quilt exhibit; published a related book, *Alzheimer's: Forgetting Piece by Piece*; and raised over one million dollars to support basic science research on Alzheimer's disease.[61]

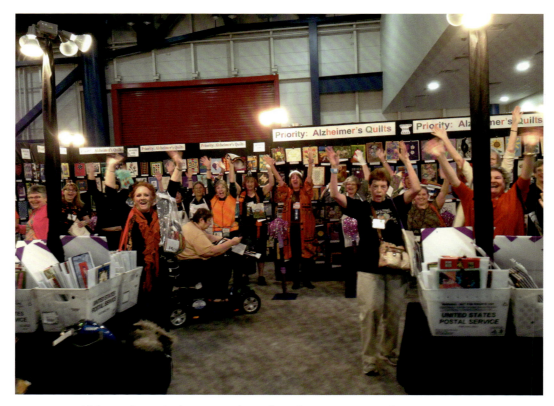

Figure 4.22. Alzheimer's Art Quilt Initiative (AAQI) reaches $1,000,000 goal. Photo taken by Ami Simms at International Quilt Festival, October 31, 2013 (Lori, October 31, 2013, "AAQI!! Hooray!" *Humble Quilts*, http://humblequilts .blogspot.com/2013/10/aaqi-hooray.html).

Figure 4.23. *Once a Shining Star*, Helen Marshall, Waikanae, New Zealand, 2006. 36" × 36". Collection of the MSU Museum. Photo by Pearl Yee Wong.

Memory Star blocks were crafted with circles of fabric with forget-me-nots on it. Forget-me-not buttons are also stitched to the quilt. "This quilt was part of the special exhibit 'Alzheimer's: Forgetting Piece by Piece.' The exhibit debuted at the American Quilter's Society Quilt Exposition in Nashville, Tennessee, in August 2006. It traveled to quilt shows all over the country through July 2009."
"Helen has been quilting and embroidering for many years. She teaches widely throughout New Zealand and internationally as well." She has published on quilts and serves as a curator of quilt shows (Quilt Index, http://www.quiltindex.org/fulldisplay.php?kid=1E-3D-2618; see also accession materials, Michigan State University Museum).

Quilts, Comfort, and the Military

The quiltmaking activity associated with the United States Sanitary Commission during the Civil War in the United States was perhaps the first time that collective quilt efforts became so closely connected to military action or personnel. The connection has continued into the twenty-first century, its growth, as with other collective quilting actions, greatly facilitated by the Internet. Like the commission quilts, there has been a proliferation of projects intended to comfort those who are serving in the military or have suffered war-related injuries, to comfort the families of soldiers who have been deployed overseas or killed in combat, or sometimes simply to honor military service. Many of these efforts started with local action by members of quilt guilds, often by family members of those in service or by veterans themselves. For instance, Judy Brown, a disabled veteran who served in Iraq in 2009 and was herself the recipient of a quilt upon her return, is a member of the Old Glory Quilters.[62] They make quilts in red, white, and blue for Quilts of Honor.[63] Brown, who stitches the words "freedom" and "honor" into the quilts she makes, expresses a sentiment often communicated by others who make quilts for honoring and comforting military: "I love this. It's my heart. And my heart is to give back to the veterans because so many never got what they deserved."[64]

Some projects make quilts for specific military groups, such as spouses or children of those currently deployed or killed, branches of the military, or veterans of a specific war.[65] For instance, Home of the Brave Quilts, started by Donald Beld, is a project that pays tribute to the "fallen heroes of the wars in Iraq and Afghanistan" by individuals who make quilts that are presented to the surviving family members.[66] The quilts made in this project are reproductions of quilts that were originally made as part of the U.S. Sanitary Commission's efforts to help the cause of the northern states during the Civil War.[67] The Agent Orange Quilt of Tears Project is intended to raise awareness and funding for those servicemen and women suffering from exposure to the chemical known as Agent Orange. Sheila Snyder and her husband, Henry, a Vietnam War veteran, worked closely with project founder Jennie LeFevre and then carried the project forward when LeFevre passed away. Snyder says that when Vietnam War veterans and their families view the quilts, the quilts spur them to open up about their experiences and it helps "widows and families work through their grief."[68] Betty Nielsen, of Fonda, Iowa, started Freedom Quilts to make quilts to comfort the families of those lost in the 9/11 tragedy as well as families of fallen soldiers.[69] Where possible, quilts are personalized with photo transfers of the individuals who died, and a section of the Freedom Quilts website presents photographs and brief biographies of the honorees. Testimonies from recipients posted on the site reflect Nielsen's own observations that the quilts make them feel as though their loved ones' arms are around them.[70]

Quiltmaker Linda Wieck of Wisconsin started the Camo Quilt Project when her son-in-law, a member of the Wisconsin Army National Guard was getting ready to be deployed to Iraq and asked her to make a quilt out of the same camouflage fabric as his uniform and in a size that he could easily attached to his backpack. Fellow soldiers saw the finished quilts and also wanted one, so Wieck made more. Soon requests were pouring in and a number of organizations joined Wieck in filling the requests. As of 2016, more than sixteen thousand "camo quilts" made in colors associated with various branches of military service have been sent to soldiers, marines, and airmen.[71]

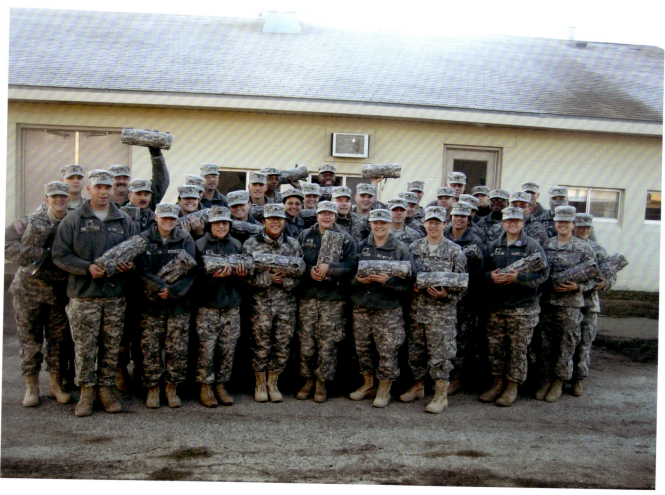

Figure 4.24. Before her death in the Fort Hood massacre, Staff Sergeant Amy Krueger had requested quilts for her entire unit. The Camo Quilt Project completed forty-six quilts, and a Plymouth, Wisconsin, company had them delivered to Fort Hood before the unit deployed. Here the 467th Medical Detachment, headed by Major Laura Suttinger, is shown holding what they call "Amy's Quilts." Photo reproduced with permission of Linda Wieck, the Camo Quilts Project (Suzanne Labry; see Andy Romey, "Camo Quilts Comfort Troops," *The American Legion*, November 19, 2009, https://www.legion.org/troops/3598 /camo-quilts-comfort-troops.

One of the largest and perhaps best known of the honoring and comforting quilt and military projects in recent history is the Quilts of Valor Project with its mission "to cover service members and veterans touched by war with comforting and healing Quilts of Valor." As of March 2016, this effort facilitated the making and distribution of over 133,700 quilts.[72] The Quilts of Valor Project was started in 2003 when founder Catherine Roberts, of Seaford, Delaware, whose son Nat was deployed in Iraq, had a dream. According to Roberts:

> The dream was as vivid as real life. I saw a young man sitting on the side of his bed in the middle of the night, hunched over. The permeating feeling was one of utter despair. I could see his war demons clustered around, dragging him down into an emotional gutter. Then, as if viewing a movie, I saw him in the next scene wrapped in a quilt. His whole demeanor changed from one of despair to one of hope and wellbeing. The quilt had made this dramatic change. The message of my dream was:
>
> Quilts = Healing.
>
> The model appeared simple: have a volunteer team who would donate their time and materials to make a quilt. One person would piece the top and the other would quilt it. I saw the name for this special quilt. It was Quilt of Valor, a QOV."[73]

Most charity and service quilt projects encourage the use of quilt patterns that could be easily done and often did not require quilting but rather tying the three layers together. Roberts, however, had strict ideas about the visual and construction quality of QOV quilts:

> I knew a Quilt of Valor had to be a quality-made quilt, not a "charity quilt." Quilts of Valor would be the civilian equivalent of a Purple Heart award. A Quilt of Valor had to be quilted, not tied, which meant hand or machine quilting. Quilts of Valor would be "awarded," not just passed out like magazines or videos. A Quilt of Valor would say unequivocally, "Thank you for your service, sacrifice, and valor" in service to our nation in combat.[74]

Thus the Quilts of Valor website provides clear guidelines for size, colors, fabrics, type of batting, binding technique, design, craftsmanship, and even labeling.[75] Although the quilts do not have to be in red, white, and blue, many quilts are, and nearly all are patriotic in theme. Sample patterns or designs suitable for QOV are illustrated on the website and printed in magazines, and YouTube tutorials are readily available on the Internet. Even given the restrictions of design, the variations in the quilts are remarkable; a Google search for "QOV quilts" reveals an array of unique quilts that incorporate eagles, medals, the American flag, and many different fabrics of solid and printed red, white, and blue. The QOV Project has a system of matching requests for quilts for honorees with those who make them and encourages the presentation of QOV quilts at events held in veterans centers, military hospitals, and such local public community venues as libraries, churches, museums, and government buildings.

As veterans, often attired in their uniforms, are given their quilts, a presiding officiant reads the name of the honoree, tells about the honoree's military service, gives information about the QOV Project, and often reads any notes, cards, or journals that document the making of the quilt. Peggy Luck conveyed the meaning of the quilts to the veterans at a QOV presentation she presided over:

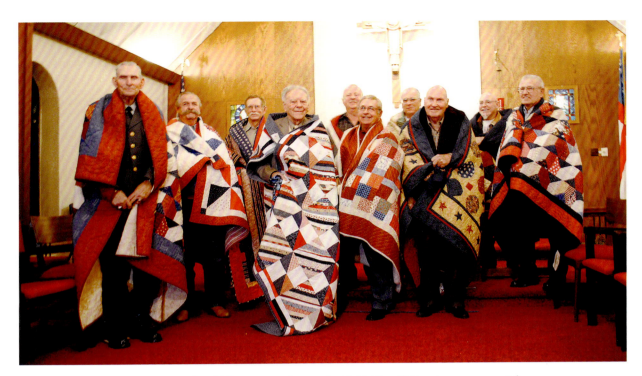

Figure 4.25. Military veterans in Liberal, Kansas, were honored with Quilts of Valor at a ceremony at the local St. Andrew Episcopal Church in November 2013. As local QOV volunteer coordinator Peggy Luck said at the event before she called each to stand and accept his quilt, "These quilts are a tangible reminder for these men that have served our country that have made sacrifices, and a tangible thank you to then. . . . A hug is the final contact that we have with your quilt, and so the hug comes from the Needles and Friends Quilt Guild members and from the Quilts of Valor family." Photo by Giseelle Arredondo/courtesy of Earl Watt, *Leader & Times* (Liberal, KS) (Giseelle Arredondo, "Quilts of Valor: Veterans Get Wrapped in Personalized Quilts Presented by Needles and Friends," *Leader & Times* (Liberal, KS), November 11, 2013).

Figure 4.26. Former seaman Tom Seymour, in his original uniform from his 1962–1965 service in the navy, gives a salute along with thirty-five fellow recipients of Quilts of Valor in a ceremony on May 17, 2015, in Davenport, Iowa. Photo © John Schultz/*Quad City Times* via *Zuma Wire* (Linda Cook, "Veterans Receive Quilts of Valor in Moving Ceremony," *Quad City Times*, May 17, 2015, http://qctimes.com/news/local /veterans-receive-quilts-of-valor-in-moving-ceremony/article_be71326a-4a0a-52fc-a3f6–6e2659770bb2 .html).

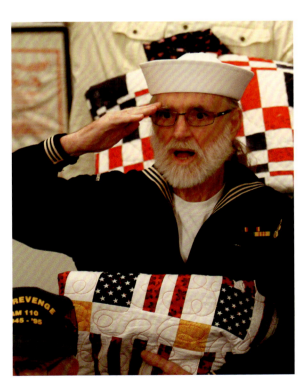

"One of our machine quilters has a counter on her machine, and it counts how many stitches that machine is making to put the three layers together and the counter on just one of these quilts was over 50,000," Luck said. "And that's just the stitches that are holding it together, not the ones that sew together each piece.

"So that kind of tells you that all these stitches are the ones that you can see, the 50,000, but you know the other ones are there because you will feel the warmth of the quilt through these stitches," she added. The middle of the quilt represents the hope that the quilt will bring comfort and warmth, maybe peace, and maybe some healing, Luck said.

"The back of the quilt is a big piece of fabric and it contains everything. It holds the whole thing together and that is the strength of the quilt," she continued. "It reminds us of the strength of each one of you soldiers. It also reminds us of the strength of the families. Families make quite a sacrifice for soldiers, and it also reminds us of the strength and support of the community and of our nation."[76]

At one of the presentations to a group of Vietnam War veterans early on in the project, Roberts reported that over and over again they said, "Ma'am, this is the first time in forty years anyone has ever thanked me for my service." The reaction of the veterans who receive QOV quilts remains the same—of deep gratitude and often statements of knowing that others cared about their service. Likely because of the patriotic element of the QOV Project, because the presentation events bring public recognition to service to the country, and because the recipient responses are so heartfelt, these events are often covered by local news media and thus bring positive attention to the overall project, to the recipients, and to the quiltmakers.

The parent of a young soldier identified only as Chris, who was injured and photographed while en route to medical care on a gurney, covered in a QOV quilt, wrote a letter to the Quilts of Valor Foundation, saying:

> We will never forget the first pic that we saw of our son wrapped in red, white and blue. Truly it is an expression of so much love, caring, and compassion for our Soldiers, Airmen, and Sailors who have given so much for Our Country. I can assure you that it gave our Chris comfort mentally to know that folks cared as well as provided him physical warmth on the cold flights. It is now one of "his treasures" that he has requested us to safeguard until he is out of treatment and back on his own.[77]

Quiltmaking in Prisons

One arena of collective quiltmaking that is connected to several dimensions of health and well-being is based in prisons. One of the first documented uses of quiltmaking as a way for prisoners to cope with their incarceration by creating meaningful work dates from 1840, and there are numerous accounts of prisoners making quilts either as therapy or as a way to give something back to society.[78] As of the beginning of the twenty-first century, there has been a proliferation of quilting projects in both men's and women's prisons as well as in juvenile detention centers. Typically, these programs are initiated and run by local quiltmakers, many of whom take these projects on as part of their guild outreach activities, teaching prisoners the

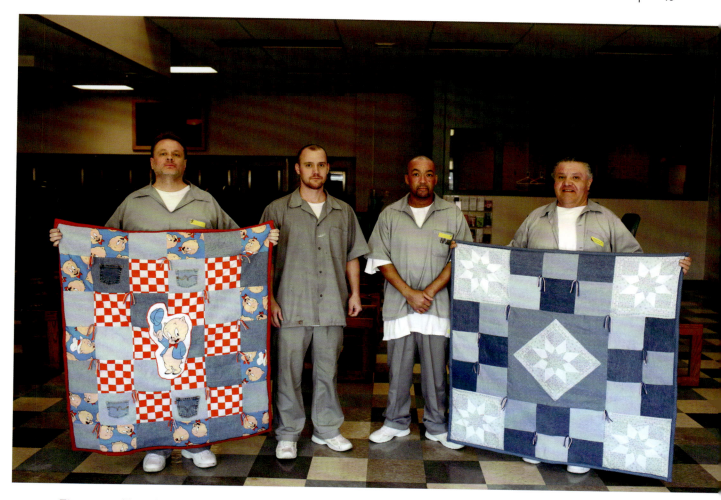

Figure 4.27. Tavis Canon, Christopher Maldonado, Patrick Starr, and Gerald Toahty (left to right), all inmates at the Jefferson City Correctional Center, Jefferson City, Missouri, show some of the quilts they have made in a restorative justice program. Photo by Chris Mottalini/www.mottalini.com (Meribah Knight, "Men with Quilts: Prisoners Piece together Their Lives One Square at a Time," *American Craft* (September—October 2010); reprinted in *Utne Reader*, http://www.utne.com/politics/men-quilts -prisoners-restorative-justice.aspx#ixzz2ii21ySF).

rudiments of quiltmaking and often supplying all or at least part of the fabric and equipment needed. Prisoners also scavenge fabric wherever they can within the prison, including using worn prison-issued blue jeans and bright orange offender transport jumpsuits. Some prisoners quilt simply to help pass the time; others quilt as part of restorative justice programs in which prisoners are engaged in activities that help pay their debt to society.[79] Many prisoners find purpose in life by making these quilts and then giving them to local individuals in need, hospitals and nursing homes, or to the large nonprofit charity groups like Project Linus to which other quiltmakers outside of prison are donating. It is a redemptive activity that builds self-worth, a sense of purpose, and a feeling of being connected to something bigger than themselves.[80]

In some cases, prisoners make quilts for other prisoners who are receiving hospice care or are dealing with serious illnesses. The prisoners often report how the activity—both making the quilts and giving them to others—facilitates a sense of purpose and well-being. As one inmate who is a team leader of the other inmates involved in a quilting program at the North Idaho Correctional Institute, Cottonwood, Idaho, stated simply, "It just gives you a sense of worth, doing something worthwhile."[81] Another inmate quilter at the same facility says, "So there's some thought and detail that goes into it and we're all pretty proud to be part of this. Not just working in the laundry but giving back. . . . It gives us a sense that we're still connected to everybody out there."[82] In Cheyenne, Wyoming, patients at the Cheyenne Veterans Affairs Medical Center (VAMC) have received quilts made by women inmates at the nearby Laramie County Detention Center. VAMC spokesman Samuel House speaks of the positive impact of these quilts on both the veterans and the inmates: "Our veterans love these gifts. And I think for these inmates, if what they're doing is helping them get through their own healing, and for them to come out of it a more well-rounded individual, knowing the time they spent actually helped to benefit someone, I think that's important as well."[83]

Quilts of Individual and Collective Agency and Meaning

Stories of the work of groups engaged in making quilts for others are regularly featured in local news media; these are human-interest stories of people who are making a difference in individual and community health and well-being. They are stories of compassion, altruism, and dedication. And they are stories of improving the quality of life for individuals and communities in need and of strengthening the capacity of organizations to deliver quality health care. The work positively contributes to the welfare of individual citizens and to the common good; their service activity defies notions of uncaring citizens. As scholar Debora J. Halbert reports in one study of women's charitable quilting activity, altruism is often at the core of their work: "Their creative work, in other words, is a gift they want to share, not a product they want to sell."[84]

Sociology professor, quilt studies scholar, and quilter Mary Beth Stalp has explored "the meaning of quiltmaking as a form of unpaid creative work among contemporary American women who make it an important part of their lives," and explores "how quilters simultaneously affirm and transform traditional women's roles through quilting."[85] She points out that "the quilting process immerses women in an often overlooked form of cultural production in the context of everyday life activities [and that] quilting is used in multiple ways as an extension of women's caretaking and tradition-maintaining activities."[86] Stalp's studies also explore the struggles of quilters within families "to gain time, space, and other resources to continue their work. These conflicts signify the difficulties women face in many domains of contemporary life, where they are often expected to support and care for others at the expense of self-development and creative expression."[87] These difficulties might be most acute when artists are perceived as working only for their own self-expression needs. When they are producing quilts for charitable purposes, their expenditures of time and money are looked on more hospitably and even encouraged and praised.

Women involved in communal aspects of charity quilting have found that this activity strengthens existing, and creates new, meaningful connections among those with whom they share family and community ties, values, and beliefs. Importantly, communal quilting creates circles of individuals who provide care and support to each other. As Carla Fisher, a member of the Lizzies, a virtual group of forty-one women from disparate backgrounds who are connected only through charity quilting activities, says, "I believe our greatest gift has been in our support of one another through our quilts."[88] Sometimes the communities created by shared engagement in quilting are vast in terms of numbers and geography. When Libby Lehman, a well-known quilt artist and professional quilt instructor, suffered a stroke, quiltmakers around the world who had studied with her, read her book, watched her on television shows, or simply knew of her work in quilts donated thousands of dollars to help her address her medical bills.[89] These circles both follow and cross over geographical location and racial, religious, educational, political, and economic lines.[90]

Notes

1. Linda S. Schmidt, "The Quilters Resistance Movement," *Short Attention Span Quilting: Linda. S. Schmidt*, http://www.shortattentionspanquilting.com/the-quilters-resistance-movement.html.

2. Ibid.

3. Ibid.

4. Marsha MacDowell, Mary Worrall, Lynne Swanson and Beth Donaldson, *Quilts and Human Rights* (Lincoln: University of Nebraska Press, 2016), 7.

5. Ibid. See also Jacqueline Marx Atkins, *Shared Threads: Quilting Together—Past and Present* (New York: Viking Studio Books, 1994), 65.

6. MacDowell et al., *Quilts and Human Rights*, 7–8. For contextual information, see Atkins, *Shared Threads*; Betty MacDowell, Marsha MacDowell, and C. Kurt Dewhurst, *Artists in Aprons: Folk Art by American Women* (New York: E. P. Dutton, 1979); and Pat Ferrero, Elaine Hedges, and Julie Silber, *Hearts and Hands: The Influence of Women and Quilts in American Society* (San Francisco: Quilt Digest Press, 1987).

7. MacDowell et al., *Quilts and Human Rights*, 9. See also Virginia Gunn, "Quilts for Union Soldiers in the Civil War," in *Uncoverings 1985*, ed. Sally Garoutte, 95–121 (Mill Valley, CA: American Quilt Study Group, 1986); Barbara Brackman, *Quilts from the Civil War* (Lafayette, CA: C&T Publishing, 1997); and Pam Weeks and Don Beld, *Civil War Quilts* (Atglen, PA: Schiffer Publishing, 2011).

8. Gunn, "Quilts for Union Soldiers," 97.

9. MacDowell et al., *Quilts and Human Rights*, 17; see also Sue Reich, "The Eleventh Hour of the Eleventh Day of the Eleventh Month: World War I Quilts," *Covering Quilt History*, http://www.coveringquilt history.com/quilts-of-world-war-i.php.

10. See Deborah Harding, *Red & White: American Redwork Quilts* (New York: Rizzoli, 2000) for a definitive history and description of techniques of red and white quilts.

11. Sue Reich, "Canadian Benevolent Quiltmaking during World War II for the Red Cross and the I.O.D.E.," Covering Quilt History, http://www.coveringquilthistory.com/ww-ii-benevolent-quiltmaking .php. A Canadian Red Cross Research Group has been formed to locate and document still extant quilts; for more information, see Anna Mansi, "Quilts, Comfort from Kindness," *Popular Patchwork*, http://www .popularpatchwork.com/news/article/quilts-comfort-from-kindness/14352.

12. Reena Singh, "Handmade Hope Pulaski Church Group Makes It Its Mission to Sew Quilts to Comfort Cancer Patients," *Watertown Daily News*, January 7, 2012, http://www.watertowndailytimes.com /article/20120107/CURR04/70107997.

13. For example, see "Free Charity Quilt Patterns," Free Quilt Patterns, http://www.freequiltpatterns .info/QuiltCategories/FreeCharityQuiltPatterns.htm.

14. See Prayers & Squares, http://www.prayerquilt.org. For an example of one in practice, see "Prayers & Squares Quilt Ministry," First United Methodist Church of Redondo Beach, http://fumcrb.org/prayer -quilts.

15. Quilt for Change: Inspiring Social Change through the Art of Quilting, www.quiltforchange.org.

16. Disaster Quilting Project, "About Disaster Quilters," http://disasterquiltingproject.com/on -going-crisis-quilting.

17. See especially Amanda Grace Sikarskie, *Textile Collections: Preservation, Access, Curation, and Interpretation in the Digital Age* (Lanham, MD: Rowman & Littlefield, 2016).

18. Jessica Haak, "Constructing Quilts, Online Communities, and Quilter Legacies: A Narrative Case Study," in *Educational, Psychological, and Behavioral Considerations in Niche Online Communities*, edited by Vivek Venkatesh, Jason Wallin, Juan Carlos Castro, and Jason Edward Lewis, 51–66 (Hershey, PA: IGI Global, 2014).

19. Anonymous list of cost breakdown was circulated on several Facebook quilting sites in May 2016, and commenters consistently agreed with the estimates of labor time and materials costs.

20. "Michigan Heritage Awards: Messiah Quilters, 2004 awardee," Michigan State University Museum, http://museum.msu.edu/s-program/mh_awards/awards/2004MQ.html.

21. Ashley Franscell, "Quilting for a Cause RSVP Volunteers Help Patients," *Daily Herald* (Provo Utah), May 16, 2011, http://www.heraldextra.com/news/local/central/provo/quilting-for-a-cause-rsvp -volunteers-help-patients/article_519ea501-7b77-5635-b543-eb652c73094e.html.

22. Cary Ashby, "Many Quilters 'Touched by Breast Cancer,'" *Norwalk Reflector*, October 22, 2015, http://www.norwalkreflector.com/Local/2015/10/22/Many-quilters-touched-by-breast-cancer.html ?ci=stream&lp=10&p=1.

23. "Quilt for a Cause: A History," Quilt for a Cause: Sew a Cure for Women's Cancer, March 2, 2012, http://quiltforacause.org/about/history.

24. "Gabby Gifford Quilts," Quilt for a Cause: Sew a Cure for Women's Cancer, http://quiltforacause .org/galleries/gabby-giffords-quilts.

25. Neva Hart, email communication with Beth Donaldson, January 7, 2016; Jennifer Prince, "The Art of Crafting: Local Places to Get Creative," *Lynchburg Living*, http://www.lynchburgliving.com/the-art -of-crafting-local-places-to-get-creative; see also "Fabric Shop in Lynchburg . . . Quilted Expressions . . . To Date They've Raised over $300,000." Rainbow of Hope, http://roh4hospice.org.

26. "Global Fund Quilts," Quilt for Change, http://quiltforchange.org/category/globalfundquilts/.

27. "Metaphors on Aging," Studio Art Quilt Associates, http://www.saqa.com/memberArt.php?cat =8&ec=4&ex=3; and "I'm Not Crazy," Studio Art Quilt Associates, http://www.saqa.com/memberArt .php?ID=2217; see also Salli McQuaid, ed., *I'm Not Crazy: Stigma Revealed* (Self-published, 2012).

28. Healing Quilts in Medicine, http://healingquiltsinmedicine.org.

29. Kimberly Ky, "Mental Health Wellness Quilt Shows What Community Healing Looks Like," *California State University East Bay News*, July 23, 2012, http://www.csueastbay.edu/news/2012/07/Alumna AdelinaTancioco-072012.html.

30. For more about the agency of women in health care, see Susan Sherwin and Feminist Health Care Ethics Research Network, *The Politics of Women's Health: Exploring Agency and Autonomy* (Philadelphia: Temple University Press, 1998).

31. Karen E. Smith, "Framing Quilts/Framing Culture: Women's Work and the Politics of Display," PhD diss., University of Iowa, 2011, http://ir.uiowa.edu/cgi/viewcontent.cgi?article=2468&context=etd.

32. NAMES Project Foundation, http://www.aidsquilt.org/about/the-names-project-foundation.

33. Mickey Weems, Marsha MacDowell, and Mike Smith, "The Quilt," *Qualia Encyclopedia of Gay Folklife*, December 8, 2011, http://www.qualiafolk.com/2011/12/08/the-quilt.

34. AIDS Quilt Touch, http://aidsquilttouch.org.

35. Project Linus, https://www.projectlinus.org.

36. Quilts for Kids, www.quiltsforkids.org.

37. "ABC Quilts," American Mothers, http://www.americanmothers.org/abc-quilts. "N. H. Quilting Project Delivers Love and Comfort Worldwide," narrated by Eric Larrabee, New Hampshire Public Radio, July 9, 2015, http://nhpr.org/post/archives-nh-quilting-project-delivers-love-and-comfort- worldwide.

38. Wrap Them in Love, http://www.wraptheminlove.com/index.html.

39. "The LWR Quilt Campaign," *Lutheran World Relief*, http://lwr.org/site/c.dmJXKiOYJgI6G/b.8107877/k.B058/2013_LWR_Quilt_Campaign1_Year500000_Quilts.htm.

40. "Mission Quilts," Lutheran World Relief, http://lwr.org/quilts.

41. For more about these relief sales, see "Relief Sales," *Mennonite Central Committee*, http://mcc.org/get-involved/relief-sales. See also Bill Tameus, "Mennonite Women Quilt for a Cause—Their Church," *St. Augustine Record*, April 29, 2005, http://staugustine.com/stories/042905/rel_3045894.shtml#.VtUQ1hGRRtI; Quilting Culture, http://www.quiltingculture.com/index.html; and Karen E. Smith, "Framing Quilts/Framing Culture."

42. Quilting Culture, http://www.quiltingculture.com/pages/ourproject/kaleidoscope.htm.

43. "History," Pennsylvania Relief Sale, http://pareliefsale.org/about- us/history.

44. As examples, see "Ann's Quilt Journal," Ann's Multiple World of Personality, http://www.annmultipleworldofpersonality.com/p/resume.html; "Endometriosis Quilt," *EndoTimes*, http://endotimes.blogspot.com/2007/03/add-your-name-to-endometriosis-quilt.html; Susan Fitzgerald, "Plain People, Exotic Illnesses Pennsylvania's Amish and Mennonite Populations Carry Dozens of Diseases Nearly Unknown Anywhere Else," *Philly.com*, December 1, 2002, http://articles.philly.com/2002–12–01/news/25359231_1_clinic-for-special-children-lights-long-bulbs; and Kevin Howell, "Traveling Quilt Raising Awareness of Cancer-Like Disease," *Salem News*, January 26, 2014, http://www.salemnews.net/page/content.detail/id/570443/Traveling-quilt-raising-awareness-of-cancer-like-disease.html?nav=5007.

45. Tony Reid, "Moweaqua Woman Participates in Parkinson's Quilt Project for World Congress," *Herald & Review* (Decatur, IL), May 19, 2010, http://herald-review.com/news/local/moweaqua-women-participates-in-parkinson-s-quilt-project-for-world/article_e5de80be-1b8e-5dd6-89c8-1a424a47376f.html. See also "Piecing for Parkinson's," Parkinson's Comfort Project, https://parkinsonscomfort.org/hello-quilters/p4p.

46. For instance, see "Display the Parkinson's Quilt," Parkinson's Disease Foundation, http://www.pdf.org/quilt. See also *Creativity & Parkinson's Quilt Project 2010* (New York: Parkinson's Disease Foundation, 2010).

47. "Arts and Health Program," Great Lakes Folk Festival, http://www.greatlakesfolkfest.net/glff2016.

48. "Memorial Quilts," San Antonio Eye Bank, http://www.saeyebank.org/search-memorial-quilts.php?page=0; "Donor Memorial Quilts," Midwest Transplant Network, http://www.mwtn.org/quilt?quilt=1; "The Donor Quilt," National Kidney Foundation, https://www.kidney.org/transplantation/donorFamilies/quiltPatch.

49. "IBD Quilt Project," Facebook, https://www.facebook.com/IBD-Quilt-Project-IQP -125862724159873/info/?tab=page_info.

50. Susan G. Komen Race for the Cure, http://ww5.komen.org/findarace.aspx.

51. Neighborhood Ford Store Warriors Quilt Project, http://www.quiltforthecure.com. See especially "Warriors in Pink Quilts, Susan G. Komen Race for the Cure Patchwork Stations," Neighborhood Ford Store Warriors Quilt Project, http://www.quiltforthecure.com. See also "2013 Ford 'Warriors in Pink' Quilt Presented to Images Breast Imaging Center at Trinity," Trinity Health System, http://www.trinityhealth.com/news/articles/2013/sep/24/2013-ford-warriors-pink-quilt-presented -images-bre.

52. Kelly M. Power-Kean, "A Stitch in Time: Women and Heart Health Quilt Project," *Canadian Nurse* 97, no. 6 (2001): 30–32.

53. "Have a Heart, Make a Quilt Campaign," Accuquilt, http://www.accuquilt.com/shop/heart.

54. "American Heart Association Sponsors Juried Quilt Show," January 13, 2016, New England Quilt Museum, *Our Blog* Archives, http://nequiltmuseum.org/blog/american-heart-assn-sponsors-juried -quilt-show.

55. "Go Red for Women Quilt Program—2010," UW Health, http://www.uwhealth.org/go-red /go-red-for-women-quilt-program-2010/29424; and "American Heart Association's 'Go Red for Women' Quilt Display Coming to Fort Atkinson," Fort Health Care for Health, January 19, 2010, https://www.forthealthcare.com/news/american-heart-associations-go-red-for-women-quilt -display-coming-to-fort-atkinson.

56. See, for instance, Laura Zander, *Sew Red: Sewing & Quilting for Women's Heart Health (Stitch Red)* (New York: sixth&springbooks, 2013); see also Katie Blakesley, "Cross Roads Block Tutorial," *Swim Bike Quilt*, April 3, 2012, http://swimbikequilt.com/2012/04/cross-roads-sew-red-for-women-block.html.

57. Prairie Point Quilts in Shawnee, Kansas, showcased new and old red and white quilts that were auctioned off to support the American Heart Association. Barbara Brackman, "Red and White," *Material Culture*, February 22, 2012, http://barbarabrackman.blogspot.com/2012/02/red-and-white .html.

58. "Local Quilts," National Kidney Foundation, https://www.kidney.org/transplantation/donor families/quiltlocal.

59. "The Donor Quilt," National Kidney Foundation, https://www.kidney.org/transplantation /donorFamilies/quiltPatch.

60. Alzheimer's Association, http://www.alz.org/facts/overview.asp.

61. Alzheimer's Art Quilt Initiative (AAQI), http://www.amisimms.com/aaqi.html.

62. Sue Loughlin, "Quilts of Honor," *Tribune Star* (Terre Haute, IN), November 10, 2015, http://www.tribstar.com/news/local_news/quilts-of-honor/article_d0a97b12-f52e-559b-b310– 9cff42ede706.html.

63. Quilts of Honor, http://quiltsofhonor.org.

64. Loughlin, "Quilts of Honor."

65. For quilts associated with Desert Storm, see Nancy Cameron Armstrong, "Quilts of the Gulf War, Desert Storm—Participation or Protest?" in *Uncoverings 1992*, edited by Laurel Horton, 9–44 (San Francisco: American Quilt Study Group, 1992).

66. Home of the Brave Quilts, Facebook, https://www.facebook.com/media/set/?set=a .162928430406307.35364.162638487101968&type=3. For more see Jonathon Gregory, "Wrapped in Meanings: Quilts for Families of Soldiers Killed in the Afghanistan and Iraq Wars," in *Uncoverings 2010*, edited by Laurel Horton, 161–204 (Lincoln, NE: American Quilt Study Group, 2010).

67. For more about quilts for the Sanitary Commission, see Pamela Weeks and Don Beld, *Civil War Quilts* (Atglen, PA: Schiffer Publishing, 2011); Bets Ramsey and Merikay Waldvogel, *Southern Quilts: Surviving Relics of the Civil War* (Nashville: Rutledge Hill Press, 1998); Gunn, "Quilts for Union Soldiers," 95–121; and Virginia Eisemon, "Sunday School Scholars Quilt: Civil War Textile Document," in *Uncoverings 2004*, edited by Kathryn Sullivan, 41–78 (San Francisco: American Quilt Study Group, 2005).

68. Tammy Krikorian, "Support Offered for Victims of Agent Orange Exposure," *Reno Gazette-Journal*, November 7, 2010, http://www.rgj.com/article/20101107/NEWS/11070349/1321/NEWS. This site is no longer accessible, but additional information on this project can be found at "Agent Orange Quilt of Tears," http://www.vietnamproject.ttu.edu/inmemory/vietwarmem/aoquilts.htm.

69. Freedom Quilts, http://freedomquilts.net.

70. Mo Haider, "Families Share Unique Bonds through Freedom Quilts," Siouxlandmatters.com, April 4, 2015, http://www.siouxlandmatters.com/news/local-news/families-share-unique-bond-through -freedom-quilts.

71. Camo Quilt Project, http://camoquiltproject.blogspot.co.za; see also Sara Bagwell, "Military Mom Pays It Forward," *Bristol-Warren Patch*, February 24, 2012, http://patch.com/rhode-island/bristol-warren /military-mom-pays-it-forward-with-camo-quilts.

72. For instance, see Quilts of Valor, http://www.qovf.org.

73. "Quilts of Valor Foundation History," Quilts of Valor, http://www.qovf.org/about-qovf/qov -history.

74. Ibid.

75. "Basic Requirements," Quilts of Valor, http://www.qovf.org/quilters-questions/basic -requirements; see also "Fabric and Pattern," Quilts of Valor, http://www.qovf.org/quilters-questions /fabric-pattern.

76. Peggy Luck, quoted in Giseelle Arredondo, "Quilts of Valor: Veterans Get Wrapped in Personalized Quilts Presented by Needles and Friends," *Leader & Times* (Liberal, KS), November 11, 2013.

77. Caroline and Lee [no last name given], "Wrapped in Red, White, and Blue," letter to QOV, *Quilts of Valor*, posted by Karla Locke, April 15, 2014, http://qovf.blogspot.com/2014/04/wrapped-in-red-white -and-blue.html.

78. See information regarding the Rajah quilt in Marsha MacDowell, Mary Worrall, Lynne Swanson, and Beth Donaldson, *Quilts and Human Rights* (Lincoln: University of Nebraska Press, 2016), 5–7.

79. "Helping Hands in the Hoosegow: State's Inmates Knitting, Quilting for Charities," *Winona Daily News*, June 18, 2007, http://www.winonadailynews.com/news/helping-hands-in-the-hoosegow-state-s -inmates-knitting-quilting/article_05e2b6c2–5c36–5f01-a21d-ca03303cb172.html.

80. Ibid.

81. Kathy Hedberg, "Quilts Blanket Prison Inmates with Hope," *Lewiston Tribune*, November 26, 2012, http://www.idahopress.com/news/state/quilts-blanket-prison-inmates-with-hope/article_42de65e2 -a34a-51e2-9a45-8072ad2a487e.html.

82. Ibid.

83. James Chilton, "Detention Center Teaches Female Inmates to Quilt," *Wyoming Tribune Eagle*, April 24, 2016, http://www.wyomingnews.com/news/detention-center-teaches-female-inmates-to-quilt /article_0e80e6c4-09d9-11e6-b597-ffe7121e44e9.html.

84. See abstract for Debora J. Halbert, "The Labor of Creativity: Women's Work, Quilting, and the Uncommodified Life," *Transformative Works and Cultures* 3 (2009), http://journal.transformativeworks.org /index.php/twc/article/view/41/118.

85. See abstract for Marybeth C. Stalp, "Women, Quilting, and Cultural Production: The Preservation of Self in Everyday Life," PhD diss., University of Georgia, 2001, http://athenaeum.libs.uga.edu /handle/10724/20448; and Marybeth C. Stalp, *Quilting: The Fabric of Everyday Life* (Oxford, NY: Berg, 2007).

86. See Stalp, "Women, Quilting, and Cultural Production"; and Stalp, *Quilting*.

87. Ibid. .

88. Carla Fisher, email to Beth Donaldson, December 19, 2015.

89. Claudia Feldman, "Libby Lehman Qualifies as the Quilting World's Comeback Kid," *Houston Chronicle*, October 23, 2015, http://www.houstonchronicle.com/entertainment/arts-theater/article /Libby-Lehman-qualifies-as-the-quilting-world-s-6587256.php.

90. For deeper exploration, see Lora J. Bristow, "Women's Work: Social Relations of Quilting," MA thesis, Humboldt State University, 2013, http://humboldt-dspace.calstate.edu/handle/2148/1468.

Quilts in Healing Environments and Clinical Care

One goal of this book is to describe the many ways quilts and quiltmaking are being used in relation to health—from raising public awareness, as in the example of the national AIDS quilt, to comforting victims of war and natural disaster. In chapter 3 we provided empirical evidence of the association between art and positive, measurable health outcomes, along with nascent evidence of such impact related to quilts in particular. Even in the absence of scientific "proof," quilts have been used in clinical settings for years to help create a healing environment, and their use in actual clinical practice is rapidly expanding. It now goes well beyond just giving patients quilts for spiritual and physical comfort. There are countless examples of clinics, residential facilities, and hospitals in which quilts have become part of the milieu and are used as a therapeutic "intervention."

Quilts and Healing Environments

Health care is increasingly moving away from a disease-based medical model to a more holistic model with greater emphasis on multiple dimensions of "good health," such as psychological and social well-being and their contributions to the healing process. The value of beauty and the arts to a sense of well-being and quality of life has long been recognized. Long before antibiotics and advanced medicine, attention to the environment helped form the logic behind the development of sanatoriums and health resorts where patients were exposed to nature, fresh air, and aesthetically pleasing surroundings. More recently, Roger Ulrich provided some of the first empirical evidence that a view of nature out a hospital window can make a positive difference in health outcomes, including a decreased length of stay and lower narcotic use for pain.[1] It doesn't take much of a stretch to posit that the interior physical environment may also affect health outcomes. If guided imagery, in which people picture a peaceful place in their minds, can help reduce anxiety and stress, it stands to reason that an actual peaceful place will contribute to similar results. Quilts, as both an object of beauty and symbol of comfort, now adorn clinical walls as a strategic way to help people cope and heal. They are therapeutic for patients and staff alike.

Joanne Lester and Amy Rettig describe what now seems to be a typical case in which a young woman, newly diagnosed with invasive cancer, arrives at her first clinic consultation, frightened and uncertain of her future. She later recalls that "the colorful quilt on the conference room wall remind[ed] her of her grandmother's home, and the soft quilts she curled

up with as a child," and how she quietly thanked "someone" at the clinic for providing the distraction.[2] The authors, both oncology nurses, laud quilts as supportive care in disguise and argue for recognizing the physical environment for its therapeutic value. Lynn Lancaster Gorges, from New Bern, North Carolina, echoes the value of aesthetics in the following story:

> My mother was in a nursing home for a total of 17 years after a stroke at age 67. I realized that too often people in the medical needs area of care were cared for physically, but not mentally/emotionally/visually. So often I thought of the "hyacinths" for the soul poem. Loosely . . . if you have 2 pence use one for bread and the other for hyacinths for the soul. People who have medical needs don't get enough hyacinths. Our mother was given a lovely signature quilt by her Extension Homemakers Group that we hung on her wall and then decorated the nursing home room in those same colors. . . .
>
> We need to treat the aesthetics/individuality of people receiving medical treatment. That is often just as important as the equipment, the tests, etc. It is hyacinths for the soul.[3]

Lisa Ellis, founder of Fiber Artists @ Loose Ends, is committed to providing more hyacinths in the form of art quilts that make a difference in the lives of patients and their families. Members of Fiber Artists @ Loose Ends were inspired by the actions of Judy House, Ellis's quilt instructor, who died of breast cancer in 2005. Before her death, House organized a group of thirty-seven art quiltmakers to make art quilts based on the plants and animals used in chemotherapies. Through this activity, the organization Healing Quilts in Medicine was conceived. These quilts now hang in the oncology unit of Walter Reed National Military Medical Center. Fiber Artists @ Loose Ends carries on House's legacy and is "dedicated to projects that bring beauty and education through art quilts into hospitals."[4] In 2012 the organization was brought under the umbrella of the organization Sacred Threads. In addition to Walter Reed, "Healing Quilts" are now on display at the University of Michigan's Brehm Center for Diabetes Research, Comprehensive Cancer Center, and Center for Organogenesis; the National Institutes of Health; and other major institutions. An illustrative story of the value of these quilts to health involves a patient returning to the Walter Reed Cancer Unit who requested that the "funereal landscape print" in her room be removed and replaced by one of the framed wall quilts hanging in the hall, quilts from the Healing Quilts "Natural Healing" project collection.[5]

Figure 5.1. *Castor Bean (Ricinus communis)*, Lisa Ellis, Fairfax, Virginia, 2012. Collection of Inova Fair Oaks Hospital, Fairfax, Virginia. Photo by Bonnie McCaffrey.

Ricinus Communis was made for a special exhibit at the National Institutes of Health (NIH) featuring pharmaceutical plants and animals that are used to make cancer treatments. The collection of 30" × 30" art quilts hung in a public area in the clinical center for a year. Following their debut at NIH the Healing Quilts in Medicine exhibit traveled with the International Quilt Festival to Chicago, Long Beach and finally to Houston where we inspired other quilters to use their passion to make work for their local hospitals. The collection of quilts is now permanently installed at the Inova Fair Oaks Hospital Cancer Center in Fairfax, Virginia. I chose the Ricinus Communis, commonly known as the Castor Bean because of its promise in melanoma treatment. My husband is a twenty-four-year survivor. Ricinus Communis is a source of ricin. Ricin is used against metastatic melanoma, metastatic colon cancers, and other cancers.

Figure 5.1., continued

In addition to my own art, I seek to make the world a better place through the Healing Quilts in Medicine initiative, which commissions art quilts for installation in hospitals to improve the healing environment for patients and their families. I have witnessed the transformation of clinical areas through installations of art quilts. The feedback from patients and their families is overwhelming. Not only is the art itself beautiful and supports the healing process, but the use of cloth and stitches, and the depth of the layers, draws the patient into the piece and provides connections to family, memories of childhood, cherished ancestors and traditions.

(Lisa Ellis *Healing Quilts Exhibition: Featuring Plants Used in Cancer Treatments.*
Fiber Artists @ Loose Ends, privately printed, 2012; see also http://www.ellisquilts.com.)

Figure 5.2. *True Indigo (Indigofera tinctoria)*, Bunnie Jordan, Vienna, Virginia, 2012. 30" × 30". Collection of Inova Fair Oaks Hospital, Fairfax, Virginia. Photo by Lisa Ellis.

This particular piece pays tribute to Brad Jordan, who died in 1998 at age sixteen of Stage IV Hodgkin's Lymphoma. According to Jordan, Indigo tinctoria "is active against chronic myelogenous and other leukemias as well as some lung cancers. The aerial parts of the plants are being researched for antihepatoxic properties. I chose to focus on the blossom part of the plant as blossoms have long been thought to symbolize the promise of life." Jordan made this piece for an exhibition of quilts based on plants and animals used in cancer research today or are being used in clinical trials. In 2014 the exhibition was permanently installed at the cancer center at Inova Fair Oaks Hospital, in Fairfax, Virginia (quoted in Lisa Ellis, *Healing Quilts Exhibition: Featuring Plants Used in Cancer Treatments*. Fiber Artists @ Loose Ends, Privately Printed, 2012; artist statement and materials sent to Beth Donaldson, May 3, 2016; see also http://bunniejordan.com.)

The Lombardi Comprehensive Cancer Center (LCCC) at Medstar Georgetown University Hospital in Washington, D.C., is another facility where quilts decorate the walls. Lauren Kingsland, fiber artist/quilter and professional artist for the Lombardi Arts and Humanities Program says that their mission is to engage patients, families, and staff in the healing power of art through quiltmaking, sewing, music, painting, dance, writing, and other art forms: "When we engage in any creative activity we tap into our inner reservoirs for coping, resilience and hope." The program started in 2000 with a class on quiltmaking held in the infusion unit. Today quilts made through community participation that are on display throughout the hospital are reminders of the importance of creative expression and self-care in dealing with illness and stress and preventing burnout. Kingsland describes an offshoot project meant to help staff of the neonatal intensive care unit deal with grief. Weekly sewing classes held from January 2013 to July 2014 gave staff a chance to create pieced butterfly blocks in honor of babies with brief lives. The blocks were sewn onto an altar cloth which continues to be used during an annual service of remembrance. Other projects have resulted in a new canopy over the coffee cart in the LCCC clinic; a quilt "house" pieced around text written by patients, families, and staff; and seven-inch mug mats, which "are an ideal handwork activity for patients or companions during the tethered hours of infusion."[6]

Even major corporations and organizations now recognize the role that quilts can play in creating healing environments. The Ford Motor Company, a supporter of the Susan G. Komen Race for the Cure, has presented multiple quilts to hospitals and breast cancer clinics in Pennsylvania, Ohio, West Virginia, and Maryland.[7] The quilts, associated with breast cancer, are predominantly pink and are made by patients and family member volunteers. When Wheeling Hospital's Comprehensive Breast Care Center received a quilt from local Ford dealerships, the hospital manager, Deb Radosevich, said, "The quilt will serve as a constant reminder to our patients and their families that there is hope and success. It also is a reminder that many people are thinking of and praying for them."[8] Other hospitals commission professional quiltmakers to create quilts for specific clinic locations and purposes. Bernie Rowell, an artist from Asheville, North Carolina, and a longtime member of the Southern Highland Craft Guild, says that commissioned work is her bread and butter. Her painted quilts can be found in hospitals and major medical centers across the United States. In her words, "Many of my art quilts grace hospital walls such as Kaiser Permanente in California. I love the role these healing quilts play in health care."[9] On a personal note, Rowell says, "I have to be an artist; it's how I heal myself."[10] In addition to commissioned artists, hospitals are hiring art consultants. Lin Swensson is an art consultant with Capital Health in Hopewell, New Jersey, who is incorporating the quilts of Kate Graves into a new state-of-the-art oncology center; the quilts are made of fabric chosen by the oncology staff.[11] Similarly, Christine Mauersberger is an art consultant, designer, and textile artist who has overseen the preparation and installation of artwork, including quilts, from regional and national artists for three major northeast Ohio hospital systems. At Henry Ford Hospital in Dearborn, Michigan, she worked with Gayle Pritchard, a fiber artist, curator, lecturer, and teacher, who provided advice and counsel on the installation of the Dr. Karen J. Stuck Memorial Art Quilt in the Fairlane Mammography Clinic. As part of the installation celebration, Pritchard spoke on the renaissance of art quilts in the Midwest, with an emphasis on the health-care

environment.[12] The Detroit Receiving Hospital has one of the major hospital art collections in the country, providing an enhanced healing environment for patients and families as well as a sense of well-being for staff. Art is installed in patient rooms, corridors, waiting rooms, reception areas, and meditation spaces. Detroiter Carole Harris was commissioned to create one of several quilts in the collection, and her *City Rhythms* is installed in the emergency room entrance. The collection also contains historical quilts by unidentified artists.[13]

Adorning walls with quilts changes the physical environment from one that is austere and clinical, even cold, to one that is warm, infused with beauty, perhaps memory, and comfort. It signals a shift in health-care culture, one that is demonstrated in other ways as well. The Radiological Society of North America provides an illustrative example of how health care is becoming more relationship oriented with their virtual quilt. *The Caring Quilt: Messages from Our Patients* is an online "quilt" that gives patients and family members an opportunity to express appreciation for their radiologist's care by posting messages that are laid out in a pattern of squares on-screen.[14] Other hospitals are providing quilt rooms, such as the one at McKay-Dee Hospital in Ogden, Utah, where volunteers make full-size quilts by hand that are commissioned or sold in the gift shop to purchase equipment for the hospital, everything from wheelchairs and surgical equipment to treadmills and infant warming beds.[15] Until recently, the Lilly Foundation held an annual Lilly Oncology on Canvas (LOOC) Art Competition, through which thousands of people shared their stories through art and narrative.[16] The program has now evolved beyond the original format. It is no longer competitive but reflects a mission to "give those affected by cancer an outlet to share their cancer journey through creative expression."[17] One such person is Judy Elsley, a quilt historian and artist who was diagnosed with breast cancer in 2012 and took first prize in the LOOC 2012 competition. She says of her winning quilt, "This quilt shows visually the work of chemotherapy as it flows through the port into my blood stream. The colored beads represent the chemo, and the white beads signify white blood cells helping my body move towards health. I visualize the future in the smallest plume on the right side of the quilt, a time when my blood stream will carry plenty of white blood cells, no chemo or cancer present."[18]

Patients involved in national clinical trials have been given the opportunity to express the human experience of their illness through quilts as in the case with the Women's Health Initiative (WHI), a long-term national health study aimed at preventing heart disease, breast and colorectal cancer, and osteoporotic fractures in postmenopausal women. It is a telling sign of a shifting health-care environment when patients from multiple clinics involved in the WHI participate in making quilts for both individual and collective good. Each block is accompanied by a personal statement, and together these statements communicate a powerful message of "generosity, diversity and commitment to leaving a legacy of knowledge about women's health for future generations."[19]

Joyce Graff, another cancer survivor and a member of the Uncommon Threads Quilt Guild, created a quilt design in 1979 titled *Healing Garden* in response to the guild's challenge to create a group of quilts to hang in the new Women's Health Center at Baptist Memorial Hospital in Memphis, Tennessee. Graff based her design on a painting by Dennis McGregor of Sisters, Oregon, and used fabrics designed by Bonnie Benn for the Healing Garden collection produced by Timeless Treasures. The fabrics depicted plants used in the treatment of

Figure 5.3. *The Yellow Boat*, Dawn Sees, Columbia, Missouri, 2011. Collection of the University of Missouri Women's and Children's Hospital. Photo by Justin Kelly, University of Missouri Health Care photographer, courtesy University of Missouri Health Care.

While Dawn Sees was earning a graduate degree in art education at University of Missouri, she worked with thirty patients at the University of Missouri's Children's Hospital on a quilt project that combined her work in art, technology, and education as an applied healing therapy for hospitalized children. Her design for the quilt was inspired by David Saar's *The Yellow Boat*, a children's book about a young boy with a fatal disease who nonetheless finds courage to sail forward in life. Thirty patients each contributed "at least one small printed image to the quilt as well as some written words about things they love and fill them with happiness." A group of young actors from Columbia, Missouri, performed *The Yellow Boat* play when the quilt was unveiled for public viewing. The quilt is permanently installed at the Children's Hospital (Dawn Denise Sees, email communication to Marsha MacDowell, June 3, 2011; Quilt Index documentation form submitted by Sees to the Michigan State University Museum; see also Dawn Sees and Kathleen Unrath, "The Yellow Boat Project: How Art Heals, Connects and Transforms," *Canadian Review of Art Education* 42 (2015): 44–56).

cancer and other illnesses. In the squares of muslin in the background, Graff integrated signature blocks with the names of people who have had breast cancer. In 2003 Graff made a second version of the quilt, this time in honor of her son and donated it to the Transplant Center of Beth Israel Deaconess Hospital, Boston, Massachusetts, where it hangs in the family conference room.

There are endless other examples of quilts in hospitals and clinical settings that have helped to create a healing environment, to comfort and establish a greater sense of well-being. We offer just a few more moving stories among hundreds. Many groups choose to focus their charity work on sick newborns and young children. The Angel Quilt Project, a large enterprise founded in 2000, has donated thousands of quilts, handmade by volunteers, to hospitals in the United States, Canada, and the United Kingdom for families with premature babies.[20] Smaller groups, such as the Piece-Makers Quilt Group in Dexter, Michigan, do similar work. Member Elaine Owsley says, "Parents usually can't bring anything from home to the hospital, so when the quilts come in, it brightens the room for their kids. We get a lot of letters from parents thanking us, which is very rewarding. Perhaps the saddest part of this project is hearing that some quilts go home from the hospital but the children do not."[21]

"Heaven Scent" groups are now engaging in a new kind of quilting ministry focused on babies who are sick. They typically give the mothers of newborns in neonatal intensive care units (NICUs) two quilted blankets. Based on the idea that a mother's smell is important to the baby's comfort, development, and health, the mother wears one of the blankets throughout the day to give it her scent; then she takes it to the NICU for the baby to be wrapped in it while she wears, and thus puts her scent on, the other. To give an idea of the magnitude of such projects, just one group alone, made up of volunteers from Christ Our Savior Lutheran

Figure 5.4. Facing: *Healing Garden*, designed by Joyce Graff, quilted by Wilma Cogliantry, Brookline, Massachusetts, 2003. 40" × 40". Collection of the Transplant Center, Beth Israel Deaconess Hospital, Boston, Massachusetts. Photo courtesy of Joyce Graff.

In 2001 I donated a kidney to my son who has von Hippel-Lindau, a genetic condition that increases the chances of getting tumors in six different organ systems, including the kidney. Had four kidney surgeries to remove early-stage kidney cancer tumors, avoiding metastasis but leaving him on dialysis. It was my privilege to share my own kidney with him—markedly improving his health and quality of life. For me it was also a personal victory—having survived breast cancer in 1979 I was well enough in 2001 to be able to donate a kidney for him. In celebration of these twin victories, and in gratitude to the staff of the Transplant Center at Beth Israel Deaconess Hospital in Boston, I made this quilt and presented it to them.

(Joyce Graff, artist statement and materials sent to Beth Donaldson, January 5, 2016.)

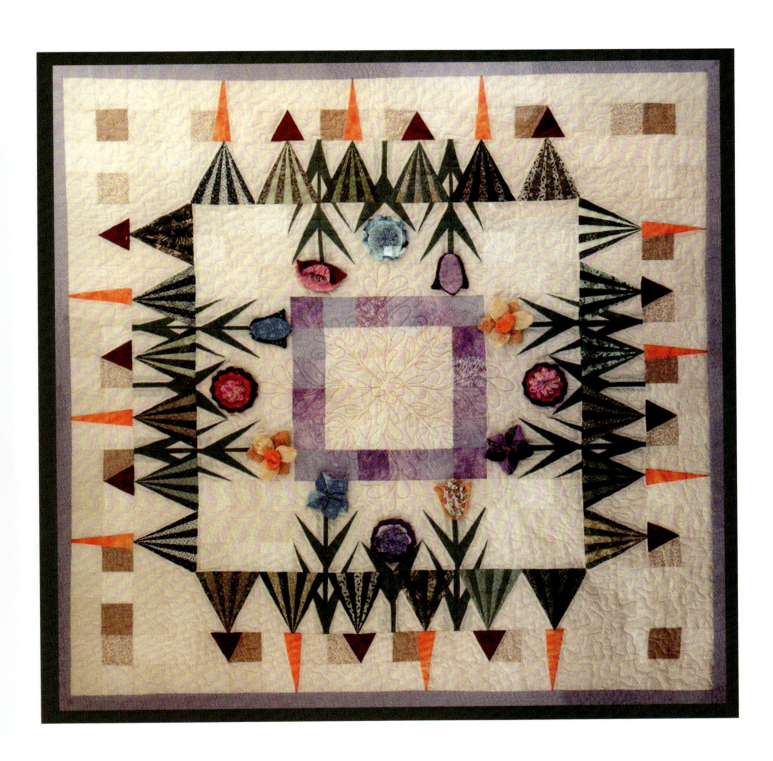

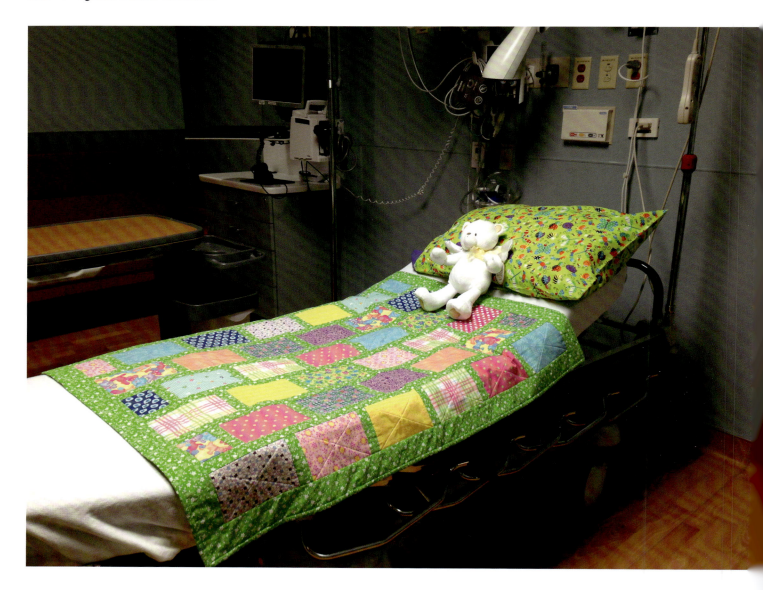

Church in Loudon, Tennessee, has donated nearly eight thousand quilts since 2005 to the East Tennessee Children's Hospital in Knoxville.[22]

Quilts also provide solace to older children facing difficult situations ranging from eating disorders to sexual abuse. Quiltmakers in Palatine, Illinois, made and donated quilts to Northwest Treatment Associates to comfort teenage girls who had been sexually abused. Executive director and therapist Carol Fetzner stated, "The girls were really astonished that these quilts were given to them.... They are extremely well made and quite beautiful and precious." The quilts had multiple healing consequences. They "created a new context . . . a new sense of safety in their bedrooms [where the abuse or subsequent nightmares may have taken place]." They prompted meaningful discussions about how each girl is unique and beautiful, just like the quilts, and how there are people who do bad things but also those who do good things.[23]

Figure 5.5. Facing: "Giving Comfort to Children."
Photo by Sandra Hess, courtesy the Riverwalk Quilters Guild.

Members of the Riverwalk Quilters Guild of Naperville, Illinois, generously make quilts, pillowcases, and other handmade items to distribute to local charities and people in need, including the Edward Hospital Care Center, which exists to help children, teens, and special needs adults who are known or suspected to be victims of sexual abuse. On one occasion Sandra Hess and another guild member visited the hospital's Pediatric Sexual Abuse Center. Hess said this about the experience:

> The specialist told us that because of the extreme fear that children have of this [examination to determine the nature and extent of abuse], the room is equipped with anything that might be needed. There is no waiting to get something for the exam. This is a room with a small chrome bed and all the equipment necessary for gynecological exams. In other words, thinking of the past abuse and the present use of the room, our blood ran cold. As we fought tears, our guide asked us to step outside the room while she transformed it with a bright quilt, pillowcase, and a teddy bear with a necklace. The picture tells the story of how a terrified child, grasping the nurse as he or she is carried in, sees the new room. It was explained to us that the child is told they get to have everything and quite often their little shoulders start to relax. Every month when we take our stack of beautiful child size quilts to this department, our minds are given over to the horrors these children have lived through and we are inspired to continue taking as many quilts as possible.

(Sandra Hess, email communication to Beth Donaldson, December 29, 2015).

At the other end of the age spectrum, quilts are being made by and for older adults to demonstrate care and respect, add to quality of life, and promote healing.

> Marie Bryant, 71, clearly recalls the day she delivered her group's quilts to residents of a nursing home in Franklin County.
>
> "The staff told me about this one woman who never got out of bed, so I left her quilt for last," she said.
>
> Bryant assured the elderly woman that the quilt was free and she picked one out.
>
> "I went back to the nurses station and I turned around, and there she was, out of her room," Bryant said.
>
> For members of the Red Hill Baptist Quilters, founded by Bryant in 1989, quilts offer comforts both tangible and intangible.[24]

Quilts are being made by nursing home residents to drape over the bodies of friends who have died and are being carried out of the facility on gurneys. A nurse in Grand Rapids, Michigan, tells the story of a nursing home resident who asked why new residents came in through the front door while those who died were taken out the back door, without any acknowledgment or ceremony. The resident expressed her feelings about the difficulty of not knowing what has happened to a fellow resident and not being able to mark the passing or honor the person's life in a dignified manner. The nurse agreed and advocated for a change in policy; people who died would be taken out the front door, and the residents and staff would have the opportunity to recognize their lives. An idea developed to make quilts to cover the person as they left the facility. Over time, these quilts, many made by the residents themselves, became more personalized, and eventually residents began making quilts for themselves in anticipation of their own deaths, using familiar fabrics and favorite colors.[25]

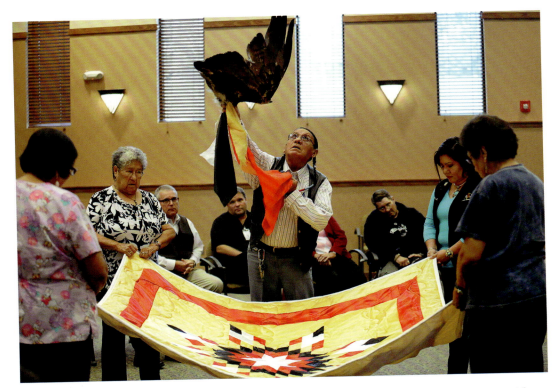

Figure 5.6. North Cheyenne Elders Ceremony, October 2012, at the Willows, Red Lodge, Montana, with quilt made by Mary Leadom. Photo by James Woodcock/*Billings Gazette* staff.

When a wildfire destroyed the Heritage Living Center assisted living home in Billings, Montana, St. John's Lutheran Ministries provided its forty residents with week-long shelter at the Willows, its new assisted living center in Red Lodge. In gratitude, the Heritage residents gave St. John's officials a traditional Cheyenne star quilt during a blessing ceremony led by "Cheyenne elder Clinton Bird Hat—a Heritage Living Center resident, powwow fancy dancer, and Vietnam War veteran."

> Bird Hat waved an eagle wing over the quilt, held at the corners by four women elders. Scarves in the quilt's vibrant yellow, red, black and white had been attached. Bird Hat knelt on one knee and sang a song in Cheyenne.
> He then draped the quilt around the shoulders of David Trost, St. John's regional administrator, and Michelle DeBoer, The Willows administrator, and offered another blessing.
> Susie Cain, a Heritage Living Center resident whose niece . . . made the quilt, thanked the group.
> "We were tired. Some of us were sick from the smoke. We were afraid for our grandchildren and relatives back home. Your staff made us feel at home. . . .
> That was really kind of them. . . .
> Lots of Indians are not treated with respect. . . .
> We will always keep you in our hearts and prayers."

The quilt now hangs at the Willows.
(Claire Johnson, "Northern Cheyenne Elders Thank St. John's with Quilt," *Billings Gazette*, October 17, 2012, http://billingsgazette.com/news/state-and-regional/montana/northern-cheyenne-elders-thank-st-john-s-with-quilt/article_e6d56dd6-fe60–5745-a2dd-3a69eb0ce934.html.)

At the Cheyenne Veterans Administration Medical Center, red, white, and blue quilts made by volunteers are given to veterans in the final days of their lives and then draped over the gurneys and gurney blankets that cover the bodies of deceased veterans as they are taken out of the facility. Chaplain Carol Carr, chief of chaplain services, explains, "When veterans die at the VA Medical Center, they are removed from the facility in a Final Salute ceremony. . . . Anyone there at the time a veteran is removed—doctors, nurses and other employees as well as residents—stop to salute the person as the gurney is wheeled out."[26] She describes why the hospital established such a practice of respect:

"Typically when a person dies at a hospital or nursing home anywhere in this country, the funeral home removes the body on a covered gurney in a very professional and discreet manner. That's so most patients and staff remain unaware that a death has occurred." Then, Ron Martin, a nursing supervisor and a veteran, suggested that employees and anyone else present should pause and provide a Final Salute as the gurney passes. By 2010 the staff was providing a Final Salute to all veterans who died, day or night. Carr explained that "to add to the ceremony, we began to drape the gurney in a red, white and blue afghan." Since 2013, on the suggestion of Sue Tardif, a VA Medical Center nurse and volunteer, donated quilts have been used to drape the gurney and then given to family members of the veteran.[27]

Figure 5.7. Hospital staff recreate the "Final Salute" they give patients who die.
Photo by Pamela L. Hill, courtesy Cheyenne Veterans Administration Medical Center.

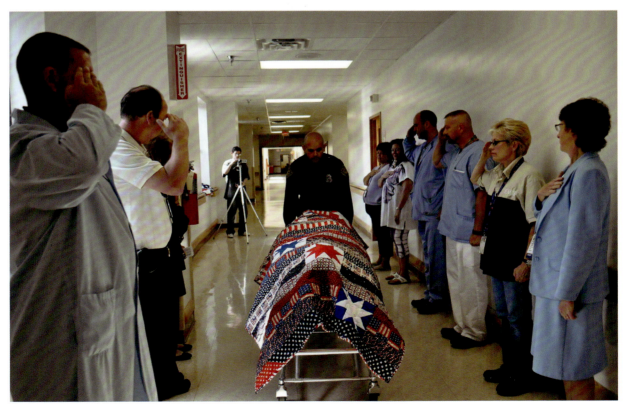

Final salutes are an attempt to make health care more humane and dignified, to show respect to individual patients and their families. In a more lighthearted way of being sensitive to the importance of treating people with respect and compassion, some quilt groups are now making "dignity robes," which are used with conventional hospital gowns to cover the backside opening and provide privacy.

A quilt is being used at the Beth Israel Deaconess Medical Center, a major teaching hospital of Harvard Medical School, as a source of inspiration for individuals who are undergoing weight loss treatments. In their outpatient bariatric clinic, a "Now I Can" quilt hangs by the scale, a location that no patient can avoid. "Patients and staff collaborated to create the quilt, in which each square lists something a patient can now do after experiencing weight loss following surgery." It tells stories that inspire other patients, such as that of Donna Foley-Hodges, who says, "Now I can walk longer distances, sit in a chair without fear of breaking it, and go to a theater without the embarrassment of not fitting in the seat. I can dance and just did so for the first time in 20 years! Now I can blend into the crowd instead of standing out because of my size, and be happier and healthier than I have been for the majority of my life."[28]

Quilts and Clinical Practice

In a clinical practice setting, quilts can educate patients about clinical procedure options that save lives, such as quilts that have been displayed at the Meadowview Regional Medical Centre in Maysville, Kentucky, to promote organ donation. Each square represents someone who died and became an organ and tissue donor, potentially saving the lives of three others. Quilts can raise awareness of issues ranging from the impact of war to human trafficking, awareness that can lead to policy and practice change. The medical world can and should provide physical, digital, and other environmental venues that reflect cultural and societal activism and transformation.

There are also ways that health-care providers can and do incorporate quilts into actual clinical and therapeutic care, some of which have been showcased in earlier chapters. Their pioneering efforts are admirable, particularly in light of having to challenge the pervasive medical disease–oriented model of health care, health-care financing, and the emphasis on billable services. Today the number of hospital-based arts programs is growing rapidly. The Arts-in-Medicine program at the University of Florida has been successful for over twenty years, with artists providing opportunities to engage in artwork, crocheting, crafts, poetry, and playing musical instruments. Their research findings indicate a positive impact on multiple clinical outcomes. Hospitals are increasingly using quilts in particular to produce desired health outcomes.

One very simple, and literally touching, concept, "fidget quilts," seems to calm persons with dementia who are exhibiting signs of restlessness or anxiety.[29] Also referred to as "fiddle," "busy," or "activity quilts," they are typically small enough to put on a lap and provide sensory and tactile experiences, or something to "fidget" with, through the use of different textures, colors, and embellishments, including objects that are sewn on, such as keys, buttons, netting, satin, ribbons, lace, or fur-like material. Some of the objects move—washers that slide, working zippers, or Velcro on the sides of the quilt that allow it to be opened and

Figure 5.8. Sensory Stimulation Quilt for Alzheimer Patients, Conejo Valley Quilters, Thousand Oaks, California, August 2015. 33" × 33". Photo by Lynn M. Jurss.

closed like a book—a feature that reportedly has universal appeal for people with dementia. The quilts can be personalized. One made for a former accountant had dollar bills sewn onto it that could be folded and unfolded.

Similar to fidget quilts, Grace MacNab of the Ottawa Valley Quilters Guild (OVQG) says "touch quilts" paradoxically both calm and stimulate those dealing with dementia.[30] She describes them as "textured lap quilts designed for those who need focused sensory stimulation, especially those with Alzheimer's and other form of dementia." They can potentially increase a more relaxed and happy state without the use of medication or physical restraints. MacNab, who volunteers at the local Civic Hospital, says that patients with Alzheimer's dis-

Figure 5.9. Conejo Valley Quilters and community members at a workshop construct sensory stimulation quilts. Photo by Lynn M. Jurss.

Lynn Jurss, outreach coordinator for her guild, Conejo Valley Quilters, in Thousand Oaks, California, told us that her guild makes and donates sensory stimulation quilts for Alzheimer's patients. As part of working on her Girl Scout Gold Award, Jurss's daughter Allison Medley teamed up with the guild to make an instructional YouTube video and brochure on how to make these quilts and held a few community events to make the quilts. "Her effort increased the level of donated quilts by at least three-fold. We've partnered with local nonprofits and the Alzheimer's Association to make and distribute these quilts. We also have plans to expand into autism" (Lynn Jurss, email to Beth Donaldson, October 31, 2015).

ease sometimes come into the emergency department for other reasons and are often confused and distressed. "They do not know that they are in a hospital, they may think they have been kidnapped, they cannot imagine why someone would stick a needle into their arm."[31] Staff find that the OVQG quilts "help calm patients . . . keeping them from pulling at catheters and monitoring wires." They provide a positive diversion and focus for attention, keeping hands and minds busy. They can also be used to keep residents' hands busy when they are participating in group settings and activities. For example, nursing home residents "can attend larger concerts without reaching to touch co-residents or others' wheelchairs."[32]

Joshua Barnes, while a student at the University of Brighton in England, participated in a competition run by the Future Perfect Company and then went on to be selected as a "Future Pioneer" by the Design Council (United Kingdom) for his creation *The Communica-*

tion Quilt. The goal of the original competition was to encourage students to create innovative designs that could help older people live more enjoyable, independent lives. However, Barnes's *Communication Quilt* was actually designed for children, those enduring prolonged hospitalization, to help combat separation issues and distress. The quilt is similar to fidget quilts but with a digital twist. It is made up of thirteen to twenty animal illustrations, each one representing a real-life friend or family member assigned by the child. The selected people can then record messages and "attach" them to their respective symbol on the quilts. "Much like with how a QR code works, the child uses an Augmented Reality app (Aurasma) on a smart-device to scan the quilts and release the message."[33] Using the camera on a phone or tablet, the app recognizes the image of the quilt, and then related, individualized content such as a photo or video shows up on the screen. "By merging together the tactile and physical meaning a quilt embodies, with the communication capabilities of Augmented Reality, the child is literally wrapped in a great sense of comfort and being in touch with their loved ones."[34] Barnes says, "'It also played into the idea of the quilt being a magic object and playful for the child, and hopefully it all adds up to making it an easier experience for them.' . . . The idea behind the quilt though, he says, comes from his memories of when his father endured a lengthy hospital stay and had his own quilt from home with him, the color of which broke up the otherwise sterile room."[35]

When the Quiltmaker Is the Health-Care Provider

Given the numbers of individuals engaged in quiltmaking and the growing intersections of health, well-being, healing, and quilts, it is not surprising that so many medical practitioners and health-care workers have turned to quiltmaking for their own coping with or recovery from illnesses or accidents. When Boston physician Michele David had to cease work after she was diagnosed with a rare and debilitating disease, during which she could not even read or write, she took a quilting class. The activity helped her to heal. In an article by Sandra Larson, David clearly states:

> "I wanted to do handwork because I couldn't think, I couldn't concentrate. . . . That process [of making a quilt], I think, helps your brain heal faster when you have difficulty concentrating, so you can come back to your full self. Within two years I was able to regain everything back."
>
> She returned to full-time medical work . . . but never stopped quilting.[36]

Quiltmakers whose life work has been predominantly in the sciences often find that engagement in quiltmaking opens up new ways of approaching problems. For instance, in a news article interview by Michael Guilfoil, retired family doctor Judy Bell said she

> spent her whole career, "being very technical, very scientific, very linear.". . .
>
> Upon retiring, she took up quilting, and "in the last five years, I've discovered a part of my brain I didn't know I had—an artistic and creative side I never had a chance to use when I was working with patients."[37]

Figure 5.10. *Tree of Life*, Susan Schrott and residents of Avalon Hills Foundation for Eating Disorders, Logan, Utah, 2012. 66" × 54". Private collection. Photo courtesy of the artist.

Quilt artist and licensed clinical social worker Susan Schrott, used multiple therapeutic techniques to guide women and girls in residential treatment for an eating disorders through each step of a creative process that resulted in several quilts such as this one. Schrott designed the *Tree of Life* pattern and gave it to the patients in her two-day workshop; they then selected their own fabric and a set of quotes that were transferred onto fabric then fused onto the quilt top. According to Fay Frazier, director of the Avalon Hills Foundation for Eating Disorders, Logan, Utah. "Not only did each patient learn new skills to use on their recovery journeys, they also gained new personal insights and the satisfaction of working as a group to create a beautiful work of art." The piece here was auctioned off to benefit the Avalon Hills Foundation. (Susan Schrott, "Art Therapy Workshop/Fundraiser for Avalon Hills Foundation," *Susan Schrott Therapy*, September 2014, http://www.susanschrotttherapy.com/weblog/?p=62).

Figure 5.11. *First Star I See Tonight*, Susan Schrott, Shelter Island, New York, 2004. Collection of the artist. Photo by Susan Schrott.

A photograph I took of my daughter, who was dancing out in the woods one afternoon, inspired First Star I See Tonight. It depicts a young woman with her heart lifted and her head thrown back as she exudes both a sense of confidence and curiosity. I display this quilt in my private psychotherapy practice specifically because it generates discussions with and among my patients about the inherent beauty and intelligence in honoring and caring for our healthy bodies when they are nourished and respected, connected with the environment as well as allowing for personal self-expression infused with self compassion.

As a health professional, my objective is "to move people and instill a sense of hopefulness that is dormant within themselves until they realize that they possess the energy to inspire others." So many of my eating disorder patients compare their bodies to their peers or those in social media so in *First Star I See Tonight*, I intentionally made the young woman's hair striped and her legs orange. The quilt thus prompts my patients to reframe their perspective of themselves, which can often be judgmental. (Susan Schrott, email correspondence with Beth Donaldson, May 13, 2016, and artist statement provided to Michigan State University Museum; see also http://www.susanschrottartist.com.)

Figure 5.12. Facing: *Not Just Blue*, Sue Walen, Bethesda, Maryland, 2012. 42" × 52". Collection of the artist. Photo by Mark Gulezian.

> Depression caused several of my colleagues to [commit] suicide. As psychologists, we never spoke about our own depression. They, like me, suffered an illness that was "supposed" to be for others—not mental healthcare professionals. We lived in secret, with our own tides of grief, despair, anxiety, and self-doubt. One of the healthiest things I learned to do in my career was to come out of my closet. I gave talks, workshops, wrote papers, and a book and now offer my story-quilt about my journey in owning depression. Perhaps someone will find it helpful.
>
> [Making this] was a labor of passion, actually, and the images came to me fully formed. The work began by me digging out an old essay I'd written in a weekend "creative writing" workshop, about my own battles with depression. It divided nicely into 9 paragraphs . . . and, voila! . . . another nine-patch.

(Quoted in Lauren Kingsland, ed., *Sacred Threads Exhibition 2013* [Rockville, MD: CQS Press, 2013], 148; see also http://suewalen.blogspot.com.)

Susan Schrott sees her work as a psychotherapist and yoga instructor and as an artist as part of a continuum of connected experiences. "Whether working in my clinical psychotherapy practice or creating alone in my studio, my greatest desire is to instill in others the ability to connect with the world in a meaningful way."[38]

The art of health-care providers who are quilt artists themselves often includes literal or symbolic references to their professional work. Several of their stories have been shared in earlier chapters. Thousands more exist, like that of Dr. Ramona L. Bates, a plastic surgeon in Little Rock, Arkansas, who says, "I used to 'suture for a living,' I continue 'to live to sew.' These days most of my sewing is piecing quilts. I love the patterns and interplay of the fabric color. I would like to explore writing about medical/surgical topics as well as sewing/quilting topics. I will do my best to make sure both are represented accurately as I share with both colleagues and the general public."[39] Bates has had a blog titled *Suture for a Living* since 2007.

Another example of the creativity of medical personnel with quilts stems in part from hospitals moving toward color-coded "scrubs" or uniforms so that patients can distinguish between the vast array of staff members providing care. Old, highly personalized scrubs that don't conform to more recent codes are being put to new use. At the University of Alabama at Birmingham (UAB), staff donated 150 tops and pants that were turned into two quilts for "Compassionate Pieces: A Community Quilt Project," to celebrate the fifth anniversary of the UAB Women and Infants Center. They depict a mother and child, and a nurse with an elderly patient. Sandra Holt Milstead, a family nurse liaison, helped to develop the idea and create the quilts. She worked with Kimberly Kirklin, of the UAB Arts in Medicine program, and Lillis Taylor, a textile artist and quiltmaker. Milstead expressed how meaningful the quilts are to her: "'Seeing something that's used to care for patients, and it's on a wall . . . that's overwhelming to me. . . . Something that I put on every day is now a piece of art that tells what nursing is all about.'"[40] As Mary Colurso says:

> Lives saved. Mothers comforted. Babies cuddled. Families helped.
>
> If these nursing scrubs could talk, they'd have stories to tell, about love and hope, caring and support, passion and professionalism. . . .
>
> These scrubs have been stained by blood, drenched in sweat and bathed in tears.[41]

Figure 5.13. *Compassionate Pieces: A Community Quilt Project.* Lillis Taylor (designer), community members and staff and patients of the University of Alabama at Birmingham Institute for Arts in Medicine, Birmingham, Alabama, 2015. 4'× 6'. Collection of University of Alabama at Birmingham's Women and Infants Center. Photo courtesy of University of Alabama at Birmingham/Steve Wood.

Figure 5.14. Lillis Taylor, Kimberly Kirklin, and Sandra Holt Milstead at University of Alabama at Birmingham making hexies (hexagon pieces) out of scrubs. Photo courtesy of University of Alabama at Birmingham/Steve Wood (Mary Colurso, "These Scrubs Were Worn While Lives Were Saved. Now They're a Work of Art in Birmingham," AL.com, December 21, 2015, http://www.al.com /entertainment/index.ssf/2015/12/these_scrubs_were_worn_while_l.html).

In response, Angellia Walker, a nursing coordinator, says, "'Sometimes you do cry. . . . It brings you closer to what you do, it brings you closer to your patients, and they do appreciate it. A lot of moms see you cry, and they say, 'Hey, she really does care about my baby.' So you don't hold those feelings back.'"[42]

> [Lillis Taylor] "designed the quilts from scratch, using techniques adopted from the Birmingham Quilters Guild. . . . [She then] taught and supervised more than 100 volunteers who made the essential building blocks from fabric. . . .
>
> Nurses, doctors, and other staffers at the Women and Infants Center participated in the project, along with patients, family members, and visitors. . . .
>
> As Taylor explains it, about 1,600 geometric shapes, called "hexies," were sewn from the scrubs material after it was cut into circles. . . . [and she then] used the pieces to hand-sew the quilts in sections. . . .
>
> "Making the hexies was a group effort, with a lot of community bonding. But putting it together was very solitary and meditative. I listened to a lot of books on tape."[43]

Colurso reported that the group effort included people like Dr. Lingling Guo, "a UAB microsurgeon who used her suturing skills to produce a small treasure trove of precisely stitched hexies."[44] And Deardra Pinkett, "a young mother who spent about six months at the center, waiting for her premature child to thrive and grow," stated, "'I was here for a long time. . . . I made a lot of those (hexies). . . . Lillis taught me how to sew. She's wonderful. I'm just a people person, so I enjoyed being around the nurses and patients, to share my story and listen to the stories of other patients. We helped each other get through our time here.'"[45] During the project, Kirklin's research supported the idea that such quilting can reduce stress and anxiety in patients, distract from illness, and create a support network. Taylor said, "Community arts is a way to open people's hearts and minds to a different perspective. . . . Arts in Medicine is certainly trying to take a more holistic approach to mind, body and spirit."[46]

At St. David's Medical Center in Austin, Texas, scrub quilts are actually used for newborns in the NICU to cover their isolette, an incubator with controlled temperature, humidity, oxygen levels, and armholes through which the infant can be touched and cared for. Isolettes are typically covered to keep the baby in a dark environment, approximating conditions in the womb. The handmade covers are intended to reduce the sterile look of the isolette and thereby mitigate the trauma experienced by parents who are facing a difficult situation. NICU nurse Kay Needles coordinates volunteers who make isolette covers, including individual donors and members of such charitable organization as Threads of Love and Newborns in Need, all dedicated to providing handmade articles for premature and sick infants. The scrub quilts are especially meaningful because they have been worn by nurses who, as Needles explains, have become very attached to their scrubs. As Needles says, "Some of us remember which pair of scrubs we were wearing when we were caring for a certain baby or even our own babies. Most of us hang on to them—scrubs are not something that we give away."[47] Like many hospitals, St. David's made the decision to standardize uniforms, and all nurses were assigned navy blue scrubs. Needles had a brilliant idea: use all of the scrubs that staff could no longer wear to make new, much needed isolette covers. The project provides the added bonus of the nurses being able to "see" and enjoy their treasured scrubs while also knowing they have been donated to a good cause. Many of the NICU nurses have helped

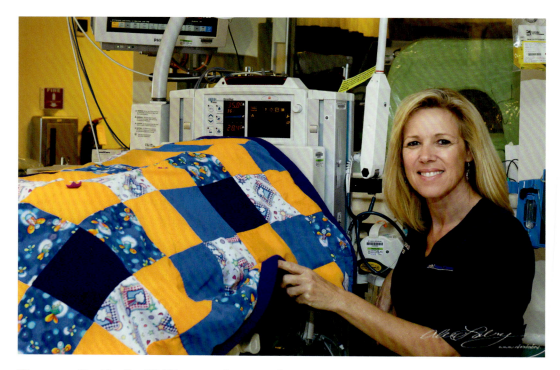

Figure 5.15. Kay Needles, NICU nurse and sewing volunteer coordinator at St. David's Medical Center, Austin, Texas, shows off one of the scrub quilts on an isolette that will hold a premature baby. Photo by Alex Labry ("NICU Nurse Uses Scrubs to Make Blankets," *Statesman*, December 24, 2011, https://www.pressreader.com/usa/austin-america -statesman-sunday/20111225/281792805875265).

make the covers or held fund-raisers to buy quiltmaking supplies for Needles, who does most of the sewing. She has made over one hundred covers and says she has promised the other nurses that she'll keep making them until all of their scrubs are used. She strongly believes in the healing benefits of these quilts for the families of premature babies: "They get to know which isolette holds their baby by which quilt is on it. . . . The cheerful quilts help soften the hospital environment and bring some comfort. . . . My children were all born healthy, and I never had to be on the other side of NICU as a parent. I've had so many blessings and I'm happy to be able to use my talent to give something back. All the NICU nurses want to do anything we can do for the parents to make their journey easier."[48]

Quilted Tributes to Health-Care Providers

Health-care providers in all settings are often considered heroes. As the definition of health is broadened to one that is more holistic, and care is more team-based, we might begin to think of "the team" as a wide circle of individuals who promote healing, health, and quality of life. In this worldview, the quiltmakers are clearly part of the circle of care, the "team," and worthy of hero status. In addition to health-care providers who are quiltmakers, there are quiltmakers, such as Kathy Weaver, who do not provide direct patient care but who pay special tribute to those who do. In Weaver's words:

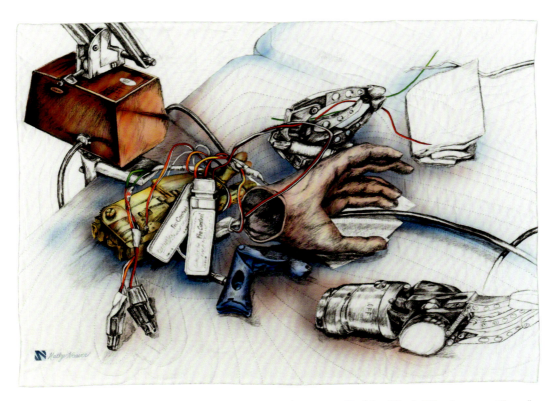

Figure 5.16. *Biomechatronics Development Lab 2, V2*, Kathy Weaver, Highland Park, Illinois, 2012. 48" × 53". Photo by Tom Van Eynde.

"We often think of quilts for cancer and other diseases, but this quilt honors those who have suffered traumatic injury and the wonderful researchers and doctors who are devoting their lives to making a better quality of life for their patients. The environment that I found myself in, at the Rehabilitation Institute, was one of total dedication and caring and also a place where students, researchers and doctors from all over the world worked together for a common cause, with lots of intelligence, hope and humor" (Kathy Weaver, email to Beth Donaldson, December 31, 2015).

I have had a longtime interest in robots and technology and this imagery often appears in my quilts. Several years ago I was invited to be an artist participant at a world conference on artificial intelligence at Indiana University. That spurred my interest in the actual technology and workings of robots. I became particularly interested in the robotic mechanism of prosthetic limbs, especially in the soldiers who were victims of IEDs [improvised explosive devices]. To that end, I asked the Robotics Department at the Rehabilitation Institute of Chicago if I could come and draw in their department. To my surprise and delight, they welcomed me and on a weekly basis I went there to spend a day drawing patients who were being trained on various robotic devices to help their conditions. These devices were prototypes for robots being used all over the world. One of these drawings I had enlarged, placed on fabric which I then airbrushed, embroidered and hand quilted. This quilt, *Biomechatronics Development Lab2, V2*, was selected to be in Quilt National 2013.[49]

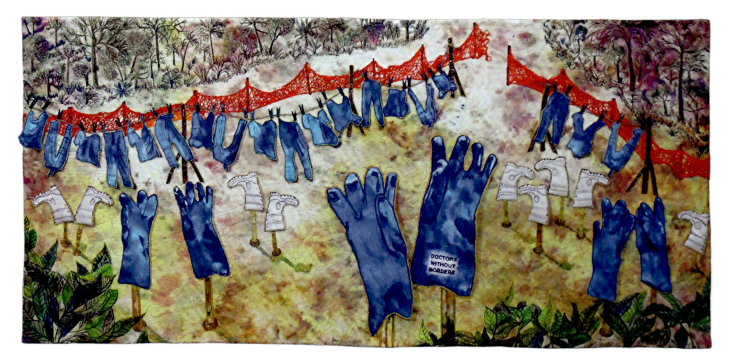

Figure 5.17. *Earth's Super Heroes Battle Ebola in Liberia*, Patricia Anderson Turner, Punta Gorda, Florida, 2015. 33" × 65". Collection of the artist. Photo by Lloyd Begg.

Ebola, first discovered in 1976, became one of the world's deadliest viral illnesses with its 2014 outbreak in West Africa. Here, quilt artist Patricia Turner pays tribute to the medical personnel who put their lives on the line to help contain the virus and treat its victims (World Health Organization, "Ebola Virus Disease," January 2016, http://www.who.int/mediacentre/factsheets/fs103/en).

Another example is Patricia Turner, who created an award-winning quilt related to the Ebola virus. She states, "We've all grown up with fictional stories of Supermen and Wonder Women and how their super powers save mere mortals from certain disaster and death. But we truly do have real life super heroes among us: the doctors and support staff of Doctors without Borders. They traverse the earth wherever and whenever needed to face down earthquakes, tsunamis, the ravages of war, and the threat of pandemic. They work tirelessly to save mere mortals from themselves and from Mother Nature. They are, indeed, Earth's Super Heroes."[50]

We close with a story about a quiltmaker who made quilts to support and inspire future health-care providers. In 2010 Joyce Goode, an award-winning quiltmaker from San Francisco, was contacted by Marsha Rappley, MD, then dean of the Michigan State University College of Human Medicine (MSU-CHM), who wanted to give every medical student expecting a new baby a baby quilt with an MSU Spartan theme.[51] Rappley had met Joyce's husband, Merton Goode, an MSU-CHM alumnus. Joyce agreed to make the quilts, each one with a unique pattern on one side and material printed with images of Sparty [the university's mascot] on the back. A tradition was started, and when all was said and done, Joyce had gifted more than three hundred quilts to medical students, staff, and faculty. In addition, she

and Merton commissioned and gifted a quilt made by Ann Loveless, 2013 and 2015 winner of the ArtPrize competition in Grand Rapids, Michigan, in honor of CHM's fiftieth anniversary. The quilt now hangs in the college's Secchia Center in Grand Rapids. Sadly, Joyce developed a rare brain disease and died during the writing of this book, but her legacy will live on, as one hundred of her baby quilts are still available to be distributed, and her story has been told in a new seminar that uses quilt images and stories to teach medical students and residents about the human experience of illness.[52] Joyce's story and the stories of so many quiltmakers like her have become, and will continue to be, part of the multifaceted fabric of life, enriching its quality and contributing to individual and collective health and well-being.

Notes

1. Roger S. Ulrich, "View through a Window May Influence Recovery from Surgery," *Science* 224, no. 4647 (1984): 420–21.

2. J. L. Lester and A. Rettig, "Supportive Patient Care in the Guise of a Quilt," *Clinical Journal of Oncology Nursing* 13, no. 6 (2009): 723–25.

3. Lynn Lancaster Gorges, September 5, 2011, comment on "Fwd: Walk and Roll—and more," *H-Quilts*, http://h-net.msu.edu/cgi-bin/logbrowse.pl?trx=vx&list=h-quilts&month=1109&week=a&msg=1eG5ekjazQV705AP56BzZQ&user=&pw=.

4. Healing Quilts in Medicine, http://healingquiltsinmedicine.org.

5. Fiber Artists @ Loose Ends. *Healing Quilts Exhibition National Institutes of Health: Featuring Plants Used in Cancer Treatments* (Fairfax, VA: n.p., 2012).

6. Lauren Kingsland, email and phone communications with Marsha MacDowell, November 3, 2015, and with Beth Donaldson, October 27, 2015.

7. Tyler Reynard, "Breast Cancer Center Receives Quilt," *Intelligencer/Wheeling News-Register*, October 28, 2011, http://www.theintelligencer.net/page/content.detail/id/561123/Breast-Cancer-Center-Receives-Quilt.html?nav=510.

8. Deb Radosevich, quoted in ibid.

9. "Commissions," *Bernie Rowell*, http://www.bernierowell.com/commissions.

10. Ibid.

11. "Capital Health 'Building Blocks' Completed," *Kate Graves Makes Quilts*—Archive for the Capital Health Category. September 15, 2011, http://blog.kategraves.com/category/capital-health.

12. "INSIDE HFHS: Women's Lecture Series Starts This Week," *HBCUConnect.com*, March 30, 2009, http://hbcuconnect.com/content/125849/blog.cgi?cid=&reading=1. For more on Christine Mauersberger, see http://christinemauersberger.com/artist-bio-and-statement.

13. See Irene Walt and Grace Serra, eds., *The Healing Work of Art: From the Collection of the Detroit Receiving Hospital* (Detroit: Detroit Receiving Hospital, 2007); see especially 28 and 29.

14. "The Caring Quilt: Messages from Our Patients," Radiological Society of North America, https://www.rsna.org/The-Caring-Quilt.

15. Mark Saal, "Hospital 'Quilt Room' Turns Fabric into Wheelchairs," *Standard Examiner*, August 7, 2014, http://www.standard.net/Lifestyle/2014/08/07/Turning-fabric-into-wheelchairs.

16. "Lilly Oncology on Canvas: Expressions of a Cancer Journey," Lily Oncology, http://www.lillyoncology.com/support-resources/lilly-oncology-on-canvas.html.

17. Ibid.

18. Judy Elsley, "Chemo," artist statement in ibid.

19. WHI Quilts, https://www.whi.org/participants/quilts/Pages/Home.aspx.

20. The Angel Quilt Project, http://www.aqphome.org/about.html.

21. Daniel Lai, "Dexter's Piece-Makers Quilt Group Delivers Bundles of Love to Sick Children," *Dexter Patch*, October 17, 2011, http://patch.com/michigan/dexter/dexter-s-piece-makers-quilt-group-deliver-bundles-of-0da614a756.

22. The Heaven Scent Project, http://coslctn.org/heavenscent2.php.

23. Tracy Gruen, "Quilters Help Sexually Abused Teens," *Chicago Tribune*, August 12, 2013, http://articles.chicagotribune.com/2013-08-12/news/ct-tl-palatine-quilts-20130815_1_quilts-abused-teens-friendly-ties.

24. Duncan Adams, "'A Token of Love,' Stitch by Stitch," *Roanoke Times*, October 7, 2013, http://www.roanoke.com/news/local/roanoke_county/a-token-of-love-stitch-by-stitch/article_b7083a9d-6308-51b6-8b09-a02a0da9ed86.html.

25. Field notes of Clare Luz, from meeting with staff at Pilgrim Manor Retirement Community, January 26, 2011.

26. Becky Orr, "Quilting for Fallen Heroes," *Wyoming Tribune Eagle*, February 24, 2015, http://www.wyomingnews.com/news/quilting-for-fallen-heroes/article_e3bd2bbf-339b-5927-9155-9b5b58f71e95.html.

27. Ibid.

28. See more at "Weight Loss Surgery Success Stories: 'Now I Can . . .'" *BIDMC's Health Notes*, http://www.bidmc.org/YourHealth/Health-Notes/WeightLoss/NowICan.aspx#sthash.WsmNNeqq.XJGcLVIu.dpuf.

29. "Quilters Keep Their Hands Busy with Fidget Quilts," *Laurel Outlook*, October 2, 2013, http://www.laureloutlook.com/community/article_faeee9e4-2b7d-11e3-89; Jennifer Stockinger, "Fidget Quilts Made to Help Seniors in Need," *Brainerd Dispatch*, May 12, 2014, http://www.brainerddispatch.com/content/fidget-quilts-made-help-seniors-need; Blake Herzog, "Fidget Quilts' Help Soothe Nerves of Alzheimer's Patients," *Yuma Sun*, January 1, 2015, http://www.yumasun.com/features/fidget-quilts-help-soothe-nerves-of-alzheimer-s-patients/article_659b66c6-921d-11e4-a564-93a72ab9c95b.html; and Barbara Harrison, "Sharing the Memories: Creative Support for Alzheimer's Care," *The Quilter* (Spring 2013): 32–33.

30. Janice Henderson, "Quilting to Change Quality of Life for Those with Dementia," *Ottawa Citizen*, May 2015, http://ottawacitizen.com/news/local-news/the-upbeat-quilting-to-change-quality-of-life-for-those-with-dementia.

31. Janice Henderson, "Quilting with an Impact: Touch Quilts in Ottawa," *Newswest* Online, March 26, 2015, http://newswest.org/easyread/archives/4079. See also Henderson, "Quilting to Change Quality of Life."

32. Henderson, "Quilting to Change Quality of Life."

33. "Stunning Digital Quilt Impresses at Brighton Graduate Show," *The Future Perfect Company*, June 3, 2013, http://blog.thefutureperfectcompany.com/2013/06/03/stunning-digital-quilt-impresses-at-brighton-graduate-show.

34. Ibid.

35. "Augmented Reality Quilt: No More Loneliness for Hospitalized Children," July 17, 2013, http://www.augmentedrealitytrends.com/augmented-reality/augmented-reality-quilt-no-more-loneliness-for-hospitalized-children.html; see also *Joshua Barnes*, http://joshuabarnes.co.uk/augmented-quilt.

36. Sandra Larson, "A Healing Art," *Exhale*, www.exhalelifestyle.com/2010–2–2/AHealingArt.html.

37. Michael Guilfoil, "Front and Center: Retired Physician Judy Bell Stitches New Passion," *Spokesman-Review*, October 12, 2015, http://www.spokesman.com/stories/2015/oct/12/front-center-retired-physician-judy-bell-stitches-.

38. Peter Boody, "Island Profile: Artist, Psychologist Susan Schrott," *Shelter Island Reporter*, April 21, 2014, http://shelterislandreporter.timesreview.com/2014/04/21/island-profile-artist-psychologist-susan-schrott, see also www.susanschrottartist.com.

39. Ramona Bates, *Suture for a Living*, http://rlbatesmd.blogspot.com.

40. Sandra Holt Milstead, quoted in Mary Colurso, "These Scrubs Were Worn While Lives Were Saved. Now They're a Work of Art in Birmingham," AL.com, December 21, 2015, http://www.al.com/entertainment/index.ssf/2015/12/these_scrubs_were_worn_while_l.html.

41. Ibid.

42. Angellia Walker, quoted in ibid.

43. Lillis Taylor, quoted in ibid.

44. Ibid.

45. Deandra Pinkett, quoted in ibid.

46. Kimberly Kirklin, Sandra Holt Milstead, quoted in ibid.

47. Kay Needles, quoted in "NICU Nurse Uses Scrubs to Make Blankets," *Statesman*, December 24, 2011, http:// www.statesman.com/news/news/local/nicu-nurse-uses-scrubs-to-make-blankets/nRjGk.

48. Ibid.

49. Kathy Weaver, email to Beth Donaldson, December 31, 2015.

50. Patricia Turner, artist statement and materials sent to Beth Donaldson, 2016.

51. Marsha Rappley, email to Clare Luz, June, 2016.

52. Merton Goode, phone communication with Clare Luz, June 2016, and materials provided to authors by Merton Goode, September, 2016.

Fidget Quilt, Beth Donaldson, Lansing, Michigan, 2017. 17" x 23".
Collection of Beth Donaldson. Photo by Pearl Yee Wong

Fidget quilts are quilts are small quilts with activities stitched into them. They are used to help calm people who are restless or agitated. They have been used by people with Alzheimer's, other forms of dementia, ADD or autism. This quilt was made to display in the Arts and Health Tent at the 2017 Great Lakes Folk Festival. The activities included in this quilt are: Texture nine patch, buckle slide, peak-a-boo triangles (opens to the Beatles), pony tail holders, smooth mirror squares, twisted fabric patch, pom-poms, zipper, giant snap hiding Elvis Presley, and marble maze.

six 〜

Conclusion

Our goal with this book was to raise awareness of the massive realm of health-related quilts and start to make sense of it. We have introduced one way of organizing and understanding its depth, breadth, meaning, and impact on the multiple facets of good health, well-being, and quality of life for not only the quiltmakers but also the recipients, users, and viewers of their works of art. It is just a beginning. The sheer size and scope of this production of material culture warrants further research. There are countless lines of inquiry left to be explored, such as what gives life meaning, the role of aesthetics in good health, self-promotional behaviors, grassroots financing of health care, and women's studies. It also demands greater recognition in the health-care field and attention to the many creative ways in which quiltmaking and quilts could be leveraged to deliver better person-centered, holistic care with improved outcomes at lower costs. Finally, if this recognition and potential is better realized, we hope it signals a higher appreciation for the interrelatedness of the arts and humanities and good health. Common themes—or threads if you will—throughout this book have been the critical role that beauty, creative expression, and a sense of worth, belonging, purpose and community can play in achieving optimal health and quality of life. The evidence and testimonies are abundantly clear on this, and we hope that by our sharing such rich findings, your own sense of health and well-being is enriched.

Afterword

In mid-September 2012, Betty MacDowell was diagnosed with pancreatic cancer, and within two weeks she was transferred to a hospital hospice room. There, surrounded by her husband, children, and close family, she was covered in two family quilts—one made by her maternal grandmother as a present for her wedding and the other pieced by her great-grandmother, quilted by her grandmother, and bound by her mother.[1] In her final hours of life, these precious textiles must have surely and silently given her both physical warmth and spiritual comfort. Those who stood around her felt the presence, through quilts, of those who went before her.

Notes

1. Similar stories are told about the laying of quilts on dying patients. For example, see "Companion Quilt," Oregon Health and Science University, Center for Ethics, http://www.ohsu.edu/xd/education /continuing-education/center-for-ethics/ethics-outreach/outreach-programs/quilt.cfm. This site includes information on making companion quilts for a formalized program at the OHSU Hospital.

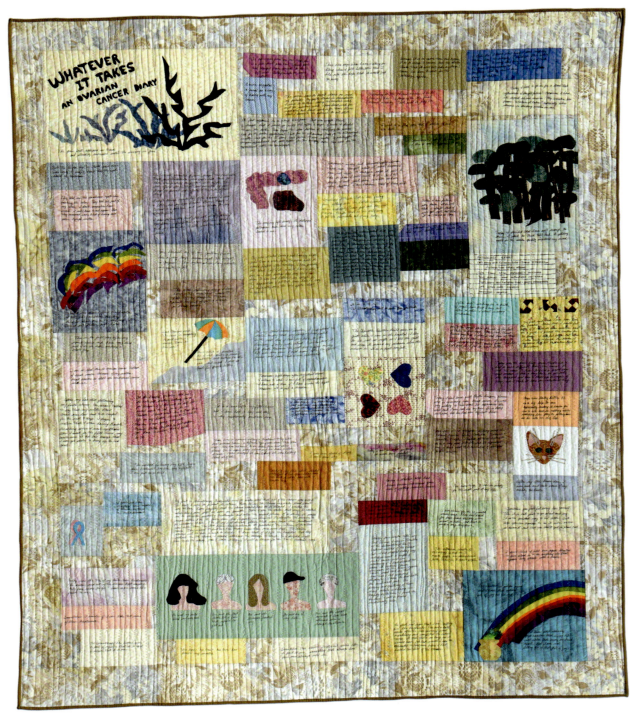

Figure 2.14. *Whatever It Takes: An Ovarian Cancer Diary.*

APPENDIX

Guide to *Whatever It Takes: An Ovarian Cancer Diary*

Phyllis Tarrant, of Mint Hill, North Carolina, provides a more detailed description of the images and the full text of the words written on her diary quilt, *Whatever It Takes: An Ovarian Cancer Diary* (see fig. 2.14): "I would like for this quilt to be used in any way that can benefit cancer patients especially to help family and friends to understand what they are going thru. I would also like to make women more aware of ovarian cancer. I have found health care workers appreciate it more than other people. Friends and family of people who have cancer, but will not talk about it seem to appreciate it also. Some people seem to want to stay as far away from anything connected to cancer as possible."

The following is a transcription of the text on each block, reading left to right from top to bottom. A slash mark (/) denotes the beginning and/or end of each block:

WHATEVER IT TAKES an ovarian cancer diary The pain first appeared in March and steadily increased until the surgery in June. / The pain grew from a one Advil pain to a four Advil pain plus two Tylenol pain. And changed from general to the left side. Sitting made it much worst. / There were days when I was walking or biking when I felt little pain and I held onto the hope that it would just go away. / Because it is on more than one organ, it is a stage 3 cancer, but the doctor thinks that it will act like a stage 1 cancer. We have to wait for the pathology reports. / I could see Steve [Phyllis's husband] sitting in a chair. He may have been asleep, but I think he knew I was coming to. He did not say anything. That is when I knew. When Dr. Stubbs came, he told me. / A nurse suggested a journal as a way of dealing with my cancer. / The nurse said to avoid stairs as much as possible. My quilt studio is downstairs. I need to be there, doing the creative work and the machine work, I have handwork for upstairs, but handwork is for those times that I haven't the patience to sit still. / According to the chemo nurse, I will lose my hair 18 days after the first chemo session. That will be July 23. / Today I had to go in for a blood test. Afterwards I bought fabric. Tomorrow I have the second chemo session. My mantra has become "Whatever it takes." Especially when someone is sticking needles in me. / It first appeared as a cramp like pain. That was maybe March. I thought that it would go away but after a couple of weeks I decided to see the doctor. Then began the slow process of identifying the problem. Wait for the doctor's appointment. Wait for the ultrasound. Wait for the ultrasound results. Wait for the CT scan. Wait for the CT scan results. No waiting for the surgeon's appointment, but wait again for the surgery date. Now

wait for the appointment with the oncologist. / I want to be told both that I will be OK and the truth. / Sometimes I don't believe all of this is really happening to me. /

Both Dr. Grafton and Dr. Stubbs said there was only a slight chance that the cyst would be cancerous. / They told me the cancerous cyst was touching the colon. They took out part of my colon, I don't remember how much. I will have to ask again. Also they removed some kind of lining and some lymph nodes. / The chemo consisted of seven drugs. The chemicals Taxol and Carboplatin were given last. Prior to then was a drug to prevent side affects. The side affects drug (Ethyol) was preceded by four drugs to prevent side affects of the side affects drug. I slept through maybe half of the 6 hours. I read a little, but my eyes became blurry. Mostly I listened to a book tape and drew blocks for my doodle quilt. I was extremely tired, but not sleepy when I got home. I feel better now (bed time) except that my arms are a little swollen above the wrist. / The way my left ovary, its destroyed fallopian tube, and my colon looked to me. / Tomorrow is my chemotherapy session. I have not thought about it much because I can not begin to imagine what it will be like or how I will react to it. As I tell people I will just have to wait and see what happens. I am however tired of being sick. / Sometimes I think that I am feeling fine, getting over the latest chemo when suddenly tears pop out for no reason. Maybe that is the only way to get the chemicals out of my body. / Today I decided that I am well enough to drive. I went to the Mint Hill Park. A solitary walk in the woods greatly improves my mood. /

When I was released from the hospital, I felt like rainbows, but when I tried to draw one on the way home, it turned out broken and chaotic. / Jane Burdick, one of my quilting friends, has a very large ovarian cyst. Her surgery is August 1. This information upset me quite a bit. / The most disturbing thing that I have heard—the oncologist wants to talk with my daughter Melanie about her risk of getting ovarian or breast cancer. / My hair started coming out Sunday night, more than a week before the nurse said it would happen. After two days, I have probably lost about half of it. I still have a lot to lose as I have always had very thick hair. So far it has not bothered me except for the aggravation of all that loose hair. I may feel differently once the bald spots start to appear. / It is generally recommended that you shave your head when your hair starts coming out. That was not something I could do. On Thursday when much of my hair was gone, I decided to cut it to a half inch all over. But instead of cutting, I cried. It was all going to be gone soon anyway. Friday the rate of hair loss had slowed down and I cut it with no regrets. Sometimes an idea just takes getting used to. It is a terrible hair cut, but no one has to see it. It is now Tuesday and I still have some hair. / Tomorrow is my fourth chemo and I so don't want to do it. / My cancer is Epithelial Endometriod Carcinoma class III C. PATHOLOGY REPORT Left ovary and fallopian tube—tumor 7.5 × 4.5 × 4.0 cm fallopian tube effaced Colon—tumor 3.5 cm metastatic carcinoma Pelvic sidewall—mass metastatic carcinoma Right ovary and fallopian tube—grossly unremarkable Left lymph nodes—negative Omentum—negative. /

This is the fourth day after my second chemo and I am very tired and do hate wasting a whole day. / I am glad that this is ovarian cancer instead of breast cancer. Because of my mother[,] breast cancer is still an emotional issue with me. / Isak Dinesen said, "The cure for anything is salt water—sweat, tears, or the sea." For a week I sweated as I sat under a beach umbrella and listened to the sea and cried. I did at least feel much better. / At my third chemo

session, I understood the doctor to say that my surgery had healed. So the next day I took my bike to the Greenway. I only rode about 4 miles and it felt great. However the next day a place on my left side was sore. I tried again after the fourth chemo and found I was exhausted. / Dr. Gelder said two things. It is OK to cry. The chemotherapy will be easier than you think. / The Charlotte Quilter's Guild gave me a quilt while I was in the hospital. I like to be cool at night so I fold the quilt and wrap it around my abdomen where the incision is. It is a great comfort. / Often while working on a quilt, I forget how tired I am, but after a while I start making mistakes. / One of the worst parts for me is the loss of taste a few days after each chemo. Melanie says that I should eat less at these times, but I eat more in my search to find something that tastes good. And when I do find it, I feel so much better. / The first week that I was home from the hospital, I knew that I would feel better if I could do some machine work on a quilt. I pieced centers for 40 blocks. I did feel better, but when I was ready to finish the blocks, I discovered that all 40 centers had to be redone. /

After my lab test following my fourth chemo, the nurse called to say that my white blood count was low and to be careful for the next 3 days. I began to notice that I was having trouble breathing when I went up stairs. When I went for my fifth chemo, my counts were OK but low enough that I now get shots to bring up the red count. / At the hospital, Melanie told me she had not started looking for a job because if I did not do well she would want to look for a job in Charlotte. I don't want her to base her life on my health. She can't. She can't. I am going to do well. Melanie, child, for both our sakes, you have to believe that I will be OK. / It is a week after my fifth chemo and I have had a very bad day, a very emotionally unstable day. / The second most disturbing thing I have heard. The chemotherapy will not kill any microscopic breast cancer cells that I have. In fact chemo increases the risk of getting a different type of cancer. /

Today was the sixth lower dose treatment. I have had a more difficult time than usual. It took the nurse three tries to find a blood vein that worked. It took a long time to get over the Benadryl and then I threw up a couple of times, but I think it was an intestinal thing. / Today I had lunch with Phyllis Simpson Garner who is recovering from breast cancer. She was very willing to talk about her experiences. She said that I could call her any time. She is doing well now, but has had some difficult times. /

The weekend following my fifth lower dose treatment has been difficult. I am just so so tired. There was a woman getting a treatment today who had ovarian cancer (a different kind than me) three years ago. Hers returned to her brain, liver, and other places. She is again doing chemo and her brain is clear of cancer. I am amazed at how calmly she was talking about all of this. /

Counting my pain which started early April of last year, I have not been sick a whole year with 6 months to go. / I was never afraid of dying. I don't know why. / Today I am so tired, so tired—so much time wasted. / Jane gave me a newspaper clipping about the national Ovarian Cancer Coalition. There is a Charlotte chapter. I looked at the website. It is a very good website, but it depressed me. I don't want to be reminded of how few people survive. / Our new tabby kitten AC is a big help to me[,] especially making it easier for me to sit and do nothing while watching him play or petting him as he sits in my lap. /

I could not have managed these months of chemo without an antidepressant. / My first 6 chemotherapy treatments were to make sure that all of the cancer cells were killed. The last 2 were to prevent its return. Prior to the 7th chemo, my white blood count was too low. I was fearful that the chemo would be delayed. I wanted the whole thing over with as soon as possible. When I saw the doctor that day, he wanted me to consider switching treatments and enter a second phase of a study. It would mean either 3 or 12 lower doses, less frequent, one chemical treatment. The number to be randomly chosen. The study had already shown that the many lower dose treatments were better than the two higher dose treatments at preventing the return of ovarian cancer. They needed to find out how many lower dose ones were best. The doctor wanted me to take a week to decide. I knew that if I left the hospital that day without the 7th chemo, I would not have the courage to do it. So I decided right then to do the study. Now I wait to hear if I will be chose for the 3 or 12 month treatment group. / Having a relative who had breast cancer increases your risk of getting ovarian cancer. / I have always said that I would rather have cancer than a stroke. With cancer you have a chance. A stroke can change who you are. / Five more to go. I am so ready for the next part of my life. / I was chosen for the 12 month study group. I had half hoped for that group thinking more must be better, but that is such a long, long time. / After my 10th lower dose, I was sick and lost some of my ability to taste. /

Today was the 8th of my lower dose treatments. The doctors and all of the nurses kept saying "Only four more to go." Four more seems like forever to me. / Sometimes I wonder if I can make two more of these treatments. / Me and my wild black and gray hair. Me and the last little bit of hair that refused to fall out. Me and the straight frosted wig. Me and one of my hats. Me and the small amount of hair that returned when I changed treatments. / Exactly four weeks after my last chemo, I was in Houston at the International Quilt Festival instead of the chemo lab. I had stopped taking my antidepressant a couple of weeks earlier and was wondering if I had stopped too soon. An ovarian cancer survivor at the show's ovarian cancer booth told me that now I had to deal with the emotional part. The piecing and quilting of these diaries is helping me. Hopefully by the time I finish the binding, I will be healed emotionally also. / The interim results of the study are that the 12 month people are doing much better than the 3 month people. / Sometimes you just feel sorry for yourself. Then it is best just to go ahead and cry. It is the quickest way to feel better. Just hope that you can manage to do it when no one is around and that you don't get a phone call. / I don't think that I will ever volunteer to give blood or do anything that requires being stuck with a needle. /

The chemotherapy has become such a big part of my life that it is hard to believe that this is over. / "One more." "One more" has become my mantra. / Sometimes I wonder if I can take two more of these treatments. / Sometimes the cancer treatment seems like a part of me, something that always has been and always will be. / The first real sign that I am getting over the treatments. Five and a half weeks after the last chemo, I went orienteering and completed the entire course. I took twice as long as it should have, but last month I was too exhausted to continue before I had finished one third of the course. / My rainbow is whole again and I have that golden pot of joy at the end. I know that someday that rainbow that is my life will either fade or break apart, but I am not letting go of that pot of joy.

BIBLIOGRAPHY

"40 Quilts Honour 40 Years." *What Cancer Cannot Do*. https://40quilts.wordpress.com/about.

"300 Words about Quilting and Grief." *Quilters Newsletter*. August/September 2011. http://www .quiltersnewsletter.com/articles/300_Words_about_Quilting__Quilting_and_Grief.

"ABC Quilts." American Mothers. http://www.americanmothers.org/abc-quilts.

Adams, Duncan. "'A Token of Love,' Stitch by Stitch." *Roanoke Times*. October 7, 2013. http://www .roanoke.com/news/local/roanoke_county/a-token-of-love-stitch-by-stitch/article_p7083a9d -6308-51b6-8b09-a02a0da9ed86.html.

"Agent Orange Quilt of Tears." Agent Orange Victims and Widows Support Network. http://www .vietnamproject.ttu.edu/inmemory/vietwarmem/aoquilts.htm.

Agosin, Marjorie. *Tapestries of Hope, Threads of Love: The Arpillera Movement in Chile*. Lanham, MD: Rowman & Littlefield, 2008.

The AIDS Memorial Quilt: The NAMES Project Foundation. http://www.aidsquilt.org.

AIDS Quilt Touch. http://aidsquilttouch.org.

Alexander, Karen B. "Quilts and Passages." November 5, 2011. Quilt History List Archives. http:// quilthistory.com/2011/295.htm.

———. "William R. Dunton: Quilt Collector, Author, Psychiatrist." *The Quilters Hall of Fame Blog*. January 16, 2012. http://thequiltershalloffame.blogspot.com/2012/01/william-r-dunton-1979 -honoree.html.

Alishouse, Diana. *Depression Visible: The Ragged Edge*. Duluth, GA: Doggie in the Window Publications, 2010.

Alliance for American Quilts. http://quiltalliance.org.

Alzheimer's Art Quilt Initiative (AAQI). http://www.amisimms.com/aaqi.html.

Alzheimer's Association. http://www.alz.org/facts/overview.asp.

"American Heart Association's 'Go Red for Women' Quilt Display Coming to Fort Atkinson." Fort Health Care for Health. January 19, 2010. https://www.forthealthcare.com/news /American-heart-associations-go-red-for-women-quilt-display-coming-to-fort-atkinson.

"American Heart Association Sponsors Juried Quilt Show." January 13, 2016. New England Quilt Museum. *Our Blog* Archives. http://nequiltmuseum.org/blog/american-heart-assn-sponsors -juried-quilt-show.

Anderson, Laura, and Karen Gold. "Creative Connections: The Healing Power of Women's Art and Craft Work." *Work & Therapy* 21, no. 4 (1998): 15–36.

Anderson, Marilyn. "Area Women Transform Shirts into Quilts in Memory of a Friend." *News Record*. February 18, 2015. http://www.zumbrota.com/articles/2015/02/18/area-women-transform-shirts-quilts-memory-friend.

Anderson, Phil. "Church Makes Quilts for North-Side Agency." *Topeka Capital-Journal*. December 14, 2014. http://m.cjonline.com/news/2014-12-14/church-makes-quilts-north-side-agency.

The Angel Quilt Project. http://www.aqphome.org/about.html.

"Ann's Quilt Journal." *Ann's Multiple World of Personality*. http://www.annmultipleworldof personality.com/p/resume.html.

Archer, Bernice. "A Patchwork of Internment." *History Today* 47, no. 7 (1997): 11–18.

"Archive for Archive of Families' Letters & Photos." *Freedom Quilts*. http://freedomquilts.net /category/in-loving-memory/family-letters-photos.

Armstrong, Nancy Cameron, "Quilts of the Gulf War, Desert Storm—Participation or Protest?" In *Uncoverings 1992*, edited by Laurel Horton, 9–44. San Francisco: American Quilt Study Group, 1992.

Arredondo, Giseelle. "Quilts of Valor: Veterans Get Wrapped in Personalized Quilts Presented by Needles and Friends." *Leader & Times* (Liberal, KS). November 11, 2013.

ArtPrize. http://www.artprize.org.

"Arts and Health Program." Great Lakes Folk Festival. http://www.greatlakesfolkfest.net/glff2016.

Ashby, Cary. "Many Quilters 'Touched by Breast Cancer.'" *Norwalk Reflector*. October 22, 2015. http://www.norwalkreflector.com/Local/2015/10/22/Many-quilters-touched-by-breast-cancer .html?ci=stream&1p=10&p=1.

Atkins, Jacqueline Marx. *Shared Threads: Quilting Together—Past and Present*. New York: Viking Studio Books, 1994.

Atkinson, Jacqueline, and Emily Burt. "Quilting and Well-being." *The Quilter* 127 (Summer 2011): 22–23.

"Augmented Reality Quilt: No More Loneliness for Hospitalized Children." July 17, 2013. http:// www.augmentedrealitytrends.com/augmented-reality/augmented-reality-quilt-no-more -loneliness-for-hospitalized-children.html.

Bagwell, Sara. "Military Mom Pays It Forward." *Bristol-Warren Patch*. February 24, 2012. http:// patch.com/rhode-island/bristol-warren/military-mom-pays-it-forward-with-camo-quilts.

Ball, Helen K. "Subversive Materials: Quilts as Social Text." *Alberta Journal of Educational Research* 48, no. 3 (2002): 1–27.

"Basic Requirements." Quilts of Valor. http://www.qovf.org/quilters-questions/basic -requirements.

Bates, Ramona. *Suture for a Living*. http://ribatesmd.blogspot.com.

Berlo, Janet Catherine. *Quilting Lessons: Notes from the Scrap Bag of a Writer and a Quilter*. Lincoln: University of Nebraska Press, 2001.

Berlo, Janet Catherine, and Patricia Cox Crews. *Wild by Design: Two Hundred Years of Innovation and Artistry in American Quilts*. Seattle: International Quilt Study Center, 2003.

Berry, Jessica. "Secret Messages Sewn into POW Women's Quilts." *Telegraph*. August 5, 2001. http://www.telegraph.co.uk/news/worldnews/asia/japan/1336483/Secret-messages-sewn-into -PoW-womens-quilts.html.

Bilyeu, Michele. "The Healing Art of Sewing and Quilting." *Michele Bilyeu Creates *With Heart and Hands**. http://www.with-heart-and-hands.com/p/quilters-who-make-difference.html.

Blakesley, Katie. "Cross Roads Block Tutorial." *Swim Bike Quilt*. April 3, 2012. http://swimbikequilt .com/2012/04/cross-roads-sew-red-for-women-block.html.

Boody, Peter. "Island Profile: Artist, Psychologist Susan Schrott." *Shelter Island Reporter.* April 21, 2014. http://shelterislandreporter.timesreview.com/2014/04/21/island-profile-artist -psychologist-susan-schrott.

Brackman, Barbara. *Quilts from the Civil War.* Lafayette, CA: C&T Publishing, 1997.

———. "Red and White." *Material Culture.* February 22, 2012. http://barbarabrackman.blogspot .com/2012/02/red-and-white.html.

Brady, Erika. *Healing Logics: Culture and Medicine in Modern Health Belief Systems.* Logan: Utah State University Press, 2001.

Bresenhan, Karey Patterson. *Creative Quilting: The Journal Quilt Project.* Stow, MA: Quilting Arts, LLC, 2006.

Brickley, William. Statement on the *LeMoyne Star Quilt.* Quilt Index. http://www.quiltindex.org /fulldisplay.php?kid=1E-3D-221.

Bristow, Lora J. "Women's Work: Social Relations of Quilting." MA thesis. Humboldt State University, 2013. http://humboldt-dspace.calstate.edu/handle/2148/1468.

Bunnie Jordan. http://bunniejordan.com.

Burt, Emily L., and Jacqueline Atkinson. "The Relationship between Quilting and Well-being." *Journal of Public Health* 34, no. 1 (2012): 54–59.

Butterfield, Karen. "Homestead Stitchers Delight in Donating Handmade Quilts." *Missourian.* May 6, 2013. http://www.emissourian.com/more_news/senior_lifetimes/article_eb65d4.

Camo Quilt Project. http://camoquiltproject.blogspot.co.za.

"Capital Health 'Building Blocks' Completed." *Kate Graves Makes Quilts*—Archive for the Capital Health Category. September 15, 2011. http://blog.kategraves.com/category/capital-health.

"The Caring Quilt: Messages from Our Patients." Radiological Society of North America. https:// www.rsna.org/The-Caring-Quilt.

Carlson, Linda Giesler. *Quilting to Soothe the Soul: Create Memories for Today, Tomorrow & Forever.* Iola, WI: Krause Publications, 2003.

Carmichael, A. Christopher. "Stitching to Heal and Remember: The NAMES Project AIDS Memorial Quilt in Michigan." In *Festival of Michigan Folklife Program Book,* edited by Yvonne R. Lockwood and Ruth D. Fitzgerald, 36–41. East Lansing: Michigan State University Museum, 1996.

Carocci, Max. "Textiles of Healing: Native American AIDS Quilts." *Textile: Journal of Cloth and Culture* 8, no. 1 (2010): 68–85.

Caroline and Lee. "Wrapped in Red, White, and Blue." Letter to QOV. *Quilts of Valor.* Posted by Karla Locke, April 15, 2014. http://qovf.blogspot.com/2014/04/wrapped-in-red-white-and-blue .html.

Carson, Lynn, Gopal Sankaran, and Douglas McConatha. "The AIDS Memorial Quilt: Knitting together the Fabric of Understanding." *American Journal of Health Education* 25, no. 5 (1994): 313–15.

"CFSAC Meeting IV Quilt Unraveled." Discussion in "Fibromyalgia Main Forum" started by Michele K. June 14, 2012. http://forums.prohealth.com/forums/index.php?threads/cfsac-meeting -iv-quilt-unraveled.212957.

Chase, Candace. "Woman's Near-Death Experience Leads to Success in Quilting World." Daily Inter Lake.com. September 26, 2012. http://www.dailyinterlake.com/members/woman-s-near -death-experience-leads-to-success-in-quilting/article_0b1ac438 078e-11e2-b41d-001a4bcf887a .html.

Cheek, Cheryl, and Kathleen W. Piercy. "Quilting as Age Identity Expression in Traditional Women." *International Journal of Aging and Human Development* 59, no. 4 (2004): 321–37.

Cheek, Cheryl, and Robin G. Yaure. "Quilting as a Generative Activity: Studying Those Who Make Quilts for Wounded Service Members." *Journal of Women & Aging* 29, no. 1 (2017): 39–50.

Chilton, James. "Detention Center Teaches Female Inmates to Quilt." *Wyoming Tribune Eagle.* April 24, 2016. http://www.wyomingnews.com/news/detention-center-teaches-female-inmates -to-quilt/article_0e80e6c4-09d9-11e6-b597-ffe7121e44e9.html.

Clark, Ricky. "The Needlework of an American Lady: Social History in Quilts." In *In the Heart of Pennsylvania: Symposium Papers*, edited by Jeannette Lasansky, 64–75. Lewisburg, PA: An Oral Traditions Project of the Union County Historical Society, 1986.

Coleman, Marion. *HIV Positive: Reaching for a Cure.* 2014. Michigan State University Museum Collection, East Lansing, MI. Quilt Index. http://www2.matric.msu.edu/~quilti/fulldisplay .php?kid=1E-3D-2876.

Collie, Kate, Joan L. Bottorf, and Bonia C. Long. "A Narrative View of Art Therapy and Art Making by Women with Breast Cancer." *Journal of Health Psychology* 11, no. 5 (2006): 761.

Collier, Ann Futterman. *Using Textile Arts and Handcrafts in Therapy with Women: Weaving Lives Back Together.* London: Jessica Kingsley Publishers, 2012.

———. "The Well-being of Women Who Create With Textiles: Implications for Art Therapy." *Art Therapy: Journal of American Art Therapy Association* 28, no. 3 (2011): 104–112.

Colurso, Mary. "These Scrubs Were Worn While Lives Were Saved. Now They're a Work of Art in Birmingham." AL.com, December 21, 2015. http://www.al.com/entertainment/index.ssf/2015 /12/these_scrubs_were_worn_while_l.html.

Comeau, Jean M. "Celebrating Nursing: Quilt Begun by ED Staff Mushroomed to Successful Hospital-Wide Project." *Journal of Emergency Nursing* 31, no. 6 (2005): 610–11.

"Commissions." *Bernie Rowell.* http://www.bernierowell.com/commissions.

"Companion Quilt." Oregon Health and Science University. Center for Ethics. http://www.ohsu .edu/xd/education/continuing-edcuation/center-for-ethics/ethics-outreach/outreach -programs/quilt.cfm.

Cook, Greg. "Quilting to Mend the Wounds of the Marathon Bombing." The Artery, WBUR Radio Station. July 6, 2013. http://artery.wbur.org/2013/07/06/mending-boston-clara-wainwright ?utm_source=twitter&utm_medium=social&utm_campaign=wknd.

Cook, Linda. "Veterans Receive Quilts of Valor in Moving Ceremony." *Quad City Times*, May 17, 2015. http://qctimes.com/news/local/veterans-receive-quilts-of-valor-in-moving-ceremony /article_be71326a-4a0a-52fc-a3f6-6e2659770bb2.html.

Cooke, Ariel Zeitlin, and Marsha MacDowell. *Weavings of War: Fabrics of Memory.* East Lansing: Michigan State University Museum, 2005.

Cooper, Patricia, and Norma Bradley Burferd. *The Quilters: Women and Domestic Art, An Oral History.* Garden City, NY: Anchor Press, 1978.

Cozart, Dorothy. "A Century of Fundraising Quilts: 1860–1960." In *Uncoverings 1984*, edited by Sally Garoutte, 41–53. Mill Valley, CA: American Quilt Study Group, 1985.

———. "The Role and Look of Fundraising Quilts, 1850–1930." In *Pieced by Mother: Symposium Papers*, edited by Jeanette Lasansky, 86–95. Lewisburg, PA: Oral Traditions Project of the Union County History Society, 1987.

Creativity & Parkinson's Quilt Project 2010. New York: Parkinson's Disease Foundation, 2010.

Csikszentmihalyi, Mihaly. *Flow: The Psychology of Optimal Experience.* New York: Harper and Row, 1990.

Cueva, Kathy, and Susan Ziegler. *The Giving Quilt: Fast Quilts for Comfort and Healing.* El Cajon, CA: Cozy Quilt Designs, 2007.

Daniel, Nancy Brenan. *"Research Now . . . There's Still Time."* Michigan State University Museum Collection, East Lansing, MI. Quilt Index. http://www.quiltindex.org/fulldisplay.php?kid=1E -3D-261B.

Day, Jennifer. "Women Helping Others." *Jennifer Day Thread Stories.* http://www.jdaydesign.com /artquilting/women-helping-others.

Dickie, Virginia. "Experiencing Therapy through Doing: Making Quilts." *OTJR: Occupation, Participation, and Health* 31, no.4 (2011): 209–15.

———. "From Drunkard's Path to Kansas Cyclones: Discovering Creativity Inside the Blocks." *Journal of Occupational Science* 11, no. 2 (2004): 51–57.

Dickie, Virginia Allen. "The Role of Learning in Quilt Making." *Journal of Occupational Science* 10, no. 3 (2003): 120–29.

Diener, Ed, Shigehiro Oishi, and Richard E. Lucas. "Personality, Culture, and Subjective Well-Being: Emotional and Cognitive Evaluations of Life." *Annual Review of Psychology* 54, no. 1 (2003): 403–25.

Dietrich, Mimi. *Pink Ribbon Quilts: A Book Because of Breast Cancer.* Bothell, WA: Martingale & Company, 2011.

Disaster Quilting Project. "About Disaster Quilters." http://disasterquiltingproject.com.

"Display the Parkinson's Quilt." Parkinson's Disease Foundation. http://www.pdf.org/quilt.

Donnell, Radka. *Quilts as Women's Art.* North Vancouver, BC: Galerie Publications, 1990.

"The Donor Quilt." National Kidney Foundation. https://www.kidney.org/transplantation /donorFamilies/quiltPatch.

Dunton, William Rush, Jr. *Old Quilts.* Baltimore: Privately printed, 1946.

Eades, Guy, and Jacqui Ager. "Time Being: Difficulties in Integrating Arts in Health." *Journal of the Royal Society for the Promotion of Health* 128, no. 2 (2008): 62–67.

Eisemon, Virginia. "Sunday School Scholars Quilt: Civil War Textile Document." In *Uncoverings 2004*, edited by Kathryn Sullivan, 41–78. San Francisco: American Quilt Study Group, 2005.

Ellis, Lisa. *Healing Quilts Exhibition: Featuring Plants Used in Cancer Treatments.* Fiber Artists @ Loose Ends, privately printed, 2012.

Elsley, Judy. Artist statement. In *Lilly Oncology on Canvas: Expressions of a Cancer Journey National Coalition for Cancer Survivorship.* Indianapolis: Lilly USA, 2012. 4–5.

———. *Breast Cancer Quilts: Coping with Breast Cancer through Quilt Making.* Ogden, UT: n.p., 2016.

———. "Chemo." Artist statement. In *Lilly Oncology on Canvas: Expressions of a Cancer Journey.* Indianapolis: National Coalition for Cancer Survivorship, 2012.

———. "Journal Quilts: The Micro Series." https://www.judyelsley.com/journal-quilts-the-micro -series.

Endometriosis Quilt. *EndoTimes.* http://endotimes.blogspot.com/2007/03/add-your-name-to -endometriosis-quilt.html.

Estes, Brad. "Grandma Mary: A Quilt for Every Baby at Sheridan Hospital." Sheridan Media.com. March 31, 2012. http://www.sheridanmedia.com/news/grandma-mary-quilt-every-baby -sheridan-memoria128502.

"ETX Woman Quilts together Memories." KLTV.com. March 21, 2013. http://www.kltv.com/story /21754849/etx-woman-quilts-together-memories.

Evans, Sharron K. October 25, 2011. "RE: re: Polly's note on mourning quilts." Quilt History Listserv Archives. http://quilthistory.com/2011/289.htm.

Everitt, P. "Walking the Quilt (The Names Project, AIDS Quilt)." *Western Journal of Medicine* 153, no. 5 (1990): 541.

"Fabric and Pattern." Quilts of Valor. http://www.qovf.org/quilters-questions/fabric-pattern.

"The Faces of Dementia: An Online Quilt." Alzheimers.net. May 19, 2010. Repost of article by Tony Reid in *Herald & Review*. http://www.alzheimers.net/4-1-15-the-faces-of-dementia.

Feldman, Claudia. "Libby Lehman Qualifies as the Quilting World's Comeback Kid." *Houston Chronicle*. October 23, 2015. http://www.houstonchronicle.com/entertainment/arts-theater/article/Libby-Lehman-qualifies-as-the-quilting-world-s-6587256.php.

Ferrero, Pat, Elaine Hedges, and Julie Silber. *Hearts and Hands: The Influence of Women and Quilts in American Society*. San Francisco: Quilt Digest Press, 1987.

———. *Hearts and Hands: Women, Quilts, and American Society*. Nashville: Rutledge Hill Press, 1987.

Fiber Artists @ Loose Ends. *Healing Quilts Exhibition National Institutes of Health: Featuring Plants Used in Cancer Treatments*. Fairfax, VA: n.p., 2012.

Finley, Janet E. *Quilts in Everyday Life, 1855–1955*. Atglen, PA: Schiffer Publishing, 2012.

Fitzgerald, Susan. "Plain People, Exotic Illnesses Pennsylvania's Amish and Mennonite Populations Carry Dozens of Diseases Nearly Unknown Anywhere Else." *Philly.com*. December 1, 2001. http://articles.philly.com/2002-12-01/news/25359231_1_clinic-for-special-children-lights-long-bulbs.

Ford, Wayne. "Patch Quilters Gift Council on Aging with 57 Wheelchair Quilts." *Athens Banner-Herald* (Online Athens). December 17, 2014. http://onlineathens.com/local-news-blueprint/2014-12-15/gratitude-cotton-patch-quilters-gift-council-aging-57-wheelchair.

Franscell, Ashley. "Quilting for a Cause RSVP Volunteers Help Patients." *Daily Herald* (Provo, Utah). May 16, 2011. http://www.heraldextra.com/news/local/central/provo/quilting-for-a-cause-rsvp-volunteers-help-patients/article_519ea501-7b77-5635-b543-eb652e73094e.html.

Franger, Gaby, and Geetha Varadarajan, eds. *The Art of Survival: Fabric Images of Women's Daily Lives*. Nürnberg, Germany: Tara Publishing, 1996.

Frazier, Mary Kieras. December 9, 2014. Quiltville's Open Studio Facebook page. https://www.facebook.com/groups/291023511046957/search/?query=Mary%20Kieras%20Frazier.

"Free Charity Quilt Patterns." Free Quilt Patterns. http://www.freequiltpatterns.info/Quilt Categories/FreeCharityQuiltPatterns.htm.

Freedom Quilts. http://freedomquilts.net.

Frezon, Mary Beth. "Early Statement about Quilt." September 11, 2001. http://mbgoodman.tripod.com/911.

"Gabby Gifford Quilts." *Quilt for a Cause: Sew a Cure for Women's Cancer*. http://quiltforacause.org/about/history/ and http://quiltforacause.org/galleries/gabby-giffords-quilts.

Gambardella, Steven James. "Absent Bodies: The AIDS Memorial Quilt as Social Melancholia." *Journal of American Studies* 45, no. 2 (2011): 213–26.

Gandolfo, Enza, and Marty Grace. . . . *it keeps me sane . . . women craft well-being*. Victoria, Australia: The Vulgar Press, 2009.

Gebel, Carol. "Quilts in the Final Rite of Passage: A Multicultural Study." In *Uncoverings 1995*, edited by Virginia Gunn, 199–227. Mill Valley, CA: American Quilt Study Group, 1995.

Geist, Troyd. *Sundogs and Sunflowers: An Art for Life Program Guide for Creative Aging, Health, and Wellness*. Bismarck: North Dakota Council on the Arts, 2017.

"Global Fund Quilts." Quilt for Change. http://quiltforchange.org/category/globalfundquilts.

"Go Red for Women Quilt Program—2010." UW Health. http://www.uwhealth.org/go-red/go-red-for-women-quilt-program-2014/29424.

Goh, J. O., and D. C. Park. "Neuroplasticity and Cognitive Aging: The Scaffolding Theory of Aging and Cognition." *Restorative Neurology and Neuroscience* 27, no. 5 (2009): 391–403.

Gold, Mary. "Why I Made My Late Husband's Shirts into a Quilt for Our Little Girl." *Daily Mail*, November 11, 2015. http://www.dailymail.co.uk/femail/article-3314471/Why-late-husband-s -shirts-quilt-little-girl-knew-harrowing-worth-hour-daughter.html.

Graham, Jennifer E., Marci Lobel, Peter Glass, and Irina Lokshina. "Effects of Written Anger Expression in Chronic Pain Patients: Making Meaning from Pain." *Journal of Behavioral Medicine* 31, no. 3 (2008): 201–12.

Gregory, Jonathon. "Wrapped in Meanings: Quilts for Families of Soldiers Killed in the Afghanistan and Iraq Wars." In *Uncoverings 2010*, edited by Laurel Horton, 161–204. Lincoln, NE: American Quilt Study Group, 2010.

Gruen, Tracy. "Quilters Help Sexually Abused Teens." *Chicago Tribune*. August 12, 2013. http:// articles.chicagotribune.com/2013-08-12/news/ct-tl-palatine-quilts-20130815_1_quilts-abused -teens-friendly-ties.

Guilfoil, Michael. "Front and Center: Retired Physician Judy Bell Stitches New Passion." *Spokesman-Review*, October 12, 2015. http://www.spokesman.com/stories/2015/oct/12/front-center -retired-physician-judy-bell-stitches-/.

Gunn, Virginia. "Quilts for Union Soldiers in the Civil War." In *Uncoverings 1985*, edited by Sally Garoutte, 95–121. Mill Valley, CA: American Quilt Study Group, 1986.

Guzzetta, Cathie E. "Effects of Relaxation and Music Therapy on Patients in a Coronary Care Unit with Presumptive Acute Myocardial Infarction." *Heart Lung* 18, no. 6 (1989): 609–16.

Haak, Jessica. "Constructing Quilts, Online Communities, and Quilter Legacies: A Narrative Case Study." In *Educational, Psychological, and Behavioral Considerations in Niche Online Communities*, edited by Vivek Venkatesh, Jason Wallin, Juan Carolos Castro, and Jason Edward Lewis, 51–66. Hershey, PA: IGI Global, 2014.

Hackler, Rhoda E. A., and Loretta G. H. Woodward. *The Queen's Quilt*. Honolulu: Friends of 'Iolani Palace, 2004.

Haider, Mo. "Families Share Unique Bonds through Freedom Quilts." Siouxlandmatters.com. April 4, 2015. http://www.siouxlandproud.com/news/local-news/families-share-unique-bond -through-freedom-quilts.

Halbert, Debora J. "The Labor of Creativity: Women's Work, Quilting, and the Uncommodified Life." *Transformative Works and Cultures* 3 (2009). http://journal.transformativeworks.org /index.php/twc/article/view/41/118.

Hanz, Joyce. "Fidget Quilts to Dignity Robes, Fawn Sewing Club Does It All." *Trib Live*. May 17, 2015. http://triblive.com/lifestyles/moelifestyles/8180055-74/group-sewing-says.

Harding, Deborah. *Red & White: American Redwork Quilts*. New York: Rizzoli, 2000.

Harrison, Barbara. "Sharing the Memories: Creative Support for Alzheimer's Care." *The Quilter* (Spring 2013): 32–33.

"Have a Heart, Make a Quilt Campaign." Accuquilt. http://www.accuquilt.com/shop/heart.

Hawkins, Peter S. "Naming Names: The Art of Memory and the NAMES Project AIDS Quilt." *Critical Inquiry* 19, no. 4 (1993): 752–79.

Healing Quilts in Medicine. http://healingquiltsinmedicine.org.

The Healing Role of the Arts. Working Papers. New York: Rockefeller Foundation, 1978.

The Heaven Scent Project. http://coslctn.org/heavenscent2.php.

Hedberg, Kathy. "Quilts Blanket Prison Inmates with Hope." *Lewis-Tribune*. November 26, 2012. http://www.idahopress.com/news/state/quilts-blanket-prison-inmates-with-hope/article _42de65e2-a34a-51e2-9a45-8072ad2a487e.html.

"Helping Hands in the Hoosegow: State's Inmates Knitting, Quilting for Charities." *Winona Daily News.* June 18, 2007. http://www.winonadailynews.com/news/helping-hands-in-the-hoosegow -state-s-inmates-knitting-quilting/article_05e2b62-5c36-5f01-a21d-ca3303cb172.html.

Henderson, Janice. "Quilting to Change Quality of Life for Those with Dementia." *Ottawa Citizen.* May 2015. http://ottawacitizen.com/news/local-news/the-upbeat-quilting-to-change-quality -of-life-for-those-with-dementia.

———. "Quilting with an Impact: Touch Quilts in Ottawa." *Newswest* Online. March 26, 2015. http://newswest.org/easyread/archives/4079.

Herzog, Blake. "Fidget Quilts Help Soothe Nerves of Alzheimer's Patients." *Yuma Sun.* January 1, 2015. http://www.yumasun.com/features/fidget-quilts-help-soothe-nerves-of-alzheimer-s -patients/article_659b66c6–921d-11e4-a564–93a72ab9c95b.html.

Hindman, Joanne. "Witness to Fatal Ithaca Crash Turns to Quilting after Trauma." *Ithaca Voice.* September 21, 2015. http://ithacavoice.com/2015/09/witness-to-fatal-ithaca-crash-turns-to -quilting-after-trauma.

"History." Pennsylvania Relief Sale. http://pareliefsale.org/about-us/history.

"Home of the Brave Quilts." Facebook. http://www.facebook.com/media/set/?set=a .162928430406307.35364.162638487191968&type=3.

Howell, Dana, and Doris Pierce. "Exploring the Forgotten Restorative Dimension of Occupation: Quilting and Quilt Use." *Journal of Occupational Science* 7, no. 2 (2000): 68–72.

Howell, Kevin. "Traveling Quilt Raising Awareness of Cancer-Like Disease." *Salem News.* January 26, 2014. http://www.salemnews.net/page/content.detail/id/570443/Traveling-quilt-raising -awareness-of-cancer-like-disease.html?nav=5007.

Huff, Linda J. *Nevilyn.* Quilt Index. http://www.quiltindex.org/fulldisplay.php?kid=1E-3D-261A.

"IBD Quilt Project." Facebook. https://www.facebook.com/IBD-Quilt-Project-IQP -125862724159873/info/?tab=page_info.

"I'm Not Crazy." Studio Art Quilt Associates. http://www.saqa.com/memberArt.php?ID=2217.

INSIDE HFHS: Women's Lecture Series Starts This Week. *HBCUConnect.com,* March 30, 2009, http://hbcuconnect.com/content/125849/blog.cgi?cid=&reading=1.

Invernizzi, Amy. "Irish Remembering Quilt on Show at City Hall." *Emigrant Online,* 2010. http:// www.irishemigrant.com/ie/go.asp?p=story&storyID=6177#sthash.QAojOa7z.dpuf.

Jezierski, M. "The Making of ENA's Anniversary Quilt." *Journal of Emergency Nursing* 21, no. 2 (1995): 179.

"Jody's Bandana Quilt." Illustrated in "Pictures of Comfort and Charity Quilts" by Janet Wickell. *About Home.* August 31, 2015. http://quilting.about.com/od/picturesofquilts/ig/Quilting-for-a -Cure/Bandana-Quilt-by-Jody.htm#step-heading.

Johnson, Clair. "Northern Cheyenne Elders Thank St. John's with Quilt." *Billings Gazette.* October 17, 2012. http://billingsgazette.com/news/state-and-regional/montana/northern-cheyenne -elders-thank-st-john-s-with-quilt/article_e6d56dd6-fe60–5745-a2dd-3a69eb0ce934.html.

Jones, Cleve, and Jeff Dawson. *Stitching a Revolution: The Making of an Activist.* San Francisco: HarperSanFrancisco, 2000.

Jordan, Eileen. "William Rush Dunton, Jr." In *The Quilters Hall of Fame,* edited by Merikay Waldvogel and Rosalind Webster Perry, 57–60. Marion, IN: Quilters Hall of Fame, 2004.

Kapitan, Lynn. "Close to the Heart: Art Therapy's Link to Craft and Art Production." *Art Therapy: Journal of American Art Therapy Association* 28, no. 3 (2011): 94–95.

Kate Graves Makes Quilts—Archive for the Capital Health Category (blog). "Capital Health 'Building Blocks' Completed." September 15, 2011. http://blog.kategraves.com/category /capital-health.

Kausch, Kurt D., and Kim Amer. "Self-Transcendence and Depression among AIDS Memorial Quilt Panel Makers." *Journal of Psychosocial Nursing and Mental Health Services* 45, no. 6 (2007): 44–53.

Kay, Jon. *Folk Art and Aging: Life-Story Objects and Their Makers.* Bloomington: Indiana University Press, 2016.

Keuning-Tichelaar, An, and Lynn Kaplanian-Butler. *Passing on Comfort: The War, The Quilts, and the Women Who Made a Difference.* Intercourse, PA: Good Books, 2005.

Kilen, Miles. "Widower's Quilts Piece together Family Stories." *Des Moines Register.* April 20, 2014. http://www.desmoinesregister.com/story/life/2014/04/19/everett-drevs-quilts/7907693.

Kingsland, Lauren, ed. *Sacred Threads Exhibition 2013.* Rockville, MD: CQS Press, 2013.

———. *Sacred Threads Exhibition 2015.* Rockville, MD: CQS Press, 2015.

Kiracofe, Roderick. *The American Quilt.* New York: Clarkson Potter, 1993.

Klimaszewski, Cathy Rosa. *Made to Remember: American Commemorative Quilts.* Ithaca, NY: Herbert F. Johnson Museum of Art, 1991.

Knaus, C. S., and E. W. Austin. "The AIDS Memorial Quilt as Preventative Education: A Developmental Analysis of the Quilt." *AIDS Education and Prevention* 11, no. 6 (1999): 525–40.

Knight, Meribah. "Men with Quilts: Prisoners Piece together Their Lives One Square at a Time." *American Craft.* September—October 2010. Reprinted in *Utne Reader.* http://www.utne.com/politics/men-quilts-prisoners-restorative-justice.aspx#ixzz2ii21ySF.

Knowles, Frederick E., III. "Memories of Dr. Dunton." *Maryland Psychiatrist Newsletter* 22, no. 3 (1995). http://www.dunton.org/archive/biographies/William_Rush_Dunton_Jr.htm.

Krikorian, Tammy. "Support Offered for Victims of Agent Orange Exposure." *Reno Gazette-Journal.* November 7, 2010. http://www.rgj.com/article/20101107/NEWS/11070349/1321/NEWS.

Krone, Carolyn, and Thomas M. Horner. "Quilting and Bereavement: Her Grief in the Quilt." In *Uncoverings 1992,* edited by Laurel Horton, 109–126. Lincoln, NE: American Quilt Study Group, 2010.

Ky, Kimberly. "Mental Health Wellness Quilt Shows What Community Healing Looks Like." *California State University East Bay News.* July 23, 2012. http://www.csueastbay.edu/news/2012/07/AlumnaAdelinaTancioco-072012.html.

Labry, Suzanne. "The Camo Quilt Project." *Suzy's Fancy Blog.* Column #60. Quilts, Inc. http://www.quilts.com/home/viewer.php?page=. ./sfancy/2010/sf60.

La Gorce, Tammy. "Survivors' Stories of Abuse, Sewn Tight." *New York Times.* February 8, 2013. http://www.nytimes.com/2013/02/10/nyregion/insights-from-survivors-of-abuse-sewn-together.html?_r=0.

Lai, Daniel. "Dexter's Piece-Makers Quilt Group Delivers Bundles of Love to Sick Children." *Dexter Patch.* October 17, 2011. http://patch.com/michigan/dexter/dexter-s-piece-makers-quilt-group-deliver-bundles-of-0da614a756.

Lane, Mary Rockwood. "Arts in Health Care: A New Paradigm for Holistic Nursing Practice." *Journal of Holistic Nursing* 24, no. 1 (2006): 70–75.

Larson, Sandra. "A Healing Art." *Exhale.* 2010. http://exhalelifestyle.com/2010-2-2/AHealingArt.html.

Lasansky, Jeannette, ed. *In the Heart of Pennsylvania: Symposium Papers.* Lewisburg, PA: An Oral Traditions Project of the Union County Historical Society, 1986.

———. *Pieced by Mother: Symposium Papers.* Lewisburg, PA: An Oral Traditions Project of the Union County Historical Society, 1986.

Lavitt, Wendy. *Contemporary Pictorial Quilts.* Layton, UT: Peregine Smith Books, 1993.

Legacy Quilts: Quilts from the Fabric of Your Life. https://elegacyquilts.com/our-story.html.

Lehnardt, Michelle. "Quilts, Bees, and Lip Balm: Healing from the Loss of a Child." KSL.com. November 22, 2012. http://www.ksl.com?nid=1010&sid=23051616.

Lester, Joann L., and Amy Rettig. "Supportive Patient Care in the Guise of a Quilt." *Clinical Journal of Oncology Nursing* 13, no. 6 (2009): 723–25.

Lewis, Jacqueline, and Michael R. Fraser. "Patches of Grief and Rage: Visitor Responses to the NAMES Project AIDS Memorial Quilt." *Qualitative Sociology* 19, no. 4 (1996): 433–51.

Lilly Oncology. "Lilly Oncology on Canvas: Expressions of a Cancer Journey." National Coalition for Cancer Survivorship. http://www.lillyoncology.com/support-resources/lilly-oncology-on-canvas.html.

Lilly Oncology National Coalition for Cancer Survivorship. *Lilly Oncology on Canvas: Expressions of a Cancer Journey.* Indianapolis: Lilly, 2012.

"Local Quilts." National Kidney Foundation. https://www.kidney.org/transplantation/donor families/quiltlocal.

Logsdon, M. Cynthia, Patricia Gagne, Tara Hughes, Jennifer Patterson, and Vivian Rakestraw. "Social Support during Adolescent Pregnancy: Piecing together a Quilt." *Journal of Obstetric, Gynecologic & Neonatal Nursing* 34, no. 5 (2005): 606–614.

Lori. October 31, 2013. "AAQI!! Hooray!" *Humble Quilts.* http://humblequilts.blogspot.com/2013/10/aaqi-hooray.html.

Loughlin, Sue, "Quilts of Honor." *Tribune Star* (Terre Haute, IN). November 10, 2015. http://www.tribstar.com/news/local_news/quilts-of-honor/article_doa97b12-f52e-559b-b310-9cff42ede706.html.

"The LWR Quilt Campaign." *Lutheran World Relief.* http://lwr.org/site/c.dmJXKiOYJgI6G/b.8107877/k.B058/2013_LWR_Quilt_Campaign__1_Year___50000_Quilts.htm.

MacDowell, Betty, Marsha MacDowell, and C. Kurt Dewhurst. *Artists in Aprons: Folk Art by American Women.* New York: E. P. Dutton, 1979.

MacDowell, Marsha. *African American Quiltmaking in Michigan.* East Lansing: Michigan State University Press, 1998.

———. "Quilting and Needlework." In *The American Midwest: An Interpretive Encyclopedia*, edited by Richard Sisson, Christian Zacher, and Andrew Cayton, 367–68. Bloomington: Indiana University Press, 2006.

———. "Quilts and Their Stories: Revealing a Hidden History." In *Uncoverings 2000*, edited by Virginia Gunn, 155–66. Lincoln, NE: American Quilt Study Group, 2000.

———. *Stories in Thread: Hmong Pictorial Embroidery.* East Lansing: Michigan State University Museum, 1989.

———. "'There's Good Money in Quilts': Fundraising Quilts." In *1988 Festival of Michigan Folklife*, edited by Ruth Fitzgerald and Yvonne Lockwood, 59–62. East Lansing: Michigan State University Museum, 1988.

MacDowell, Marsha, and C. Kurt Dewhurst. *To Honor and Comfort: Native Quilting Traditions.* Santa Fe: Museum of New Mexico Press, 1997.

MacDowell, Marsha, and Marit Dewhurst. "Stitching Apartheid: Three South African Memory Cloth Artists." *Weavings of War: Fabrics of Memory.* East Lansing: Michigan State University Museum, 2005. 77–87.

MacDowell, Marsha, and Clare Luz. "Quilts and Health." *Quilter's Newsletter Magazine* (December/January 2012): 44–47.

MacDowell, Marsha, and Wolfgang Mieder. "When Life Hands You Scraps, Make a Quilt: Quiltmakers and the Tradition of Proverbial Inscriptions." *Proverbium: Yearbook of International Proverb Scholarship* (2010): 113–72.

MacDowell, Marsha, and Mary Worrall. "The Sum of Many Parts: 25 Quiltmakers from 21st-Century American." *25 Quiltmakers from 21st-Century America*, edited by Teresa Hollingsworth and Katy Malone, 13–34. Minneapolis: Arts Midwest, 2012.

MacDowell, Marsha, Mary Worrall, Lynne Swanson, and Beth Donaldson. *Quilts and Human Rights*. Lincoln: University of Nebraska Press, 2016.

Mainardi, Patricia. *Quilts: The Great American Art*. San Pedro, CA: Miles & Weir, Ltd., 1978.

Mansi, Anna. "Quilts, Comfort from Kindness." *Popular Patchwork*. http://www.popular patchwork.com/news/article/quilts-comfort-from-kindness/14352.

Marshall, Helen. *Once a Shining Star*. Michigan State University Museum Collection. East Lansing, MI. Quilt Index. http://quiltindex.org/fulldisplay.php?kid=1E-3D-2618.

Marshall, Suzanne. Artist statement. In *On The Issues Magazine (OTI)*. (Winter 1999). http://www .ontheissuesmagazine.com/1999winter/w99art.php.

Martin, Lauryn. *Memory Quilts by Lauryn Martin*. http://laurynmartin.com/memory-quilts-2/in -memory-of-quilts.

Mathis, Emily. "Quilts That Changed the World: Women, Movements, Healing and Art." *UMKC Women's Center*. November 4, 2011. http://info.umkc.edu/womenc/2011/11/04/quilts-that -changed-the-world-women-movements-healing-and-art.

Mazloomi, Carolyn L. *And Still We Rise: Race, Culture, and Visual Communications*. Atglen, PA: Schiffer Publishing, 2015.

McMorris, Penny, and Michael Kile. *The Art Quilt*. San Francisco: Quilt Digest Press, 1986.

McQuaid, Salli, ed. *I'm Not Crazy: Stigma Revealed*. Self-published, 2012.

"Memorial Quilts." San Antonio Eye Bank. http://www.saeyebank.org/search-memorial-quilts .php?page=0.

"Messiah Quilters." 2004 Michigan Heritage Awards. http://museum.msu.edu/s-program/mh _awards/awards/2004MQ.html.

"Metaphors on Aging." Studio Art Quilt Associates. http://www.saqa.com/membersArt.php?cat =8&ec=4&ex=3.

Meyer, Adolf. "The Philosophy of Occupational Therapy." *Archives of Occupational Therapy* 1 (1922): 1–10.

Michigan State University Community Club Group. *Caring Hands, 2011*. Michigan State University Museum Collection. East Lansing, MI. Quilt Index. http://www.quiltindex.org/basicdisplay .php?kid=1E-3D-260C.

"Mission Quilts." *Lutheran World Relief*. http://lwr.org/quilts.

Mowinski, Karen. *Inspired by Pain*. Quilt Index. http://www.quiltindex.org/basicdispaly.php?kid =1-6-2EA.

NAMES Project Foundation. http://www.aidsquilt.org/about/the-names-project-foundation.

Natural Healing. Exhibition Catalogue. 2015–2016. Blurb Publishers with Studio Art Quilt Associates of New Mexico.

Neighborhood Ford Store Warriors Quilt Project. http://www.quiltforthecure.com.

"NICU Nurse Uses Scrubs to Make Blankets." *Statesman*. December 24, 2011. https://www .pressreader.com/usa/austin-america-statesman-sunday/20111225/281792805875265.

Nifty Fifty Quilters. *50 State Block Exchange*. April 1998. Michigan State University Museum Collection. East Lansing, Michigan. Quilt Index. http://www.quiltindex.org/fulldisplay.php ?kid=1E-3D-261F.

Noguchi, Sharon. "Nisei Woman, 87, and other Japanese-Americans to Be Honored by San Jose State." *San Jose Mercury News*. May 23, 2010. http://www.mercurynews.com/education /ci_15137406.

"N.H. Quilting Project Delivers Love and Comfort Worldwide." Narrated by Eric Larrabee. New Hampshire Public Radio. July 9, 2015. http://nhpr.org/post/archives-nh-quilting-project -delivers-love-and-comfort-worldwide.

North Tees and Hartlepool NHS Foundation Trust. "A Quilt Is a Hug You Can Keep." November 12, 2015. http://www.nth.nhs.uk/news/a-quilt-is-a-hug-you-can-keep.

Norton, Alissa, ed. *One Quilt, One Moment: Quilts That Change Lives*. Golden, CO: Primedia Consumer Magazine & Internet Group, 2000.

Olson, Ilene. "Quilting Sisters: 1,000-Quilt Goal Reached." *Powell Tribune*. December 29, 2015. http://www.powelltribune.com/news/item/14370-quilting-sisters-1-000-quilt-goal-reached.

Orlofsky, Patsy, and Myron Orlofsky. *Quilts in America*. New York: McGraw Hill, 1974. Orr, Becky. "Quilting for Fallen Heroes." *Wyoming Tribune Eagle*. February 24, 2015. http://www.wyoming news.com/news/quilting-for-fallen-heroes/article_e3bd2bbf-339b-5927-9155-9b5b58f71e95.html.

Orr, Becky. "Quilting for Fallen Heroes." *Wyoming Tribune Eagle*. February 24, 2015. http://www .wyomingnews.com/news/quilting-for-fallen-heroes/article_e3bd2bbf-339b-5927-9155 -9b5b58f71e95.html.

Panizzi, Tawnya. "Warriors in Pink Quilt Offers Hope to Breast Cancer Patients, Hangs in UPMC St. Margaret." *Trib Live*. November 5, 2014. http://triblive.com/neighborhoods/yourfoxchapel /yourfoxchapelmore/7053470-74/cancer-quilt-breast.

Park, Denise C., Jennifer Lodi-Smith, Linda Drew, Sara Haber, Andrew Hebrank, Gérard N. Bischof, and Whitley Aamodt. "The Impact of Sustained Engagement on Cognitive Function in Older Adults: The Synapse Project." *Psychological Science* 25, no. 1 (2014): 103–112.

Parker, Meloday, "Quilt Historian Tells Homefront Story with World War II Quilts." *WCFCourier. com*. January 25, 2009. http://wcfcourier.com/features/lifestyles/quilt-historian-tells -homefront-story-with-world-war-ii-quilts/article_e242cc6e-5a86-5654-ac50-168af34491fe.html.

Parker, Roszika. *The Subversive Stitch*. London: Women's Press Limited, 1984.

"Parkinson's Comfort Quilts Project and Piecing for Parkinson's." *Parkinson's Comfort Project*. http://parkinsonscomfort.org.

Pattison, Cecile. "Grandma Mary Was Our Hospital Angel." *Sheridan Press*. March 31, 2012. https:// www.sheridanhospital.org/documents/GrandmaMary3-31-12.pdf.

Peek, Jane. "The History of the Changi Quilts." *Australian War Memorial*. http://www.awm.giv.au /encyclopedia/quilt/history.

Pennsylvania Relief Sale. "2015 Quilt Auction Photo Gallery." http://pareliefsale.org/auctions/2015 -quilt-auction-photo-gallery.

Pershing, Linda. *The Ribbon and the Pentagon: Peace by Piecemakers*. Knoxville: University of Tennessee Press, 1993.

Petrie, Keith J., Iris Fontanilla, Mark G. Thomas, Roger J. Booth, and James W. Pennebaker. "Effect of Written Emotional Expression on Immune Function in Patients with Human Immunodeficiency Virus Infection: A Randomized Trial." *Psychosomatic Medicine* 66, no. 2 (2004): 272–75.

Pflaum, Nadia. "Stitch by Stitch: Artist Bonds Women, Community through Quilt." *Her Kansas City*. December 2011. http://www.herkansascity.com/heart/stitch-stitch-artist-bonds-women -community-through-quilt.

"Piecing for Parkinson's." Parkinson' Comfort Project. https://parkinsonscomfort.org/hello -quilters/p4p.

Piercy, Kathleen W., and Cheryl Cheek. "Tending and Befriending: The Intertwined Relationships of Quilters." *Journal of Women & Aging* 16, nos. 1–2 (2004): 17–33.

Polansky, S. "A Sense of Peace: Women, Quiltmaking, and Mental Health." Master's thesis. University of North Carolina at Chapel Hill, 1994.

Power-Kean, Kelly M. "A Stitch in Time: Women and Heart Health Quilt Project." *Canadian Nurse* 97, no. 6 (2001): 30–32.

Powers, Marla. *Oglala Women: Myth, Ritual, and Reality*. Chicago: University of Chicago Press, 1986.

Prayers & Squares Prayer Ministry. First United Methodist Church of Redondo Beach. http://fumcrb.org/prayer-quilts.

Prince, Jennifer. "The Art of Crafting: Local Places to Get Creative." *Lynchburg Living*. http://www.lynchburgliving.com/the-art-of-crafting-local-places-to-get-creative.

Project Linus. https://www.projectlinus.org.

Pudwill, Elizabeth. "Scout's Small Effort Has a Huge Impact." *Houston Chronicle*. March 21, 2014. http://www.houstonchronicle.com/life/article/Scout-s-small-effort-has-a-huge-impact-5338654.php#photo-6053297.

Pulford, Florence. *Morning Star Quilts*. Los Altos, CA: Leone Publications, 1989.

"Quilt Art." *Wikipedia*. https://en.wikipedia.org/wiki/Quilt_art.

"Quilt for a Cause: A History." *Quilt for a Cause: Sew a Cure for Women's Cancer*. http://quiltforacause.org/about/history.

Quilt History Listserv Archives. www.quilthistory.com.

The Quilt Index. www.quiltindex.org.

Quilt Treasures. http://www.allianceforamericanquilts.org/treasures.

"Quilters Keep Their Hands Busy with Fidget Quilts." *Laurel Outlook*. October 2, 2013. http://www.laureloutlook.com/community/article_faeee9e4-2b7d-11e-89.

"Quilters' Save Our Stories" (QSOS). http://quiltalliance.org/projects/qsos.

Quilting Culture. http://quiltingculture.com/index.html.

Quilts and Health. http://quiltsandhealth.wordpress.com.

Quilt for Change: Inspiring Social Change through the Art of Quilting. www.quiltforchange.org.

"Global Fund Quilts." http://quiltforchange.org/category/globalfundquilts.

Quilts for Kids. www.quiltsforkids.org.

Quilts of Honor. www.quiltsofhonor.org.

"Quilts of Valor Foundation History." Quilts of Valor. http://www.qovg.org/about-qovf/qov-history.

Quinn, Dorothy. Artist statement. In *Gallery—Sacred Threads 2005*. http://www.sacredthreadsquilts.com/html/gallery2005.htm.

Quintana, Lisa. "Aullwood: Suzanne Mouton Riggio a Lesson in Perseverance." *Michigoose's Gander at Quilts & Life*. August 7, 2010. http://michigoose-life-quilts.blogspot.com/2010/08/aullwood-suzanne-mouton-riggio-lesson.html.

Radosevich, Deb. Quoted in Reynard, "Breast Cancer Center Receives Quilt."

Rainbow of Hope. "Fabric shop in Lynchburg . . . Quilted Expressions . . . To date they've raised over $300,000." http://roh4hospice.org.

Ramsey, Bets, and Merikay Waldvogel. *Southern Quilts: Surviving Relics of the Civil War*. Nashville: Rutledge Hill Press, 1998.

"Relief Sales." *Mennonite Central Committee*. http://mcc.org/get-involved/relief-sales.

Red Cross Quilt. 1901–1929. Michigan State University Museum Collection. East Lansing, MI. Quilt Index. http://www.quiltindex.org/fulldisplay.php?kid-1E-3D-287E.

Reece, Kevin. "1 Pound 10 Oz. Miracle Pays It Forward One Stitch at a Time," *KHOU11News*, March 17, 2014. http://www.quiltersclubofamerica.com/forums/p/46409/619912.aspx.

Reich, Sue. "Canadian Benevolent Quiltmaking during World War II for the Red Cross and the I.O.D.E." *Covering Quilt History*. http://www.coveringquilthistory.com/ww-ii-benevolent -quiltmaking.php.

Reich, Sue. "The Eleventh Hour of the Eleventh Day of the Eleventh Month: World War I Quilts." *Covering Quilt History*. http://www.coveringquilthisotry.com.

Reid, Tony. "Moweaqua Woman Participates in Parkinson's Quilt Project for World Congress." *Herald & Review* (Decatur, IL). May 19, 2010. http://herald-review.com/news/local /moweaqua-women-participates-in-parkinson-s-quilt-project-for-world/article_e5de8obe -1b8e-5dd6-89c8-1a424a47376f.html.

Reynard, Tyler. "Breast Cancer Center Receives Quilt." *Intelligencer/Wheeling News-Register*. October 28, 2011. http://www.theintelligencer.net/page/content.detail/id/561123/Breast-Cancer -Center-Receives-Quilt.html?nay=510.

Reynolds, Frances. "Coping with Chronic Illness and Disability through Creative Needlecraft." *British Journal of Occupational Therapy* 60, no. 8 (1997): 352–56.

———. "Textile Art Promoting Well-being in Long-Term Illness: Some General and Specific Influences." *Journal of Occupational Science* 11, no. 2 (2008): 58–67.

Reynolds, Frances, and Kee Hean Lim. "Contribution of Visual Art-Making to the Subjective Well-being of Women Living with Cancer: A Qualitative Study." *Arts in Psychotherapy* 34, no. 1 (2007): 1–10.

Reynolds, Frances, and Sarah Prior. "'A Lifestyle Coat-Hanger': A Phenomenological Study of the Meanings of Artwork for Women Coping with Chronic Illness and Disability." *Disability and Rehabilitation* 25, no. 14 (2003): 785–94,

Rice, Robin. "Exploring Excess: Amy Orr." *Surface Design* (Winter 2005): 30–35.

Riley, Lesley. *Quilted Memories: Journaling, Scrapbooking & Creating Keepsakes with Fabric*. New York: Sterling/Chapelle, 2006.

Roberts, Kathryn. "Patchwork and Quilting as Holistic Health Practice." *Australian Journal of Holistic Nursing* 5, no. 2 (1998): 4–6.

Robertson, Kristy. "Threads of Hope: The Living Healing Quilt Project." *English Studies in Canada* 35, no. 1 (2009): 85–107.

Ross, Edward A., Tracy L. Hollen, and Bridget M. Fitzgerald. "Observational Study of an Arts-in-Medicine Program in an Outpatient Hemodialysis Unit." *American Journal of Kidney Diseases* 47, no. 3 (2006): 462–68.

Rowley, Nancy. "Red Cross Quilts for the Great War." In *Uncoverings 1982*, edited by Sally Garoutte, 43–51. Mill Valley, CA: American Quilt Study Group, 1983.

Ruskin, Cindy. *The Quilt: Stories from the NAMES Project*. New York: Pocket Books, 1988.

Saal, Mark. "Hospital 'Quilt Room' Turns Fabric into Wheelchairs." *Standard Examiner*. August 7, 2014. http://www.standard.net/Lifestyle/2014/08/07Turning-fabric-into-wheelchairs.

Samuels, Michael D., and Mary Rockwood Lane. *Creative Healing: How to Heal Yourself by Tapping Your Hidden Creativity*. San Francisco: HarperSanFrancisco, 1998.

San Antonio Eye Bank. "Memorial Quilts." http://www.saeyebank.org/search-memorial-quilts .php?page=0.

Schmidt, Linda S. "The Quilters Resistance Movement." *Short Attention Span Quilting: Linda S. Schmidt*. http://www.shortattentionspanquilting.com/the-quilters-resistance-movement.html.

Schrott, Susan. "Art Therapy Workshop/Fundraiser for Avalon Hills Foundation." *Susan Schrott Therapy*. September 2014. http://www.susanschrotttherapy.com/weblog/?p=62.

Sees, Dawn, and Kathleen Unrath. "The Yellow Boat Project: How Art Heals, Connects, and Transforms." *Canadian Review of Art Education* 42, no. 1 (2015): 44–56.

Shaw, Robert. *The Art Quilt*. Paris: Beaux Arts Editions, 1997.

Shea, Marlene. Artist statement. In *Gallery—Sacred Threads 2008*. http://www.sacredthreads quilts.com/html/gallery_2009.htm.

Sherwin, Susan, and Feminist Health Care Ethics Research Network. *The Politics of Women's Health: Exploring Agency and Autonomy*. Philadelphia: Temple University Press, 1988.

Shortley, Vanessa. "Touch the Masterpieces: Local Creates Visual Art for Blind, Sighted Alike to Enjoy." *News of Orange County*. January 29, 2014. http://www.newsoforange.com/arts_and _entertainment/article_8f7923da-8903-11e3-84e2-0019bb2963f4.html.

Sikarskie, Amanda Grace. *Textile Collections: Preservation, Access, Curation, and Interpretation in the Digital Age*. Lanham, MD: Rowman & Littlefield, 2016.

Silk, Louise. *The Quilting Path: A Guide to Spiritual Discovery through Fabric, Thread, and Kabbalah*. Woodstock, VT: Skylights Paths Publishing, 2006.

Simms, Ami. *Alzheimer's Forgetting Piece by Piece*. Flint, MI: Mallery Press, 2007.

Singh, Reena. "Handmade Hope Pulaski Church Group Makes It Its Mission to Sew Quilt to Comfort Cancer Patients." *Watertown Daily News*. January 7, 2012. http://www.watertowndailytimes .com/article/20120107/CUU04/70107997.

Smith, Karen. "Framing Quilts/Framing Culture: Women's Work and the Politics of Display." PhD diss. University of Iowa, 2011. http://ir.uiowa.edu/cgi/viewcontent.cgi?article=2468 &context=etd.

Smith, Kelly M. *Open Your Heart with Quilting—Mastering Life through Patches of Love*. Las Vegas: DreamTime Publishing, 2008.

Sophiasworth, Linda. "Memory Quilt from Dad's Shirts." Worthquilts. *Etsy*. https://www.etsy .com/listing/91887855/memory-quilt-from-dads-shirts?ref=shop_home_active_20.

———. "Profile." *Etsy*. https://www.etsy.com/people/lcsrn927?ref=owner_profile_leftnav.

Spotted Tail, Pearl. *Broken Star*. 1994. Michigan State University Museum Collection. Quilt Index. http://www.quiltindex.org/fulldisplay.php?kid=1E-3D-1176.

St. Charles, Cynthia. "'All Alone and Blue' Juried into Sacred Threads 2011." *Living and Dyeing under the Big Sky*. http://cythia-stcharles.blogspot.com/2011_04_01_archive.html.

Stalp, Marybeth C. *Quilting: The Fabric of Everyday Life*. Oxford, NY: Berg, 2017.

———. "Women, Quilting, and Cultural Production: The Preservation of Self in Everyday Life." PhD diss. University of Georgia, 2001. http://athenaeum.libs.uga.edu/handle/10724/20488.

Stockinger, Jennifer. "Fidget Quilts Made to Help Seniors in Need." *Brainerd Dispatch*. May 12, 2014. http://www.brainerddispatch.com/content/fidget-quilts-made-help-seniors-need.

Stuckey, Heather L., and Jeremy Nobel. "The Connection between Art, Healing, and Public Health: A Review of Current Literature." *American Journal of Public Health* 100, no. 2 (2010): 254–63.

"Stunning Digital Quilt Impresses at Brighton Graduate Show." *The Future Perfect Company*. June 3, 2013. http://blog.thefutureperfectcompany.com/2013/06/03/stunning-digital-quilt-impresses -at-brighton-graduate-show.

Susan G. Komen Race for the Cure. http://ww5.komen.org/findarace.aspx.

Tameus, Bill. "Mennonite Women Quilt for a Cause—Their Church." *St. Augustine Record*. April 29, 2005. http://staugustine.com/stories/042905/rel_3045894.shtml#.VtUQ1hGRRtI.

Tarrant, Phyllis. Artist statement. In *Gallery—Sacred Threads 2011*. http://www.sacredthreads quilts.com/html/gallery2011.html.

Thompson, Romayne A., Marlene H. Frost, Teresa A. Allers, and Julie A. Ponto. "Twin Quilts— Stories to Be Told." *Complementary Therapies in Nursing & Midwifery* 9, no. 4 (2003):1 82–90.

Tieche, Merrilee J. Artist statement. In *Gallery—Sacred Threads 2013*. http://www.sacredthreads quilts.com/html/gallery2013.html.

Thompson, Jeanne. Artist statement. In *Gallery—Sacred Threads 2011*. http://www.sacredthreads quilts.com/html/gallery2011.html.

Torsney, Cherly B., and Judy Elsley, eds. *Quilt Culture: Tracing the Pattern*. Columbia, MO: University of Missouri Press, 1994.

Towner-Larsen, Susan, and Barbara Brewer Davis. *With Sacred Threads: Quilting and the Spiritual Life*. Cleveland: Pilgrim Press, 2000.

Treschel, Gail A. "Mourning Quilts in American." In *Uncoverings 1989*, edited by Laurel Horton, 139–58. San Francisco: American Quilt Study Group, 1990.

Trotter, Fred. "NHIN-Direct Leans towards HealthQuilt Security Model." April 18, 2010. *Fred Trotter*. http://www.fredtrotter.com/2010/04/18/nhin-direct-leans-towards-healthquilt-security -model.

Trinity Health. "2013 For 'Warriors in Pink' Quilt Presented to Images Breast Imaging Cancer Center at Trinity." http://www.trinityhealth.com/news/articles/2013/sep/24/2013-ford-warriors -pink-quilt-presented-images-bre.

"Tuskegee Syphilis Experiment." *Wikipedia*. Last updated May 25, 2016. https://en.wikipedia.org /wiki/Tuskegee_syphilis_experiment.

Ulrich, Roger S. "View through a Window May Influence Recovery from Surgery." *Science* 224, no. 4647 (1984): 420–21.

Unknown. "Thread of Life." Artist statement. In *Lilly Oncology on Canvas: Expressions of a Cancer Journey*. 232. Indianapolis: National Coalition for Cancer Survivorship, 2012.

Vlack, Barb. October 25, 2011. "Mourning Quilts." Quilt History Listserv Archives. http://quilt history.com/2011/289.htm.

Volckening, Bill. June 26, 2014. Post on *Quilts and Health* Facebook page. https://www.facebook .com/groups/quiltsandhealth/permalink/724132140959564.

Walsh, Sandra M., Susan Culpepper Martin, and Lee A. Schmidt. "Testing the Efficacy of a Creative-Arts Intervention with Family Caregivers of Patients with Cancer." *Journal of Nursing Scholarship* 36, no. 3 (2004): 214–19.

Walt, Irene, and Grace Sierra, eds. *The Healing Work of Art: From the Collection of the Detroit Receiving Hospital*. Detroit: Detroit Receiving Hospital, 2007.

"Warriors in Pink Quilts: Susan G. Komen Race for the Cure Patchwork Stations." Neighborhood Ford Store Warriors Quilt Project. http://www.quiltforthecure.com.

Washington, Olivia G. M., David P. Moxley, and Lois Jean Garriott. "The Telling My Story Quilt Workshop: Innovative Group Work with Older African American Women Transitioning out of Homelessness." *Journal of Psychosocial Nursing and Mental Health Services* 47, no. 11 (2009): 42–52.

Weaving Traditional Arts into the Fabric of Community Health: A Briefing from the Alliance for California Traditional Arts. Fresno: Alliance for California Traditional Arts, 2011.

Webber, Martha. "Crafting Citizens: Material Rhetoric, Cultural Intermediaries, and the Amazwi Abesifazane South African National Quilt Project." PhD diss. University of Illinois at Urbana-Champaign, 2013.

Webster, Marie. *Quilts: Their Stories and How to Make Them*. New York: Tudor Publishing, 1915.

Weeks, Pamela, and Don Beld. *Civil War Quilts*. Atglen, PA: Schiffer Publishing, 2011.

Weems, Mickey, Marsha MacDowell, and Mike Smith. "The Quilt." *Qualia Encyclopedia of Gay Folklife*. December 8, 2011. http://www.qualiafolk.com/2011/12/08/the-quilt.

"Weight Loss Surgery Success Stories: 'Now I Can . . .'" *BIDMC's Health Notes*. http://www.bidmc
.org/YourHealth/Health-Notes/WeightLoss/NOWICAN.aspx#sthash.WsmNNeqq
.XJGcVIu.dpuf.

Wells, Kate, Marsha MacDowell, C. Kurt Dewhurst, and Marit Dewhurst. *Siyazama: Traditional
Arts, AIDS, and Education in South Africa*. Pietermaritzburg, South Africa: University of Kwa-
Zulu Natal Press, 2012.

Wentz, M. "The Mayo Clinic Arizona 20th Anniversary Quilt." *Mayo Clinic Proceedings* 84, no. 9
(2009): 848.

"What Cancer Cannot Do Quilt Panel Fabric." *Block Party Studios Corp*. http://www.block
partystudios.com/shop/Hand-Printed-Fabric/p/What-Cancer-Cannot-Do-Quilt-Fabric
-Panel-x2719960.htm.

"What Cancer Cannot Do Quilt Pattern." http://siterepository.s3.amazonaws.com/3278/cancer
_quilt_pattern_fina12.pdf.

What Cancer CANNOT Do—Quilt Tutorial." February 3, 2015. *Home a la Mode*. http://
homalamode.blogspot.com/2015/02/what-cancer-cannot-do-quilt-tutorial.html.

WHI Quilts. https://www.whi.org/participants/quilts/Pages/Home.aspx.

White, Michael. *Arts Development in Community Health: A Social Tonic*. Oxford: Radcliffe Publish-
ing, 2009.

Wickell, Janet. "Pictures of Comfort and Charity Quilts." The Spruce, January 25, 2017. https://
www.thespruce.com/pictures-of-comfort-and-charity-quilts-4051126.

Wimp.com. "Preemie Baby Nearly Dies but Returns to the Hospital 13 Years Later to Repay a Kind-
ness." http://www.wimp.com/preemie-baby-nearly-dies-but-returns-to-the-hospital-13-years
-later-to-repay-a-kindness.

Wiebe, Adrienne, and Bonnie Klassen. "Columbia's Best Hope: Ordinary People Take Peace into
Their Own Hands." *Ploughshares Monitor* 32, no. 2 (2011). http://ploughshares.ca/pl
_publications/columbias-best-hope-ordinary-people-take-peace-into-their-own-hands.

Wolf, Terri Pauser. "Building a Caring Client Relationship and Creating a Quilt. A Parallel and
Metaphorical Process." *Journal of Holistic Nursing* 21, no. 1 (2003): 81–87.

Wood, Margaret. *Charlie Wood's Stoma*. Quilts and Health Project. East Lansing, MI: Quilt Index.
http://www2.matrix.msu.edu/~quilti/fulldisplay.php?kid=6B-FF-0

Wood, Sherri Lynn. *Passage Quilting*. 2011. http://www.passagequilts.com.

World Health Organization. "Ebola Virus Disease." January 2016. http://www.who.int/media
centre/factsheets/fs103/en.

Wrap Them in Love. http://wraptheminlove.com/index.html.

Wyatt, Linda. Artist statement. In *Gallery—Sacred Threads 2011*. http://www.sacredthreadsquilts
.com/html/gallery2011.html.

Zander, Laura. *Sew Red: Sewing and Quilting for Women's Heart Health*. New York: sixth&spring-
books, 2013.

INDEX

Marsha MacDowell is Professor of Art, Art History, and Design at Michigan State University and Curator at the Michigan State University Museum. She is also Director of the Michigan Council for Arts and Cultural Affairs and Director of the Quilt Index. She has served as president of the American Quilt Study Group, as founding board member of the Alliance for American Quilts, and as executive board member of the American Folklore Society. She has authored many publications on traditional material culture, including ones on quiltmaking in a variety of historical, regional, and cultural contexts.

Clare Luz is Assistant Professor in the Department of Family Medicine at Michigan State University. She is a gerontologist whose research focuses on quality of life for vulnerable older adults, long-term care health services, particularly the direct care workforce, and the intersection of health, creativity, and the arts. She has served on the Michigan Long-Term Supports and Services Advisory Commission, the Michigan Society of Gerontology board, and the National Quality Forum's Home and Community-Based Care Committee.

Beth Donaldson is Digital Humanities Project Asset Coordinator at the Michigan State University Museum and Coordinator of the Quilt Index. She is a quiltmaker and coauthor of *Quilts and Human Rights,* among other publications on quilts.

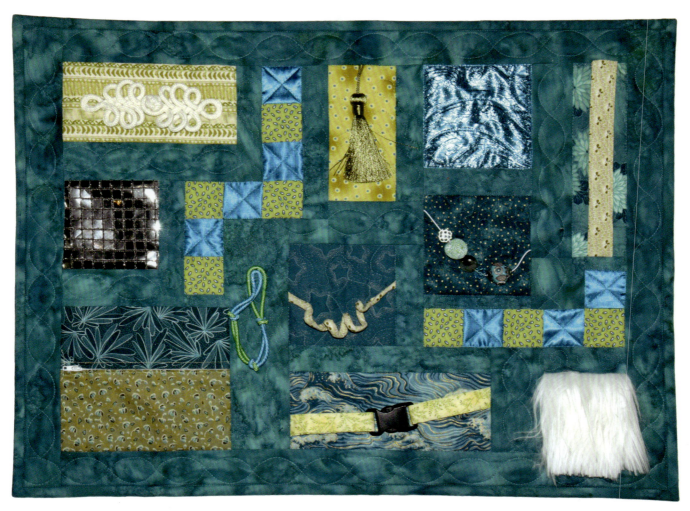

Fidget Quilt, Beth Donaldson, Lansing, Michigan, 2017. 18" x 24".
Collection of Beth Donaldson. Photo by Pearl Yee Wong

Fidget quilts are quilts are small quilts with activities stitched into them. They are used to help calm people who are restless or agitated. They have been used by people with Alzheimer's, other forms of dementia, ADD or autism. This quilt was made to display in the Arts and Health Tent at the 2017 Great Lakes Folk Festival. The activities included in this quilt are: Frog closure, smooth mirror squares, satin, fur, tassel, Velcro strip, beads on elastic string, zipper pocket with surprise, pony tail holder, pipe cleaner twister, and back pack clasp.